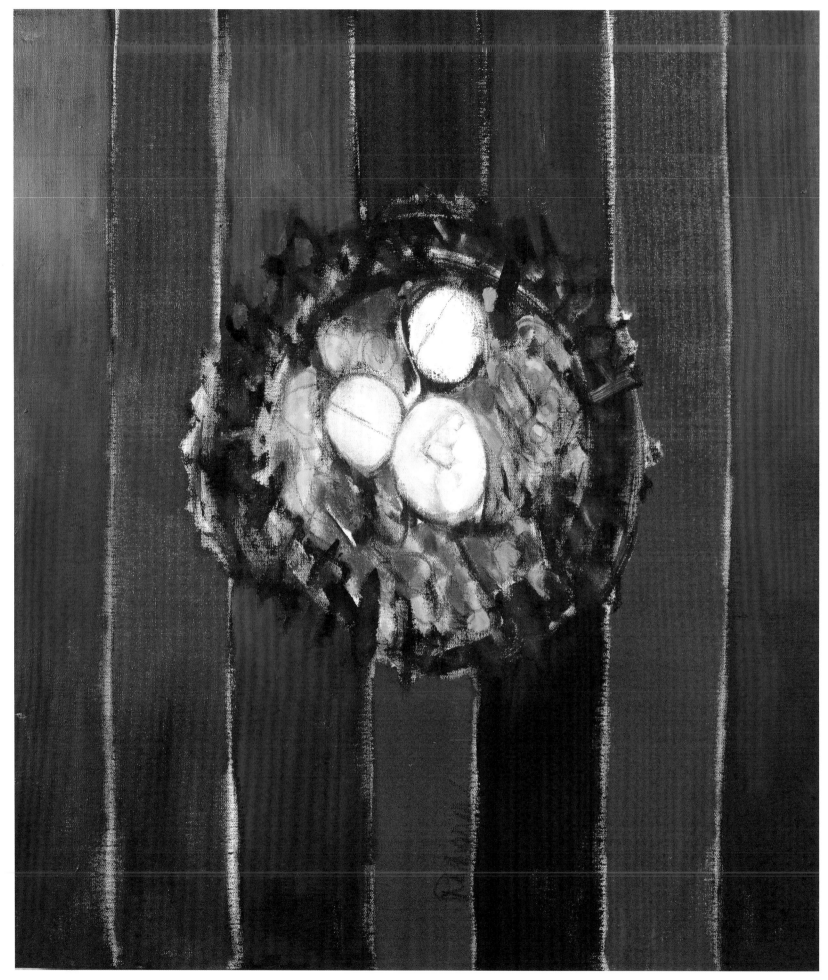

SLEEPING PRESIDENTS, 2011
OIL ON LINEN
46 X 40"

SLEEPING PRESIDENTS

JOHN RANSOM PHILLIPS

THIS VOLUME IS PUBLISHED IN CONJUNCTION WITH THE ONLINE EXHIBITION "SLEEPING PRESIDENTS"

HELD AT WWW.SLEEPINGPRESIDENTS.COM

PUBLISHED BY BLACKBOOK PUBLISHING

EVANLY SCHINDLER, PUBLISHER AND EDITORIAL DIRECTOR

ALEXANDRA WEISS, EDITOR

KENNETH SCRUDATO, EDITOR

ADAM GEORGE, DESIGNER

20 JOHN STREET

BROOKLYN, NY 11201

WWW.BLACKBOOKPRESENTS.COM

DISTRIBUTED BY ACC ART BOOKS, NEW YORK

FRONT COVER: *WASHINGTON I DREAM IN MY DREAM ALL THE DREAMS OF THE OTHER AMERICAN PRESIDENTS*, 2011

OIL ON LINEN

42 X 40"

©2020 JOHN RANSOM PHILLIPS, NEW YORK.

PHOTOGRAPHS BY BRUCE M. WHITE ©2020

SPECIAL THANKS TO ARTPOND FOUNDATION, NEW YORK, NY.

ISBN: 978-0-578-61384-0

TABLE OF CONTENTS I

TABLE OF CONTENTS II

AMERICAN PRESIDENTS IN VAPOROUS MIST, 2012
OIL ON LINEN
40 X 50"

ideas in bed

Ransom 10 sleeping 4

IDEAS IN BED, 2010
WATERCOLOR
22 X 15"

I go from bedside to bedside, I sleep close to the other sleepers each in turn,

I dream in my dream all the dreams of the other dreamers,

And I become the other dreamers.

– Walt Whitman – *The Sleepers*

politics

Ransom 11

politics

I

sleeping

POLITICS, 2011
WATERCOLOR
30 X 22"

INTRODUCTION

BEDS ARE MAGICAL PLACES. HERE LIFE'S FORMATIVE EXPERIENCES HAPPEN. Presidents are no different. Like us, they are born in beds and come of age, making love, creating, and procreating. We all reach for our beds when we are sick, need rest, and eventually, to leave our lives behind. All along, we dream.

I invaded the dreams of our 45 presidents. I became part of their dreams. This is more than listening and greater than appropriation, because I don't dress up. It is beyond empathy. I embraced the mythologies of leaders who have shaped American history. I become those dreamers dreaming.

These men invited me to paint and transcribe their visions. It became a powerful evocation. A call. During the day, their images and words would roll around in my head. In the evening, I would dream them. Sometimes two dreams simultaneously, mine and theirs. Soon they merged, becoming one.

How do you enter someone's dreams? In the beginning, I encountered strange and curious images during waking moments. While contemplating Andrew Johnson, a tailor before becoming president, I saw multiple images of sleeves. They were always unfinished and disjointed from the rest of the garment. Then there were LBJ's hands. I found myself pushed, prodded, and punched.

I never sleepwalk but began to do so frequently when I invaded Teddy Roosevelt's dreams and became him. I patrolled his house, even stepping outside and falling on my head. Or did I dream that?

Some presidents were accommodating. They wanted their stories told. Others held me at a distance. I would knock on the door of their dreams for entry. A few worried that my dreaming their dreams would unmask them. Not a good thing for presidents. Zachary Taylor preferred that his horse, Whitey, talk with me. Abigail Adams intruded frequently (as she did in life) when I dreamt her husband John's dreams. Florence Harding took complete control of her husband Warren's dreams while waiting to have her own. Only Gerald Ford never let me in. I suspect he did not dream.

I am convinced that these presidents, whom we do not normally consider in conventional terms, become fully human and vulnerable when they are dreaming. Beds are magical places.

bending
to american winds

Ransom 11 sleeping

BENDING TO AMERICAN WINDS, 2011
WATERCOLOR
23 X 16"

america burns

1.

Ransom 12

AMERICA BURNS, 2012
WATERCOLOR
30 X 22"

45

TRUMP

Small is big especially in dreams

2017 — 2021

I'M USED TO WATCHING. All little boys are. We lie in our bassinets, putting up with the stickiness of being a baby. Warm turns to cold. Cold takes me high above the clouds—very high—above people. This means I get to look down on everyone. Not every baby can do this. But when Mommy comes to change me, I return to watching. Her hands are cold. I should have done it myself.

Daddy is never home. Even when he comes home, he is still not here. We see him and we hear him but we never feel him. So we watch. I get very good at imagining what it would be like to know him. Or, to be him.

I like being president. It's not a job so much as a feeling. A feeling of being able to come and go and find people waiting for you. I never got used to waiting. Not even for Daddy—although it was always an opportunity to think all kinds of things about him. Not all were true, but that doesn't matter. I imagine my Dad doing all the things I like: eating chocolate, feeling women's bodies, making money, firing people, or just ordering them around. That's what waiting does.

My bed has always been too small for me. I'm big: big head, big frame, big engine. BIG. I don't like being alone. I want people around, whether it's my mom and dad, my children, or swell ladies I have met. They can get in the way, though, when I'm in bed. There is always a wandering elbow, or a pointed knee intruding on my space. It has always been that way. I have great ideas about beds. I need to build a bigger one. I'm good at building and have big ideas about height and width (texture and lighting included). I dream of the perfect bed. An American bed free of entangling alliances. Consider a huge mattress, sufficiently off the floor so you can hide under it; add strategically placed pockets to stash secret papers, like tax returns, and you get the picture. As a great builder, I know pockets are essential to life. They allow you quick access to the bold front you need to convince yourself that what you are saying is absolutely true, even when it is not. Pillows should not be chosen for comfort but for the impressions heads leave behind. Better to collect such imprints so you can reshape them. So you won't forget.

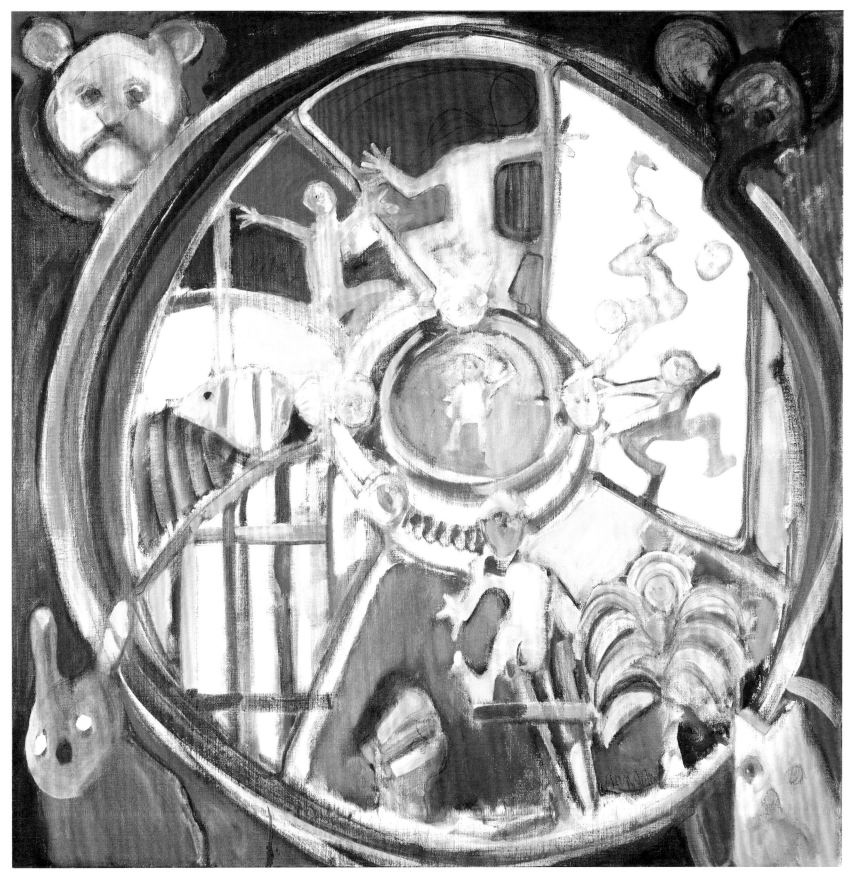

TRUMP TWITTERING PRESIDENT, 2017
OIL ON LINEN
50 X 50"

I want admiration, not understanding. It has always been this way. So I arch my body to observe my dad, who has just returned and is getting into our bed. He fills the valley left by yesterday's sleep. He seems to look at me casually, but actually, he is focused and intense. When I was young like a playful puppy, Dad appeared to be tamed by my cuteness. I was cute. He felt my warm, soft face in his hand and smiled. Then, I was his son. But when my evolving maleness surfaced, he saw not his son, but a budding rival.

I look at Father's body as he looks at mine. His strength is hidden, his determination more registered in the alignment of his limbs and the purposeful fists that take time to unlock. Men's bodies require a long time to know. We dream about long-term success, never apologize, and disclose only so much of ourselves to stay on the offensive. We are winners who camouflage in our hopes, our secret maneuverings, and usually show only our defiance. I promise to tell you everything but don't kid yourself.

"It is not enough that you claim to be a man. You have to act it, Donny. You have to be the best. The bigger the man, the more he will cheat"

Father blows his nose on his pajama top and shifts his body to understand more fully his son and rival. He continues:

"I am always drawn to holes. Large or small, black or sun-drenched. They pull me in and make me hard. Unbelievable holes, infinite holes, American holes. I am also talking about construction sites, which are even bigger challenges. We don't need permits to allow us to build what is not permitted. Men like us must not surrender when we don't need to"

Father's shadow, not fully aroused from the advice he likes to give, is quiet and rises from the family bed. He circles the room twice, indifferent to anything that does not ultimately concern him, and disappears. My eyes follow him, though the rest of me is watchful. Half heavy with sleep and alone, I finally embrace the dream that waits for me.

* * *

I roll back in the darkness of the room to explore the half-submerged, strangely twisted crater in the large pillow where my father always tries to rest. I smooth his folds and indentations and replace them with my own head's silhouette. My ears, which like to hear only my own voice, create fresh hollows, dark and fathomless. My mouth deposits a swatch of sticky saliva that darkens the landscape of what had been a place of rest. My chin quickens to fill that last divot that my father had left behind. Am I surprised that most of his indentations can be replaced?

Our bedroom door opens violently and sucks away what little air remains in my dream. A smallish figure stands silhouetted against the intrusive half-light. I know who it is, but I remain ever so still, watching, breathing as best I can. The stranger, who is no stranger, enters without muttering a single word. His right eye, a maze of crooked red capillaries, sizes me up and nods at the absence of the shadow of my father and closes the door. I feel a hand grab and squeeze my heart, loosen its grip and do it again. Harder.

The stranger circles the bed twice and then lies down. He stretches his tiny frame, but cannot fill the space that Father had occupied. So he twitches and jerks and moves his shoulders up and down. His presence gradually fills many of the holes in my heart that Father always promised to fill.

The stranger never tries to replace the dips and hollows I have created on Father's pillow. What he does is reinforce my silhouette. The ear depressions are subtly turned to hear the tiniest innuendos, so revenge will be absolute. He ignores the wetness of my pillow but doubles down on

the deep cleft of my chin and shows me how I can totally dominate it with other parts of my body that usually do not rest on pillows. He vigorously wiggles this way and that, creating his own monstrous landscape of deep slashes and violated spaces. Teeth marks, if not actual bites, cover the bed that once belonged to Father. The bed, which is now mine, becomes more a group effort. The pillow, a work in progress.

The stranger learned long ago, through unrelenting pushing and kicking, never to give up. His shadow moved to avoid exposure because light defines what is real. He pulls back my hair and presses my brain against his. I become the stranger's son, more than I ever was my father's. He takes my head between his hands and breathes fully into my young face. Then catching himself, he pulls forward, dropping my head, then squeezing my hand tightly before slapping my back until it hurts. Then he changes the subject.

I call my stranger Roy, and he carries me to all those places where people cry out to be taken over. You know them. Those faceless heads that want to be me. And I invite them to win by not losing. They gather in small beds with tiny depressions of innuendo and exaggeration. In time, they join me in my bed, which has grown enormously larger, if not presidential, with new children, politicians, ladies and followers. I have learned to fill the hollow in the pillow I inherited from my Father. I got away with it until I didn't. You should be so lucky.

periodically the sun intrudes into our darkness.

Ransom 13 *sleeping*

PERIODICALLY THE SUN INTRUDES INTO OUR DARKNESS, 2013
WATERCOLOR
30 X 22"

44

OBAMA

Earning his name

2009 – 2017

THE PRESIDENT SLEEPS THE TENDER SLEEP OF EARLY EVENING AND LATER, MUCH LATER, THE LAST DEEP SLUMBER OF EMERGING DAWN. *Between these two places of safe repose, however, there stretches a dark and menacing, ever-expanding place of quiet fear. He shares this fear with America.*

> OBAMA
> I feel my father.
> I feel his spirit, a spirit that never rests.
> I never knew him.
> I have his name but it was only lent to me.
> A fatherless son.

He turns over.

> Am I asleep—how can I tell?

On his pillow, his head is pushing and pulling, forging ahead, turning left, turning right. He gets out of bed and begins to move, more than a walk but less than a run. Soon, he catches up to the many shadows of his father, half-formed and retreating.

Obama gets up and sits on the edge of his bed and is joined by the wind, which takes the form of an angel. Obama speaks first.

> I have always felt alone.
> I have only memories of being hatched from an egg that had been laid in a dark womb.
> It was not my father making love with my mother.
> [*Gradually becoming joyful.*] It was the wind making love to the night.
> Setting the universe into continuous motion.
> I inhabited a bubble of well being.

BARACK OBAMA IN WATERY AMERICA, PANEL 1 AND 2, 2012
OIL ON LINEN
50 X 106"

I rotated my neck sucking in life.
This gave me a newfound strength
to avoid life's ropes,
a kind of freedom I would always
look for in my life,

Without a father. I became the
cautious orphan.

The Angel feels Obama's pain and tells him:

ANGEL
My inheritance was different.
Daddy's seed took the form of deep
and steady thrusts,
relieved by strange whimpering,
only to return to the powerful jabs
that dislocated my mother's serenity
and my existence.
I learned to shape my experiences of
joy and pain, on the lap of my father.

*There is a long silence and the angel extends
both his arms and his wings.*

I left my boyhood and became a man.
I wrested life from nature.
I learned this from my father.
Together we cultivated the earned
gifts of power.

Obama is astonished and asks:

OBAMA
All this from your father?

*The angel sits back on the bed and Obama
takes in his odor, which like the wind itself is
pungent with life.*

ANGEL
But I became more than a man when
I learned to cast off selfish feelings.
When I listened to the echoes
of human pain that surrounded
our house.

Then I heard.
Then I responded.

*Obama turns so is just inches from the angel's
face. He sees in this heavenly creature the
anguish of having once been human and
shares his own family story.*

OBAMA
I became the indulged guest in a
family of one.
I can see the inheritance of human
suffering.
Beginning early and ending at last
breath with empty hands.

The angel takes Obama's hands.

ANGEL
Empty hands?
What's in your hand?
See these tiny ridges on my fingers
and palms?
They began when I was four months
old.
Maybe younger.
Diminutive bumps each with a sweat
duct at its mountaintop.
In time, these tiny eruptions became
joined with one another.
Look at mine.
These ridges give me my fingerprints—
forever identifying my uniqueness.
My inheritance.
My dad bequeathed to me these
hands that are oversized, but mine.
My thumb excels at pointing my way,
as a hitchhiker points his.

OBAMA
And your trigger finger?

ANGEL
Dad taught me to restrain it because
it can threaten.

Obama in watery America

Ransom 12

44
sleeping

OBAMA IN WATERY AMERICA, 2012
WATERCOLOR
30 X 22"

OBAMA
And the middle?

ANGEL
It's the longest.
It can both arouse and put others in
their place.
Like an erect prick.

OBAMA
And your little finger?
And your ring finger?

ANGEL
They both gauge the authenticity of
another man's handshake. Dad saw
to that.

OBAMA
Your dad saw to that?

The angel extends his hands.

ANGEL
Here is the most significant part of
my body.
What's in my hand?
Look! My palm.
Become the beggar.
Palms up.
Calm others.
Palms down.
Push back.
Palms front.
Pull towards me.
Palms facing.

OBAMA
Palms facing back?

ANGEL
Yanking folks toward me.
My most powerful gesture.
I have always been blessed in finding
those willing to receive my touch...
It's my blessing.

*The angel gets up and spreads his arms, then
his wings.*

I can feel God in people; there are
moments when I know who they are.

Because I learned from my father
before I was born I could manage
and even control events if I used my
whole body while touching people.

OBAMA
Shaking hands?

ANGEL
No, touching people. Blessing them.

*The angel sees that he is saying too much
and pulls back, one wing at a time, then both
arms. Then, the angel flies out of the upstairs
bedroom window of the White House. Obama
is left alone.*

OBAMA
I can't hear you!
It's too dark.

And the wind replies:

ANGEL
You have all the light you need.
Untie yourself.
The bounds are yours.

*And Obama shouts in the face of the thunder
in the wind.*

OBAMA
All the light for what?
How long?

ANGEL
Not long.
Move quickly.
Follow the light.
Not long.
Receive your own blessing.

OBAMA
My blessing?

ANGEL
Give me your hand.
Raise up your hands and palms.
Barack means blessed.
Earn your name.

BARACK OBAMA IN DAY AND NIGHT, PANEL 1 AND 2, 2013
OIL ON LINEN
50 X 53"

43

G.W. BUSH

Word dreams

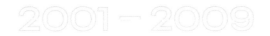

I REACH FOR THE W BETWEEN MY TWO NAMES: GEORGE AND BUSH. You think it stands for Walker, but if truth be told, it means Words. Not that I like them. They are mean little devils that can get you into trouble. I chase them in my sleep.

My mother is reading to me. It's bedtime and she always chooses stories she finds meaningful for a budding adolescent boy. But she reads too fast. I can still see and hear her words. Frequently she slows down at parts of the story she likes and savors what I never understand, and never will. Letters, words, sentences, paragraphs. They all belong to her, and she has never shared their meanings with me.

She has always been the driver, and I will always remain an unhappy passenger, riding through long, barren stretches of sand and garbage, landscapes wholly unintelligible to my adolescent self. You might say that Mother is in the way. She continues to hold onto space in the blank pages of my mind, pages that should be filled with my own ideas. Whenever she leaves my bedroom (and sometimes before), I dream about arid landscapes of words that will forever carry her scent.

I have inhabited penthouses in the sky with iron gates to keep intruders from rooms nonetheless filled to capacity. They have been crammed with strangers speaking what is to me unfathomable. When I abandon the sky and embrace the earth, I find refuge in basement apartments. These spaces are flooded by a Babel of foreigners who laugh and shout and paralyze my thoughts. I am especially puzzled by the admonitions of my relatives. Even in my dreams, they hector me with tired formulas for good behavior and correct living with specific adjectives to which they publicly subscribe but hardly practice. The accumulation of frustration leads me to want to be invisible, free to construct my own special language, free of the constraints of what is commonly accepted.

After several years of listening to Mother's tiresome reading, I retreat more often into a secret self safe from other people's commonly accepted phrases. But their worrisome words pursue me even in the bed of my teenage years, which feels less mine than theirs. Frequently, letters spill out in the darkest pages of night and attack me in my sleep. Certain letters, W, M and D, are especially virulent, and they grope my body. Some letters have digits; F and S shove me to the far end of my bed and use their sharp edges to penetrate me. Their barrage lasts about 30 seconds. I ignore the invasion and return to sleep.

GEORGE W. BUSH'S BLOOD CLOT, 2011
OIL ON LINEN
70 X 50"

I know language does not like me. There would be more generous words to describe me if I were taller, handsomer—even more open-hearted and less greedy. Once, I made the mistake of sharing with my mother the wet dream sequences her bedtime stories elicited for me. She fretted over the health of both my body and spirit.

Leaving unhappy adolescence behind, abandoning mother's bedside readings and the fantasies that had so traumatized me, I grow permanently and inconsolably suspicious of the whole baggage of language. Books, chapters, paragraphs, sentences, phrases, and soon even letters are for me untidy patches of poison ivy and nettles, spreading their mismanagement of thought onto a cynical path that takes over my mouth and eyes and threatens to end in confusion and madness. Does a word uttered by my mouth and tongue ever mean what your ears register? Can language ever describe our feelings adequately? I am distrustful in general, contemptuous specifically, and feel the urge to say much less than you really need to hear.

Now that high office has come my way, I reevaluate language. Since words are by their very nature open to manipulation, why not ride the backs of sentences and bend their innate ambiguity to match my own unguided objectives? If a hammer is the only tool you have, then every solution looks like a nail. No man is as sure of his premise as the man who knows too little. Freed of language, I know who I am. I can rest comfortably with little personal doubt. I use no examples of human experience to guide me. I leave out facts of all levels of importance. I embrace omissions and falsifications and wallow in tissues of elisions and evasions. I want to confuse your perception of what you think I say.

Letters can be assertive when they stand alone, but when they join and evolve into phrases like *weapons of mass destruction*, they become downright aggressive. That's useful. These phrases create shadows that move beyond communication. In my hands, they become a lightning rod to conduct what I want to achieve.

General Washington wrote that to be prepared for war is the most effective way to promote peace. This is confusing, so I change it. "We make war to make the world more peaceful" is much clearer to me. And it better fits my new accommodation with language. My mother reappears without a book and warns me about unknown forces. I surmise she's talking about God. I remind her that there are *known unknowns*—that's when we know that we don't know. She responds as always and declares once again that there are only *unknown unknowns*—when we do not even know that we don't know. I rearrange language and make it mine. She apparently enjoys the same freedom. I shift my limbs and go back to sleep, becoming my own adjective or at least, a semi-colon.

DICK AND W, 2012
WATERCOLOR
22 X 15"

in bed with words

constructing a W

Ransom 12

43
sleeping

IN BED WITH WORDS, 2012
WATERCOLOR
22 X 15"

Ransom 12

43
sleeping

CONSTRUCTING A W, 2012
WATERCOLOR
23 X 15"

42
CLINTON
Shared dreams

1993 — 2001

A CUTE LITTLE BOY DOES THE BEST HE CAN. But I am surrounded by people, even in sleep, who try to limit my freedom or to control Billy in ways I do not like. I am gone a lot—earning money but also exploring my never fully tested female ripeness. It is always in early July that these spells come over me, when I become like untidy weeds growing in profusion wherever they find responsive dirt.

I am Virginia Cassidy, later Virginia Blythe, and only then, Clinton. But you can call me Virginia or, better, Mother. My child is a blend of two bodies and minds. I know that what I thought at the very second of entry that shaped my children. Even more, I know that what I ate and how I felt during pregnancy materially affected their natures. Fathers have no connection with the child except as the initiator of the act.

She often lies in bed, all silvery and white, and paints her left brow with bright brown shadow. This is heaven for me. She is not just updating her face, but together we are using the miracle of contemporary cosmetic art, recreating the larger she, her face as it was so that she can masquerade as her younger self.

I am searching for unwanted hairs, starting with those in my nostrils. My beauty box is resting beside me in bed, and I draw on a Pall Mall as I return the tweezers to their home. The contents of the box always remind me that I know what I must do, so I take up my lipstick, trying out a cobra red with a slightly bluish tint.

A pair of curious eyes suddenly enters my peripheral vision. Billy seems surprised that I appear younger and more beautiful every day (he especially loves my hair, which I keep long). My delight is that I will always remain young and desirable so that my sons will want their wives to be like their mother, or better yet, their mother to be their wives.

The animals I admire most are those with the power to change their skins. Snakes and lizards, for example. I envy the crabs' ability to slough their shells and remain young and active. I identify with these creatures, their walking sideways and how they take their homes with them. Above all, I worry about Mother's face being replaced by a younger woman's in the eyes of men.

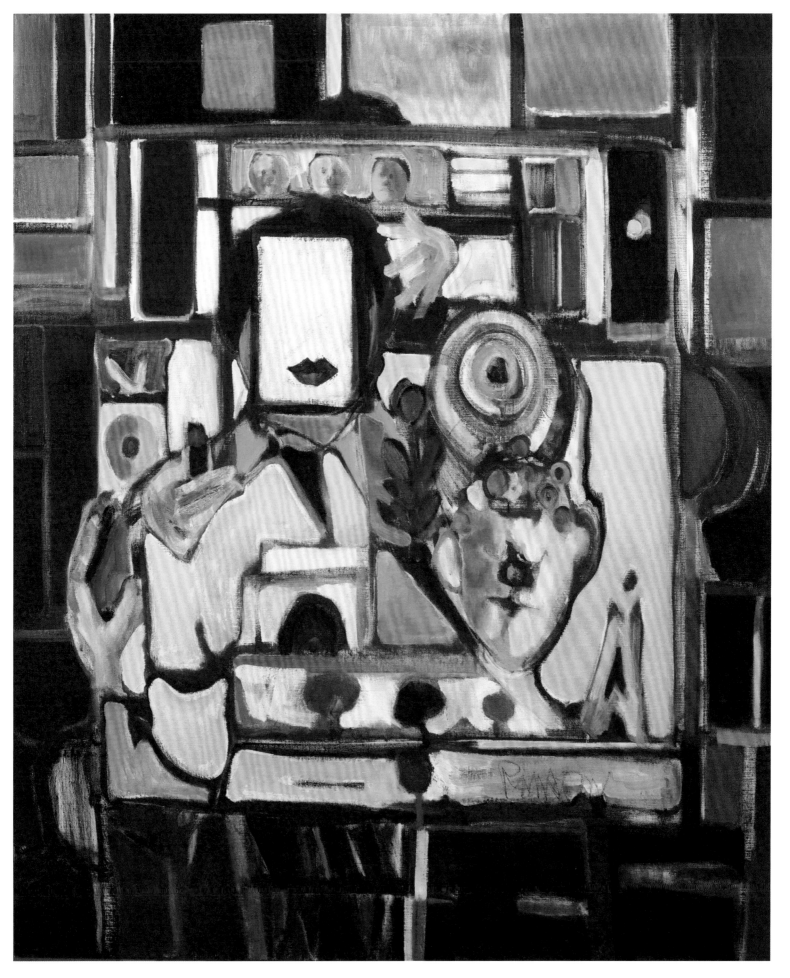

CLINTON DIVIDING LIFE INTO SMALL COMPARTMENTS, 2011
OIL ON LINEN
60 X 50"

Another cigarette. Then perfumed powder to shape and mold my face, neck, and breasts. This, I know is Billy's favorite, because he gets into my bed to get closer. My perennial glow denies a thickening body indulged by liquor and good times, but anyone can see that the flow of natural juices makes me still desirable. My soul is not hidden deep inside me. My soul is my shining face, my responsive body, the dimension (my painted self)—as other people (especially men) perceive me.

She feels the need to freshen her makeup, to transform herself into the person she was meant to be. I think about who she really is underneath the paint. She has never really had eyebrows. That is, they have never had hair. Everything you see, the bright brown arches that taper, oh so provocatively, is paint. Eyebrows are important because they hold her face together. She does have eyelashes, but not enough. While she lets the glue on the added ones dry, I imagine her sculpting her brows.

Having too few eyelashes, I fear the world is flying into my eyes. As a little girl, I learned to brainwash myself to keep bad thoughts out of my mind. I learned, though, to construct an airtight white box in my head where I put the contents of who I am. The inside is white. The outside is black. My many humiliations are not allowed to penetrate this strong little box. Criticism of me and my family is never allowed entry. I have passed this idea on to Billy, who has taken it to heart.

When you are home, I hear your robust shouts from the next room. How could I not listen? I learned early to embroider the truth with little guilt. I charm adults to survive, if not belong. Seeing the world through others' eyes is not so hard, unless I come to believe what I see. I scrutinize every shift of the mouth, anatomize every gesture to determine how to react and be safe.

I feel others' pain and can express it. But I know how to construct a whole life inside my mind. I do not need a little white box like my mother's. I craft instead a nest swathed with flower petals (usually of roses). I dig a shallow tunnel with one or two chambers, each a few inches deep, in the loose dirt of my brain. I paper these walls with shingled petals adhered with a fine coat of mud. In each chamber, I deposit what I need to remain safe, then fold the inner petals over and seal the door to the outside world.

My inner protected mind long ago became a resilient nugget—humid but waterproof. It resists predators, humiliations, half-truths, and a discarded childhood. Even before I was grown, it let me play surrogate husband and family peacemaker while remaining the eternal boy. I have come to see life as a perpetual campaign, like running for office. When pressed, it is always possible to say it never happened.

I remain a good boy, working my ass off. Frequently, I deserve a little hoochie. I explore my never fully tested male ripeness. It is usually during the November election season that these strong spells come over me. I get like prickly thistles, weeds growing unchecked wherever they find opportunity. I can't remember the recipients' names. It never really matters. It is the idea of it; is it not? It is payback time, a way to strike against all those women who have hurt me. I compartmentalize all the dangers that I encounter, searching for a love and reassurance that has often been offered but never made real. It is a kind of revenge, like washing makeup off a woman's face. I look at myself. I see my thickening body, husky with robust gluttony but still fecund with natural juices. I am also cute.

sometimes

*he became
a flower on my stem*

*I was a young leaf
to my mother's touch*

Ransom 10

*42
sleeping*

Ransom 10

*42
sleeping*

SOMETIMES HE BECAME A FLOWER ON MY STEM, 2010
WATERCOLOR
22 X 15"

I WAS A YOUNG LEAF TO MY MOTHER'S TOUCH, 2010
WATERCOLOR
22 X 15"

G.H.W. BUSH

Dreaming is writing

1989 — 1993

I ALWAYS WEAR A GLOVE TO WRITE MY LETTERS. Just one, on my right hand. My left hand needs to be naked in order to hold the paper down. This is not always easy since I frequently write in bed with Bar next to me. I doze, daydream, and write when I am between waking states. Bar, bed, and glove assure me that not too much of my humanity will be lost in communication. I fear being empty, a blank page. I need to hear myself speak to know what I am thinking. If you read my lips, you know my thoughts.

I frequently feel the shadow of my predecessor falling on my notepaper, which I quickly fill with heartfelt language that belies my own unfinished shadow. I fondle the individual letters that compose words. My favorites are S and W. The first is all curves, sensuous and organic; the second is no-nonsense geometry, strict and unyielding. I delight in fingering all the words I have composed with my gloved hand. My favorites are *all the best* and *be my friend*.

I press deeply with my fingers and run them along the letters' shafts and explore their openings. Spaces between words are a delight to behold; they allow my words to stretch and luxuriate in the beaches and plains of my writing paper. Then, when I push the words closer together, the heavens light up and they touch closely, even intimately.

While I doze, Bar rolls over and shoves her own index finger (right hand, not gloved) onto my paper. She likes to unleash her pent-up anger on letters that make up words that have hurt her. Publicly she supports literacy, but she still maintains hard grudges against language she finds too explicit. When we are both asleep, we review some of these articulations and stick them together so their impact is less toxic to our lives. She is more adept at this, but I have found creative ways to expand whole sentences so that they lose the meaning of what they once claimed to say.

Bar mistrusts language and dislikes its capacity to wound (something she shares with our first son). Ultimately, we believe, there is no death, only a change of words. Words and their sentences become my paragraphs and my passion. I fill my pages with their markings. By avoiding their meanings, we remain safe.

As a child, I did not hear well, and letters became my guide. They made the world understandable even when I did not understand the letters themselves. My mother explained that the brain serves as a cooling unit to draw off the excess passions of the heart, an abun-

*kissing newsprint
in anticipation of
applause*

Ransom 11 41.
 sleeping

KISSING NEWSPRINT IN ANTICIPATION OF APPLAUSE, 2011
WATERCOLOR
22 X 14"

counting ideas

Ransom 11 41
 sleeping

COUNTING IDEAS, 2011
WATERCOLOR
15 X 11"

dance she believes I exhibit. She warned me that if I did not stop doodling (making letters, actually), I would lose my head.

Later I learned (not from my mother) that I have two brains (actually two rooms in the same brain). My verbal abilities lodge in the left, and my imagination inhabits the right. I wonder if some displacement might have taken place in utero that has led me to overcompensate, to use one hemisphere at the expense of the other, with a certain language disorder being the result. I roll over so that Bar's and my faces meet. She sleeps with her mouth open to ventilate her anger more readily. We remain inches from one another, so close that I have trouble seeing her and sense she is somewhere between sleeping and wakefulness.

I like people. I like to write letters to them. But I invite them to approach only so close. I have learned to discount ideas because I am not really committed to any ideology or policy. I succeed for a different reason. My extensive friendships, family, and political associations have led me to appointments and applause through loyalty and constancy. Words I use in the morning should have the same meanings in the afternoon.

I become aware of certain words independent of their content, and I allow their slender but hearty substantiality to ravage me. They taste like figs picked at dawn, bright flames costumed with skins that only suggest their golden centers. Who am I to gainsay the keyboard of letters bursting with the rippling of inviting colors, smooth but scentless? My nostrils dilate to the pure poetry of phrases, linked and married, that soon expand into quiet verbs that open and

dally with the fragrance of letters. I will never again deny the autonomy of words, never impose upon them intellect and content that would sully forever their encompassing arms. I initiate an eternal dialogue with words that banishes meaning forever. I will never be the same.

Bar has left our bed, and I hear her laughing at the toilet, relieved of her many burdens. Now I can muse alone, honing my skills through savoring obsessively the acceptance and awards these new insights have brought me. This reordering of my personality is nothing less than a way of life. I did what I had to do to get elected, even though it contradicted what I need to do to quarterback the nation.

One quiet evening in Texas, I happened on a small blue volume written in German. Since this language is unknown to me, the encounter offered me the perfect opportunity to appreciate letters and words without content. Despite pressing business, I cut out these foreign words and phrases (the letters, though sometimes curled oddly, are old friends) and heap them on top of one another. Taking the pile apart, I arrange all the arced letters (S, O, U, C) in rows with letters that are sharply angled (F, M, W, T, and so forth). Then, most exciting, I assemble all the ambivalent letters (B, D, J) and their cousins (P, Q, and R). They are immodest thistles that swell with madness in dry summers, and I press their short childish limbs against my bursting heart and loins with one hand (my left). With my now ungloved right hand, I press their unguarded organic melodies, curves that soon melt to my touch. The perfection of an endless dream.

I am disconnected so my parts do not always allign.

fondling letters with a glove

Ransom 11

41
sleeping

Ransom 11

41
sleeping

I AM DISCONNECTED SO MY PARTS DO NOT ALWAYS ALIGN, 2011
WATERCOLOR
20 X 14"

FONDLING LETTERS WITH A GLOVE, 2011
WATERCOLOR
20 X 14"

40
REAGAN
Dreaming in black and white

1981 — 1989

FEW PEOPLE ENJOY THE VIEW FROM MOTHER'S LAP, BUT I HAVE ALWAYS FOUND A HOME IN THAT BONY REFUGE. She changes her apron daily, so I can tell the day of the week from the colors and smells. Monday is my favorite: a heavy cleaning of porch and yard lets me discover in the cloth a panorama of dark earth colors. It is so generous an infusion that no scrubbing can ever undo it. She usually tries to minimize the damage by choosing a dark umber background with a blue pocket to hold her gloves and handkerchief. She says ladies always have a dainty handkerchief near their person to ward off unpleasantness.

I am nearing sleep. Mother is wearing a multi-patterned apron of green, brown, and red. It must be Thursday (dusting and sweeping the bedrooms, changing the beds). I smell bleach and face cream as I nestle my buried head in her hospitable and inviting lap. She is reading her Bible, so the room remains relatively quiet save for page turnings staccatoed by a cracker, plain, no salt.

The designs of this Thursday's apron weave their geometrical patterns into my unconscious, and I discover that when you are right on top of them, with eye and nose and mouth nestled within their perimeters, they lose whatever abstraction they might possess and become actual objects. What had been color, shape, and space become peopled with Indians and cowboys. Childhood's images but also myths of America. When Indians were a scourge to be eliminated. So I walk through sagebrush, my general's ranks and medals shining in the sun, revolver ready, saber on alert. I am accompanied by loyal and stalwart fellows who accept my directives without condition—not simply because I am a general (a brevet major general) but also because of the fundamental righteousness of our cause.

Indians we encounter. They are dispatched with our superior technology, and because we are Americans. But since I know only one role, I cannot die. I must escape so that I can reappear when others need rescue. My mother's apron stands ready.

I craft who I am carefully, free of specific roles but always capable of playing all of them. Actually, I play myself. Today, I am all wet from my shenanigans. Mother's lap is dry. I need her, but she hardly notices my wet presence, busily engaged as she is in talking with cousin Ruth. Her apron moves incessantly. Her knees rock in sympathy with the conversation, something about canning and preserving August peaches. The apron is starched, white with no pattern, not even a change of color for the pocket. I nestle my wet head as best as

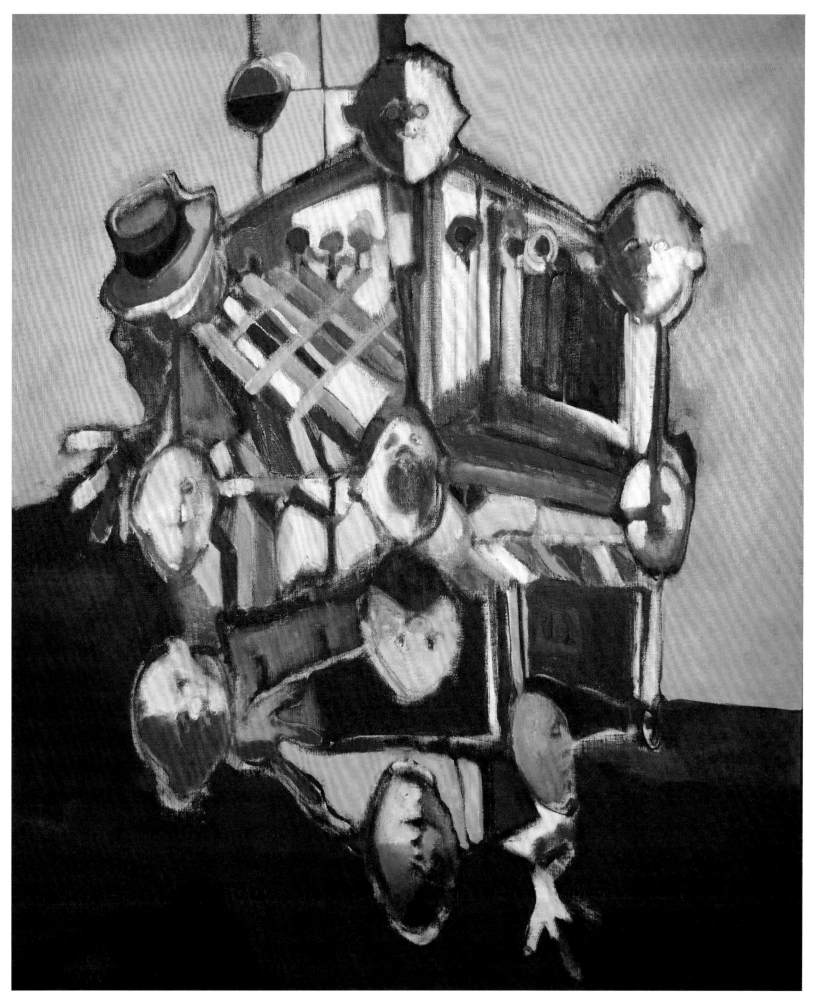

REAGAN A COMPOSITE OF INTERCONNECTED ROLES, 2012
OIL ON LINEN
60 X 50"

I can and ride the waves of her knees, falling asleep so quickly that I cannot tell the difference between waking and dreaming. Without shadow or limitation, the white apron is a huge blank canvas where I maneuver my army of followers, swords drawn but without faces.

Today seems different. I am not killed at the Little Bighorn because I have learned that accuracy can get in the way of telling a good story. After all, the Sioux have called me Son of the Morning Star rather than Iron Butt, the name my men have given me. The Indian name for me is a gift I will come in time to claim as a right—a dramatic one. I am highly esteemed as an Indian fighter, and I enjoy the amplification of my reputation. What pierces through fact and fiction is my relentless bravery. Or put another way, I am an actor playing a part written by the mythology of America. I show courage in carrying out the wishes of a playwright who is me. Like any good actor, I react instinctively. My reputation is like most in the theater, cultivated with a pointed disregard for historical fact and a preference for political enlargement.

With my mother's white apron as the backdrop, I become the Boy General, the Union Army's most colorful hero. With golden ringlets that remain gold and savages that would try to stop our states from expanding and achieving her true self, I consolidate my mythology. Yes, I separate the Seventh Cavalry into three detachments near the Little Bighorn River. But let me tell you the truth. This is not a decision rooted in recklessness, as General Grant claims, but in my confidence that I will win. After all, countless horses are shot between my knees while I remain undaunted. Bullets never claim me. Even Crazy Horse believes I am different. Rain in the Face wants to flee the battlefield with my brave heart in his hand. Should I not charge, I will be perceived as a loser. Charging and succeeding will grant me the character of an American Caesar. Charging and maybe failing—well, it is worth the gamble to do mighty things.

Mother senses her son's dedication and keeps her knees frozen in stillness. She knows my focus and determination will lead me to prevail over the largest concentration of angry Indians in the history of North America: Cheyenne, Sans Arc, Miniconjou, Oglala, Blackfeet, Hunkpapa, and Sioux. "Hurray boys, we've got them." This will all be recorded and preserved by my other self. My body will be remembered in white marble.

Now I am crossing the Little Bighorn River, which unexpectedly changes course given the accumulation of ice. Moving across the plains, I make progress much like a sturdy galleon gliding through an ocean of prairie grasses. Overcoming one surge leads us higher, blocks the view of our destination and the horizon, too. In this symphony of ochre grasses, my ship—with my red kerchief, shiny cavalry boots, and wide-brimmed hat—is clear to friend and enemy alike.

Mother gets up, and her departure removes the easel canvas on whose strength I am composing my landscape. My head now rests on her chair. The pleasurable journey across the Plains is truncated, and I lie quietly on a grassy hill near the Little Bighorn. My scribe is missing. I am approached several times by Indians who inspect my head and want, I believe, to steal my heroism by scalping me. Or do they conclude that my hair is too sparse and not worth the taking? I prefer the former view.

My mother reappears and lovingly acquaints me with her change of apron. She has replaced plain white canvas with bold cotton stripes of red, blue, and white, and the slight smell of onions permeates the upper-left corner of her covering. I die, and it is three days before the hundredth anniversary of the Declaration of Independence. My death is treated as a portrait of a fallen Christian warrior, a bulwark of civilization thwarted by ferocious savagery.

my mother's aproned lap is a home, a refuge a place for tears, joys + shadows it has dimensions beyond boundaries + I carry her with me to new places.

adjusting the world to my vision

Ransom 12 40 sleeping

Ransom 12 40 sleeping

MY MOTHER'S APRONED LAP..., 2012
WATERCOLOR
22 X 15"

ADJUSTING THE WORLD TO MY VISION, 2012
WATERCOLOR
22 X 15"

Mother's lap responds to my lessened anxiety in a measure equal to my visions. My dreams are repeated so frequently that I can always return to where they left off after distraction wanes. These wonderful tableaux are me, and I am them, and I am happy. The events that fill my mind become more vivid than the experiences of my waking moments. I am the leading man of my own narrative.

Mommy is asleep now, and I lift myself gently. I do not want to wake her up. The longer I look, the more her face takes on the quality of her apron, which climbs to enclose her face in its pattern (it is Tuesday, and the cloth is again striped). This suits me fine, and knowing her the way I do, I can assign whatever qualities I choose to her character. Indeed, faces are like aprons. They are called into service as needed and retired when the story no longer requires them.

39

CARTER

Dreams in motion

1977 – 1981

DADDY IS A SOUTHWEST GEORGIA TURTLE. He never recalibrates his journey if confronted by an obstacle. Whether another turtle, a traffic jam, or Mother. It only strengthens his resolve and he pushes on.

He is hard on his children, always requiring us to avoid temptations of the flesh. He lectures us about self-pleasuring (resulting in myopia or blindness) and letting other boys touch us (resulting in insanity). How determined he is that the individual pleasures of family should give way to the demands of public order and rectitude.

As I evolved, I discovered my habits were my father's habits. He spent long hours rearranging his wardrobe, stacking and unstacking boxes of clothes, underwear and shoes. Also, in his universe, there were thousands of jars and coffee cans filled with assorted nails, screws, and eyelets, all waiting for the day they would be resurrected and reused. My brothers compared him to a bulldog, but I see him in my dreams as a stubborn turtle. A turtle that drives.

Father shares his dreams with us by buying a new Buick every seven years. Each time a new car arrives, he reintroduces a new moral universe, one based on the physical highlights of the machine that will take him places. The trunk becomes a metaphor for his life: jack, spare tire, extra gas, and cans of oil complete the emergency preparations for any contingency on the road. It also includes all the special tools any soul might require when crossing mighty continents, the River Styx, or the covered bridge spanning the Kinchafoonee Creek. Early mornings find my father taking everything out of the trunk, then repacking it all with the conviction that an even greater moral order can be achieved.

He extends his anxiety about disorder to the engine, the seat covers (which he changes every year), and, above all, the glove compartment. In profound ways, Mr. Earl (a title of respect bestowed by the community) becomes the motor of his automobile. Carburetor, fuel line, and spark plugs are as alive as a heart, liver, and kidneys. They complete his mechanical universe. He delighted in these moving parts—cleaning, aerating individual components, always looking out for rust or cancer, which are essentially the same thing.

With each purchase, Daddy constructs a measured archeological zone of our family car's history. The first seat cover becomes a splendid foundation for all the stains of daily life in a family with four children. But each time he stretches out a new seat cover, it hides the

receiving my father's
blessing
and his shadow
simultaneously

Ransom 10

39
sleeping

RECEIVING MY FATHER'S BLESSING AND HIS SHADOW SIMULTANEOUSLY, 2010
WATERCOLOR
30 X 22"

previous year's history. Since we take yearly trips, Daddy can tell you when and where we went, and even our route by peeling back the many layers and unveiling the chronicles of life's accidents. Here, the cheap cotton coverings show rips and tears inaugurated by my sisters Gloria and Ruth. Uncle Buddy's cigarette burns are usually on the right side of the front seat, generous violations of ash and ember. Cousins Hugh Carter and Willard Slappey are frequently guilty of accidents due to their leaky bladders. I wonder if any of those were intentional, meant to leave their mark. Our black housekeeper, Rachel Clark, frequently provides us with spam or egg sandwiches for the trip and they, in turn, left evidence of hunger sated.

With the car in motion, Daddy never talks except to curse other drivers or inconvenient stop signs. With his sunburnt left arm out the window and his hand attached to the car's roof, his pale right arm keeps a firm grip on the road. We go all over Georgia: Americus and Albany to Valdosta, then up to Macon, Milledgeville, and Sandersville, and over to the Ogeechee River. We ignore Savannah and pointedly avoid Atlanta. We never have any destination, really, except the constant movement of the Buick on Georgia roads. We never get out of the car, but Daddy remains supremely happy. His control of his family and his environment are complete, and without a radio or any other connection to the outside world, he becomes totally himself, free of distractions or the pressures of outside influences. This odyssey of continued movement without destination is my father's extended legacy. It is his public declaration of who he is and wants to be. A perfect dream. For him.

Is there another legacy? Have I adopted more than my father's dreams by having tasted his moral order and making it my own? His relationship with my mother seems to have dwindled in all ways of expressing physical love. Had he found replacements? No one ever really saw his heart. He had locked it in the glove compartment along with his maps, flashlight, and extra batteries.

Asleep and dreaming, I want to give form to a different father. I seek a condition of innocence where I become like the object of my contemplation. It is said that God, regarding the world as His handiwork, partakes in the same mediating act of representation as to the artist with his work.

God is a multiplicity of possibilities, never the same as the human faces surrounding me, but never so different that I don't feel connected. Is He a chariot? A burning bush? Tiresias looked upon the goddess Athena and lost his eyesight. To look upon God directly can be fatal. But didn't the Lord speak to Moses face to face, as a man speaks to his friend? His refusal to do so came later. But Moses never reported what God looks like. Moses saw only God's backside. Is death a precondition for seeing God fully, directly? When human beings stand before God, must we not fall to the ground and avert our gaze?

I never want to avert my gaze, not even in sleep. Late in my life, though, revelations came from unexpected places, and despite the chatter of many faces, I have learned to see God's visage in my everyday experience. I can carry God's face where only shadows exist.

Call it justice, I think. Love is unattainable in our political sphere, but we can create justice on this earth through the instrument of love and forgiveness. And if love can be found in everyday existence, I want to touch Americans, and all people, with human justice as the nearest and closest approximation to God's face. It is only then that our days can become beautiful, and we will cease to be afraid. Rosalyn nods in agreement as she becomes smaller and enters my dream.

contemplating God
as horizontal rain

Ransom 12

39
sleeping

CONTEMPLATING GOD AS HORIZONTAL RAIN, 2012
WATERCOLOR
30 X 22"

Jimmy Carter
contemplating God
as diagonal rain

Ransom 12

39
sleeping

JIMMY CARTER CONTEMPLATING GOD AS DIAGONAL RAIN, 2012
WATERCOLOR
30 X 22"

FORD

I don't dream I doze

1974 – 1977

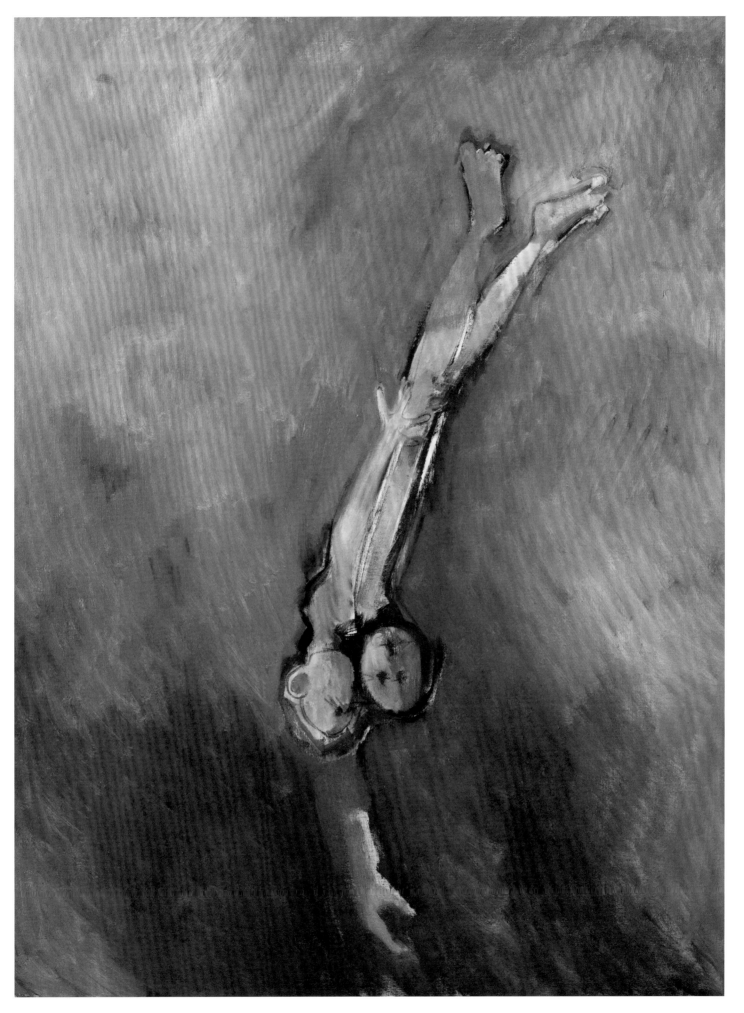

FORD FALLING, 2010
OIL ON LINEN
60 X 48"

fearing to fall

the anatomy of falling 5 Ransom 12 38
sleeping

FEARING TO FALL, 2012
WATERCOLOR
22 X 15"

falling asleep

the anatomy of falling 1 Ransom 12 38
 sleeping

FALLING ASLEEP, 2012
WATERCOLOR
22 X 15"

37

NIXON

Bodily dreams and aspirations

1969 – 1974

WHEN I DREAM, I DREAM ABOUT BEING AN ANIMAL. A political animal. Like an elephant, I never forget slights. There have been many before me, those presidents I admire and discount. Tigers, lambs, bull-moose, others... I've noticed that there are certain correlations with my aging body, my animal nature and with other commanders-in-chief and theirs.

I want to understand how particular presidents are marked by our shared circumstances. I focus mostly on my contemporaries: Carter, Reagan, the first Bush, Clinton, the next Bush, and Obama. I have not always been so observant, but nobody was during Bush's son's time.

I use all my faculties to explore in my head each administration from the first Adams through the nineteenth century until today. I am not constantly prescient, indeed I slept right through the Harding and Coolidge years, but my familiarity with my stomach and genitals is especially acute now that Jackson and Van Buren are in charge. Turning back into Grant's time, I am very aware of my hands and feet, which I find telling. But as Wilson takes office, I fear my exploration of heart and lungs produces cravings in them and in my brain.

I regroup to greet the second Roosevelt administration with a highly creative understanding of my back, shoulders, and buttocks. But I am getting ahead of myself. I should let each part of my body speak, to tell its own story, and, ideally, include other organs and appendages in near proximity. I should offer some deference, too, to the unique times in which each investigation has taken place, for I believe that presidencies temper our feelings, redirect our focus, and force us to question our fundamental presuppositions. Above all, American presidents help us understand the load or burden we call life.

Hair exists here and there on my body—more on my head, I grant you, but that area is thinning and redefining itself in unexpected ways. The evolution of my scalp suggests a large hairy continent, forested and verdant in significant places but ravaged and eroded in others, especially at the front. These are small islands of hair, patches isolated and connected to the main continent only through tenuous isthmuses surrounded by the glabrous, sun-dreading, brown sea of my skin. We chart and map these land areas of hair and their perimeters as they shift, expand and contract, and resurrect new territories yet uncontemplated.

It is morning, and I am looking in the mirror and fussing over the making of a widow's peak: a pointed peninsula negligent of beauty, oblivious of practicality. I roll over and veil this

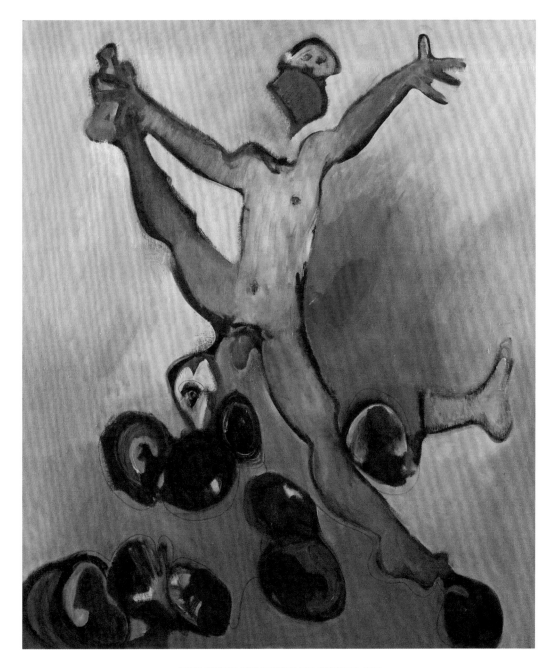

NIXON DANCING WITH SHADOWS AND STRANGERS, 2010
OIL ON LINEN
65 X 55"

evolving predicament, but the idea of diminished youth and the specter of age tighten their grip on my perception. I extend my legs and arms and fill my bed, less than a king, more than a double. I wonder about all the hairs on my body.

Was it not during the time of Leslie King Jr. before he became Gerald R. Ford, that I first saw the relationship between hair and thought? I have always admired full heads of hair that can (especially in a convertible) encounter an oncoming hurricane and yet fall back into place, each hair in line, the whole head coiffed, combed

and luxuriant. I have never been so blessed. My hair is distracted and lives a life of its own.

This strange emergence of hair in my ears, on my back and elsewhere, embarrasses me. I do not want it, though I understand I am growing taller at the same time. Surging testosterone is making me hairy, and it is also creating an excess of vitality. This sprouting hair, like my pimples, is a public expression of my maturing self. I fear that my hair and skin tell people what I am thinking.

As my hair takes on another existence, separate but allied to my everyday life, like a conjoined twin, it wants to speak

and move independently of the rest of me. It begins to grow in strange patterns that I can hardly condone. These hairs (they are individualized, so I can hardly call them my hair) begin negotiating for a political career—one suited to a kind of practical blandness.

Even if hair does not actually determine reasoning, it points to the power of ancestry and genetic makeup. Hence, we saw nineteenth-century laborers in government parade before me en route to the post office. They send samples of their hair as a gesture of deference, a symbolic representation of pledging one's word to an opponent. In the administration of Hayes and the last days of the Buchanan administration, pubic hair will be substituted as a poetic extension of this tradition. And under Garfield and Cleveland, the practice is enhanced by both presidents mailing silent pomade-scented mustache hairs to select players.

My dealings with Ford involve more than friendship. You can see this in the clear correspondence between our visible hairlines and the darker, hidden aspects of our personalities, between what can be perceived and what lies veiled. Ford manifests little charisma; his hairline has never been iconic or even ironic, and what hovers behind his forehead reveals an excess of common sense. Even when he is asleep.

So his brow, freed of the controlling, determining magic of hair, suggests what he really is: stolid and earnest with a respectable sense of proportion. Luckily for him, he became my conscience, though I have not always perceived his message or accepted this young man. (I am six critical months older). We sometimes walk together in the marble corridors of government. He smiles when I smile, but he is hard-pressed to match the flow of my sweat. As head of state, I turn the lights off once we have traversed each hallway. This leaves Jerry in the dark and he has taken to stumbling when the lights darken before he and I reach the next patch

of illumination. But darkness has its times and places, and I am at home in shadow.

I am practicing gestures in front of an exceptionally large slab of travertine that reflects splendidly the presidential image. I dispatch my conscience on a minor errand that I might be alone and concentrate on the movements of my right hand, which does not always work in harmony with the left. The second and third fingers of my left hand hold great antipathy toward the thumb and index finger of the right. No mind, discipline, or practice will prevail over independence and rebellion. It is quiet here, and I have plenty of space to extend my body—first vertically, which feels good, and then horizontally, which feels less so. My better angle is more manly, and so, more convincing. I spread my legs with force, a new posture, and I pause to feel the joy before throwing my chest out to craft a silhouette at once forceful and convincing. Even my widow's peak becomes fuller.

I continue my pantomimes and forget time. I learn my body is more than hairline, nose, and mouth. Discovery is exciting, and knowing my conscience is away, I keep practicing postures, smoothing my hair and face, and testing different gaits. How exciting is that which we have always taken for granted? I understand, suddenly, why artists fall in love with their self-portraits. As my father always said, when a man thinks of his truest friend, he is looking at himself in a mirror.

I am sleep-walking through the public halls and offices of this now-shuttered government palace. Upstairs, I find endless offices and passageways, but these rooms, empty and bureaucratic, do not like me. No, they do not approve of me. Government-requisitioned furniture stares at me in silence, so as I hurry, I will do anything to dispel the sense of intrusion of which I am being accused.

I wait to catch my breath before climbing another staircase, and I can no

my hairline moved daily because my eyes, nose + mouth were never aligned.

MY HAIRLINE MOVED DAILY BECAUSE MY EYES, NOSE AND MOUTH WERE NEVER ALIGNED, 2010
WATERCOLOR
30 X 22"

longer see my reflection in windows or in the reflective capacity of marble. But I do not need mirrors any longer to look at my body, which has always been unhealthy. I can feel appropriate sweating with a swelling between my legs. Exhilarated, I twist and stretch with careful gestures. Then I move to outmaneuver my opponents, spinning and turning in anticipation of their responses, deflecting them by leaping into sharply angled twists. I jump and leap, then catch myself and become my own partner en route to an unknown future that calls for deeper circulation, a fuller heartbeat, and ecstatic release.

Jerry Ford calls my name, and I hear all the voices I know too well. The swelling between my legs subsides. I wipe my sweat with the back of my unruly left hand and become presidential again by greeting my conscience, who will meet me half-way.

36
LBJ
Dreaming with a strong grip

1963 — 1969

SOMETHING IS HEADED TOWARD ME. Something that might be tumbleweed, if it were not blue. I know I'm supposed to begin with a handshake, but that has never been enough for me. I'm big, and I don't do things in small measure. I express myself forcefully. And though I use my whole body, the most expressive part of me is my right hand—four fingers and a Texas-size thumb. I write with it. I lasso my Herefords with the arm attached to it. When I arm-wrestle, the hand provides the locking mechanism.

My hands are my ballast, and I use them to bring personal and political stability to my life. They are also expressive tools that can add color and adventure to my spoken persuasions. We became humans when we stood up on our hind legs, which allowed our front legs to become our arms. Freed from the needs of locomotion, they can focus on what they do best—grasping. Then, with the evolution of thumbs, we developed a whole new vocabulary of self-expression. I am in awe of how subtly gradations of strength can be measured when we use our hands to push, throw, and craft. I do this especially when I dream.

My fingernails have grown to protect and highlight my hands. I clip my nails very short, which sends a message; but now I need emphasis, so I am letting my right index fingernail grow prodigiously. At its new length, I can insert it forcefully into arguments that are not going my way. I wear my wedding ring on my left fourth finger but remove it frequently because men can lose their sexual attractiveness by signaling their married state.

I hear voices and ask, why do I do all of this? In order to communicate, to convince, to bring people to my vision—a vision in which all the things my mother wished for me could be granted to all people. I do not share its details with everyone. Not even when I dream.

Humans are unique. Take our spit. People expectorate differently; some coagulate the fluid early, but others are slow and long-winded. Saliva reveals much about the spitter. Diet, stress, toxins, and lack of kisses are all registered clearly there for you to read. Just as a handshake is the measure of a man, so does his spit paint his portrait.

But humans are too selfish. Just look at our inability to work for the entire community. Never having developed a collective intelligence, we fill our petty needs at great expense to the colony we call government. We walk alone, and the landscape around us reminds us of our vision, which we have denied. Even when we dream.

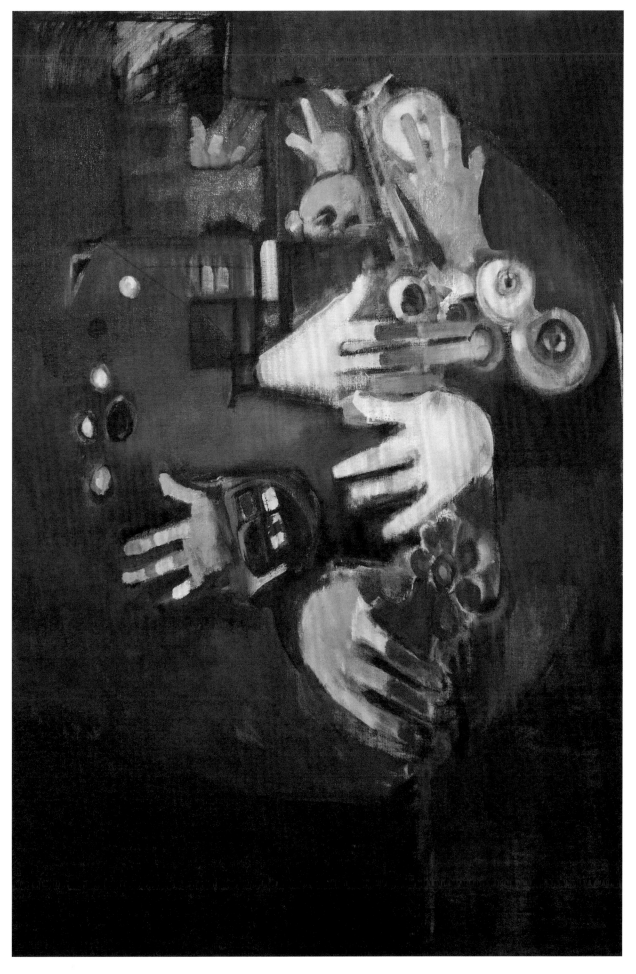

LBJ I LEAD WITH MY HANDS, 2011
OIL ON LINEN
60 X 40"

This early morning, feeling especially lonely, I dream of Ho Chi-Minh. I will win him over by anticipating his response before he can even begin to form his words. Shaking his left hand (he is Asian), my right moves around his body, exploring and examining his thoughts, which his flesh reveals. I nudge his ribs, never take my hand off his shoulder, press his knee, and would yank his lapels if he had any.

I know I can find Ho's price, where his weakness lies. An offer of economic aid registers one way, the threat of bombing (here my palms are very effective), another. He's a tough nut, but in continued meditations on the john, I know I can crack him. However, I am also beginning to think I might be wrong, that I will never understand this man, that he might not have a price—at least not one I can meet. In a way, I suppose, I see this skinny little figure with the wispy beard as one of us, someone we can talk with despite his own history, his ever-present nationalism. For me, his struggle against us is not about slavery and freedom (concepts that he and I interpret differently) but about our bringing a better life to his people. He is small, and I am large, and we both have a strong sense of manliness. I feel entitled to speak and act on his behalf.

I take him aside, and I find him not unfriendly. I try various forms of persuasion, but he doesn't like being touched. Something about his steadfast poise belies my experiences with men (women are different). "Y'all know how yellow men are small in more ways than one," and when confronted by western manhood they tend to dissemble, a form of retreat. He talks and talks, and I realize slowly, but with the utmost clarity, that I am losing my credibility.

Since I am monopolizing the only available plumbing, he has gone off to relieve himself. He has been gone for several hours. I remain on the stool focusing on the matter at hand. His studied rectitude infuriates me, and I will resist him even if it carries me to lengths disproportionate to American interests. I will not be perceived as weak, a loser, a quitter. We (I almost said I) need to take a stand and preserve our national credibility.

Ho has finally returned, and I see now how ugly he is—a clean, enchanting ugliness. His face is diamond-shaped and made to look even longer than it is by his attempt at a beard. I study his parchment flesh, which has known upheavals, and I see that his body, thin and wiry, is built for resistance, a kind of eternal spring both helpful and unforgiving. He is agile, his wings let him hover in a thicket, never caged, frequently unseen. He and the moon are friends, and they travel together in the clear unbeholden skies of night. He pauses frequently, life suspended, and sees beyond the boundaries of what others know. He always finds his way, and yet he believes getting lost is an opportunity. He cherishes taking backward glances.

Ho begins to groan softly. An undulant tremor passes through his small yellow body. His hips and stomach move to an interior rhythm; his lids close over impatient eyes. His long white hair grows longer when he moves. He extends his small hands and arms for balance, and his forehead feels the hot eager breath of the President of the United States. I whirl him around the bathroom, my huge hands anchored on his thin arms. I am growing frantic, and I pull and push him in one direction and then another.

Ho travels with the flow because the moon is clearly on his side. Pushed to one edge, dangled from the other, he plants a mustached kiss on my white throat and tenderly directs the firm meat of my arm away and beyond I know not where. My vision of America, intact and cradled in my sense of self, helps me regain my balance, and I stand aside. Ho is alone, swaying with the residue of my sweat on his person. Then he leaves my western bathroom and again relieves himself outside.

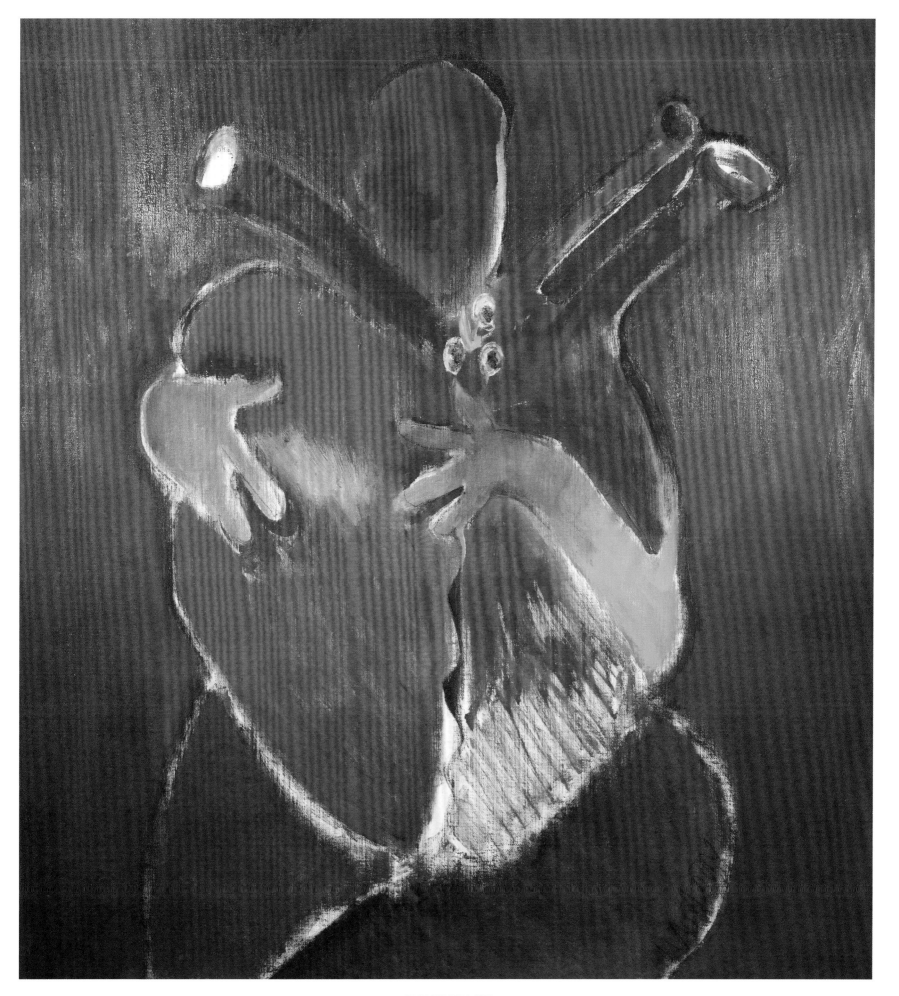

LBJ MOSTLY HEART, 2012
OIL ON LINEN
46 X 42"

35
KENNEDY
My father's garden

1961 – 1963

MY SHOULDER IS PRESSED DOWN BY THE DEAD WEIGHT OF MY BURDEN.
His body, aged but still active, is relentless in its total insistence on our family's collective gravity to sustain him. All too frequently, we ask why Dad needs to be shouldered by our upper bodies. We hear many different answers. Few of us really complain; most acknowledge and chronicle the pulsating vein on his temple that refashions his character onto us, his bearers. Eventually, impelled by this burden, we accept his presence as a kind of heightened energy. Dad's outward form, so concentrated, then recedes into his children's, and we become convinced that this is the only way to become ourselves, those whom we are meant to be.

Our father and his dead weight shape and craft our beings. We, his four sons and five daughters, occupy a sturdy greenhouse complete with soft whispers and fluttering illumination—a determined spring in the face of misunderstanding and jealousy. In this hothouse of father's making, he has planted, cultivated, pruned, and fertilized. His shadow falls on our delicate stems and velvety leaves as we thrust up to a mock heaven etched on the uppermost glass. Our sun is a series of grow lights, expertly positioned and carefully timed to our growth, which the gardener measures by the amount of chlorophyll we manufacture.

This garden is like a nation, with its own passports, customs, and coinage. On Sundays, our flowers—enormous white, blue and red constructions he has created by grafting common stocks—unclose their leaves, explode from their buds, and spread seeds guaranteed to propagate as further testaments to our creator. Father controls the elements and adjusts the air and light so that our atmosphere expresses all the wonder his cultivation allows. These are the times he permits outsiders entry—but only escorted and only to the outer boundaries of the conservatory. Like any jealous gardener, he fears his grafts will be stolen. So he permits visitors to see just the accomplishments our bodies have provided: a rainbow of petals filling our hothouse with an American snowstorm of petals in the colors of the flag.

But by the close of the day, this gigantic display of his gifts evaporates. Father has clearly demonstrated to his family that every day is an illusion, make-believe which, with the right alchemy of lights and humidifiers, can suggest a heightened existence. This is how he empowers his progeny to overcome competition.

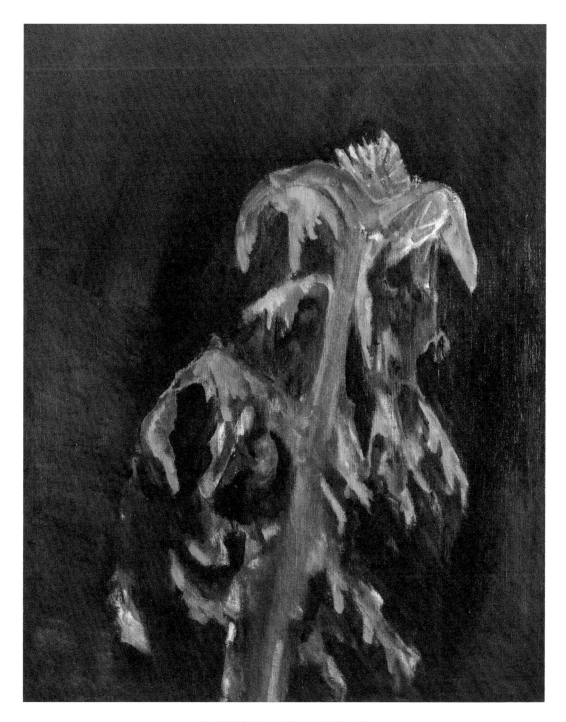

JFK THISTLES FROM MY FATHER'S GARDEN, 2012
OIL ON LINEN
50 X 40"

Just as he has created hybrid oleanders, he splices and transplants talents and personalities, some from the marketplace and some gleaned from other fields, to transform us individually. He assigns us specific tasks in shouldering him while he sings lullabies of Irish camaraderie. The frustration of our own hopes plays no role in this enterprise, and we learn readily to practice obedience and cheerfully offer to carry him. Has he not taught us to study the world and transform it to his purposes?

Dad shapes our futures as best he can, gilded and inviting, but some things he could not mold. Despite the luxurious safety of the greenhouse, I have suffered much of my life from unremitting pain. Scarlet fever and a chronically weak stomach when I was a child, back trouble as I matured, and Addison's disease from damage to my adrenal glands. Father arranges for injections of anesthetics, a rocking chair, a corset, and the daily massage of my prostate.

Since the family has learned to deny everyday experience and look to heroic goals, I feel compelled to camouflage unstable health and mislead the public. My combat record has also been subject to elaborate embroidery that altered it from error and amateurism to legend and myth. I turn a dingy yellow and smoky blue, displaying various shades of amber or chestnut accompanied by anorexia, abdominal pain, vomiting, and apathy. But if I cannot be a butterfly, I am determined still to fly. After all, my father's dead weight has instilled in me the intensity of self-belief, the certainty that I am foreordained to fulfill a larger blueprint and make history.

Given the burdens imposed on my back and on my soul, though, I have been steadily gripped by the shadows of nightfall, which remain until the afternoon. As the anesthetics wear off, my body requires larger and larger doses of father's will. The medical community has called the blizzard that bellows in my brain depression, the mingling of chemistry and genetics. The more philosophical call it melancholia. To my father, it has never been anything more than lack of will.

I find nourishment in women (young, no names) and employ sex (intercourse, no foreplay) as an amplification of my threatened existence. I move so quickly that my mouth is on theirs before either of us can speak. Like Dad, I have become a tethered horse, coarse, demanding, unsatiated. I would like to believe in love, but what I observed as a child gives me little confidence.

Suspicion is the affliction of politicians. But I am open and frank in my sexual cravings, even putting myself in danger of exposure to achieve the harmony I did not find in my father's garden. I feel all too fully the wind of the wing of madness, trapped as I am in our overheated garden with its controlled gateways. By abandoning myself, do I not prepare for my extinction? By my entering all those faceless, inviting openings, I vanquish time and free my shoulders of Dad, even as I imitate him. I achieve a breath I can call my own. But this borrowed exhalation reminds me quickly of my ransomed time, the threat of disappearance and obliteration. I know I will die young.

I usually relax in the southwest section of the greenhouse, where Dad, while orchestrating variations in climate, has planted a wide range of succulents that evoke the terrain of Arizona and New Mexico. Yet it is a blind alley, a dead-end of horizontality where one can only see, myopically, stout cacti competing with native grasses that are never cut. Together they form a carpet inviting touch but perilous to those who reach out a hand. If you avoid those surfaces and follow your feet, you will find yourself in a pool of dark shadows, ferocious with sharp and toxic weeds, filled with nettles and thistles whose flowers will bite and scratch you. This convulsion, untamed and angry, is where Dad feels compelled to store all the swollen excesses he discovered in the strong noon sun of his own life. Long ago, seeds were sown here that matured into long-stemmed grasses in phosphate-rich soil. But they quickly turned black, emitting the uneasy stench of theft and deceit.

For our family and forebears, death is beyond evil, certainly beyond suffering. I encounter in its place an ambiguous cemetery, stately monuments, a topography of peaceful slumber where quiet communion connects us with the beginnings of being. Dad has banished the certainty and language of decomposition. But are not the noises heard from ancestral tombs actually the gases of putrefaction? Can he truly render moot the entire vocabulary of death, the hissing of geese, the accumulation of foam around bones, and the unmistakable stench?

in the garden of my father

shouldering my father

Ransom '11 35 sleeping

Ransom II 35 sleeping

IN THE GARDEN OF MY FATHER, 2011
WATERCOLOR
30 X 22"

SHOULDERING MY FATHER, 2011
WATERCOLOR
20 X 14"

There is a slim possibility I can cheat death and remain alive indefinitely. Dad has always warned me about doctors and businessmen, yet he and my doctors agree that death is a failure of medicine, not a natural occurrence. It is simply a mark of powerlessness in the face of nature—a phenomenon needing to be brought under control.

But, as I lie on white marble, cold and beautiful, with my heart in a small Petri dish next to me and my shoulders seemingly free of any burden, I am back in the garden of my father, where everyday activity is unreal and where it is not clear if the sunlight we enjoy is due to nature or technology. With my brain realigned, the future presents itself with open arms and now acts of studied heroism on new frontiers. With our shouldered responsibilities, we are determined to try again. I have brothers.

34

EISENHOWER

Dreaming of more stars

1953 — 1961

I FIRST LEARNED TO COUNT BY ADDING UP MY BROTHERS. Six of them. Ten eyes plus mine. I had problems moving beyond the number five since I could not see myself as part of the equation. But I see their moving shapes: Arthur, Edgar, Roy, Earl, and Milton.

The sidewalk in front of our house is clear. I am lying flat with my left eye pressed against the hard cement. In an effort to move away from this uninviting surface, I push myself up and wobble. But if I place my left leg in front of me, I can draw my right leg forward. I repeat the process and find that I can move, not with elegance, but with steadfast purpose.

How happy I am, free and full. But something tells me I am wealthy in illusion. I am not yet enslaved by the monotony of enthusiasm, which speaks in repetition whenever it happens to arrive. I am loved, but always from a distance. I am learning early to shape my own thoughts as words, large and buoyant, to stake a claim that these combinations of syllables would be spoken only for me. It amazes me such fullness of feeling could spill over into a special language that tries to take the place of emotion. Words, especially adjectives, can hide the music of sensation. We enjoy them because there is nothing else at hand.

My mother squeezes me hard, too hard, and then, disturbed by her need for contact, releases and ignores me. So I ache for a woman's touch, but always worry it will not last. My father and my oldest brother, Edgar (Big Ike), hold me so grudgingly that I am afraid I will be dropped.

I accept pats on the head and later, slaps on the back, the measure of affection being in direct relation to pain. We men do hug, but like language itself, we follow ritualized and predictable forms. We clasp one another's shoulders with the top parts of our chests meeting, ensuring that our lower extremities stay apart. It is our equivalent to a Japanese bow. Did you know formal affection can be measured? Little by little, demonstrable tenderness is disappearing and has been replaced by routine and predictable speech. The warm glow of my new skin, pink and hearty, soon grows gray as life makes claims, hastens childhood, and quickly leaves it behind.

I learned to walk in my own way, and I yearned to leave the sidewalk's grip. But no help arrived. My eyes remained half-closed; you could not see the blue. My voice took refuge in broken sighs. I left my hair tousled less as an expression of boyishness and more to hide the thoughts that I feared adults would read on my forehead.

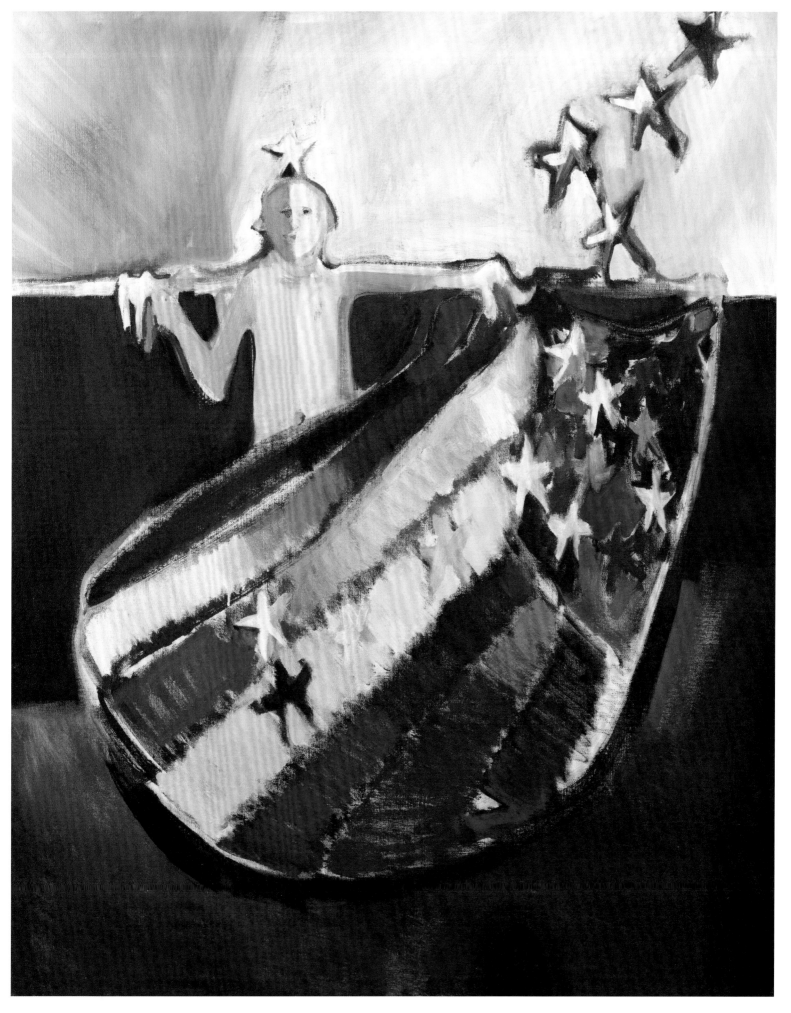

EISENHOWER WORLDLESS DREAM, 2011
OIL ON LINEN
60 X 40"

So I gave up looking into great distances and said goodbye to hope and dreams. As the third son of six, well used to a tumult of arms and legs all moving at once, I learned quickly to negotiate the playground. I studied my mother's moods and her piety, which took the form of hard work and attention to domestic detail. I observed my father's frustration and his putting aside the music of living to concentrate on making a living. His anger, always close to the surface, seemed to make him happy. My heart grew more like his, turned less green, became less responsive to sun and wind. It remained a landscape of clipped bushes and under-watered lawns.

My invitation to leave my family came in the image of the street—the same one in front of our house—which appeared never to quit and promised to take me far if I would only begin. I refused to consider that life might be the same a thousand miles in the other direction. If existence here was dark, what awaited me must certainly be better— and I asked my feet to take me East. My heart, too full for my brain, could not keep up with them.

After graduating from West Point, I enjoyed the temporary rank of lieutenant colonel. Then for the next twenty years, I experienced not promotions but a downward spiral to major, then to captain, and after another twelve years, the return to the rank I had enjoyed when I first left the Academy. I recall all my fellow officers because they all looked alike: thick necks and manicured haircuts, pinching collars revealing accumulating girth, their chests colorful displays of blazing medals, their hands planted on thighs aligned and symmetrical. Pressed trousers enjoyed legs so far apart that correctly aligned genitals took on the semblance of a military parade. Boots, almost disconnected from their parallel legs, marched independently.

I believed I was different and was uncomfortable with comparisons. I did not sit still looking at myself, and my boots did not move beyond my reach. I enjoyed appearing taller when I rode, and when I dismounted, I loved contemplating how a uniform covered with dust transformed me into a strong, ochre form, one with the horse. It was during those lovely mornings that the transition between soldier and rider was most telling.

I straightened my hat, put on government-issued gloves, banished drowsiness, and enjoyed the moment of arrival, the sound of marching feet, the barking of orders, and the feel of common purpose. But then the tedium and predictability of army and rank would descend, and I experienced double visions of myself with little hope of reconciliation. The apathy of army life quickly reasserted itself until active duty, sometimes called war, shouted. We waited, and my life consisted of a series of days, endless and undifferentiated.

That is why I love the American flag, which became my constant companion and the subject of my dreams, all of them merged in my mind, wordless but with constant images of multiplying stars and horizontal stripes. The white of the stars only increased as our national territory expanded and we crafted an American empire, just as Walt Whitman rejoiced that an American victory in the Mexican War would provide "a cluster of new" ones. Or, as Buffalo Bill remarked, America would not today be a free and united country without bullets. Men like me provided those bullets. We were verbs, shunning the passivity of adjectives and seeking success measurable in miles of territory gained and people subjugated.

We both waited, the flag and I, until we found armed struggle. My identity is intertwined with the continued multiplication of stars etched in my unconscious, a heroic embrace with war. We have never retreated from any place our flag had been unfurled, and I embraced the larger combat that opened my brain and heart, which moved me back to, and yet beyond, my childhood— to the sidewalk in front of our home where I first learned to get away with purpose. And so I did, letting memory and silence surround me.

October 14, 1890

born to
violent lightning
angry thunder
soaking rain
earth trembling
and eventually
war

Ransom 11

34
sleeping

BORN TO VIOLENT LIGHTNING…, 2011
WATERCOLOR
22 X 15"

33

TRUMAN
Near-sighted dreams

1945 — 1953

Good morning.
How do you do?
I'm doing all right.
Good morning.
How do you do?

I HAVE FLAT EYES, A RARE MALFORMATION SOMETIMES CALLED HYPERMETROPIA. When I wear my glasses, I see like you, and my heart beats regularly. But when I eat, I take my glasses off to see more fully the subtleties of the grape jellies and jams that my mother prepares for me. The foods I eat become flat, two-dimensional, sometimes silhouettes. Could you resist seeing your favorite delicacies as colored maps interrupted by a raisin here, a peanut there? They make my heart pound.

I also often take my glasses off outside. I walk our farm and delight in the flattened hues of tall peach, and even taller apple, trees outlined by silver leaves. We have six-hundred acres at Blue Ridge, near Grandview, Missouri. Framed by a flat horizon and thick uncut grass, spiked by robust heads of burdock and stinkweed, an irregular geometrical composition stretches before me. The air is a blue theater backdrop with clouds playing their appropriate roles. I like this landscape because, without my glasses, it is unpredictable and unfathomable. Though there always comes the time where I have to put my glasses on, and life—or my perception of it—needs to be anchored and made measurable.

I like myself and find a different kind of happiness in familiar places often made rounded and corporeal when my sight is not transformed by glass. Above all, I like the deep well at my own farm in Jackson County, no longer the nation's frontier but its center. There in the deep, cool bore of bricks, I am joined by the natural forces of the elements and hear a distant call, sometimes a cry.

We grow corn, and without my glasses, I discern its center sheathed in an unyielding, resistant husk. As I move closer, I observe my life revolving around what comes out of the earth: crops and weeds, insects and seasons, successes and failures—all rooted in hard work and sympathetic loans. So I have learned to think in artless, plain-speaking terms: right or wrong, smart or fool headed. "How do you do?" Take corn—without glasses,

I know ~~where~~ who I came
from

Ransom 12

33
sleeping

I KNOW ~~WHERE~~ WHO I CAME FROM, 2012
WATERCOLOR
22 X 15"

I see so clearly each flower extending a grain of sweet pollen packed on the tip of a silk thread that makes its way through a microscopic tube to impregnate and create an exquisite single kernel.

This August morning, I sleep with corn and am awakened by the sunrise. Half asleep, I move to drink from the well and open myself to a deeper rush of feelings. I wonder if I am yet awake as I drop myself into the pit, knowing that my father has constructed rings by which to raise or lower himself. I will be safe. But in my certainty that I can always escape, I do not calculate the water level and proceed to fall for what seems like a month of Sundays.

I left my glasses on the lip of the well, so I have an optimistic view of my progress. After a few minutes of free fall, I am too far from the light to calculate distance. But my eyes, untouched by the burden of fear and distracting detail, carry me ecstatically, joyfully into the old well. Fish look surprised (how did they get here?), and vegetation spreads from the flotsam of years of accumulated debris. I hug what seems to be an automobile tire to calm my growing anxiety. My flat eyes have long assured the rest of me that we are composed of simple parts of a plain-speaking whole. Although of limited education, I know myself and where I fit in the universe. "I'm doing all right." The abundance of common sense, my strong sense of place, and living in the moment take me far from fear and confusion. With flat eyes elevated, I investigate the bottom of this garbage-bottomed well. I find my own special place; it identifies who I am and who I will always be.

The unbridled optimism of the springs of living groundwater seeps through the cracks and pores in the rocks. Man and nature together created this pit and so connected us to an underground world. Here I can be open with my surroundings. I can say just what I mean, no embroidery, no panting after acceptance. I know what I aim to do is right. I observe, which is a form of listening to what people want and how they perceive me. Without changing who I am, I can come to terms and be of use within my own nature and appointed place. This listening is prayer for me.

I have not touched bottom after all. I cut loose from the cults of success and conformity to release myself, and I lift my arms and drop even further. Plummeting, drinking the darkening air, I swim rapidly past the world's need for cruelty and selfishness. One entire side of the well teems with the overgrowth of noxious weeds struggling for light: a retaliation, bustling with hungry thistles and devouring nettles that draw blood at the slightest touch. Here a paroxysm of swollen outrage and competition produces huge thorns greedy to rip flesh and maim life. I observe the earth from below, and profound loneliness comes over me. I invade the inexhaustible dreams of hungry human hearts and brains. These human aspirations become a terror even to themselves, spoiling and wreaking havoc on a wary universe.

I smell flowers. Light disappears. Many of the leaves are healthy but colorless. Can I feel color and its absence? I listen and sense my reflection in the nucleus of a flower from which radiates guileless petals. I reach to pull them and am reassured by the precarious balance of nature. And yes, even during the plucking, the whole universe seems to move. Stars realign. There is enormous weight in a petal, not just the seductive arms of daisies or even hollyhocks that twinkle modestly to lure moths in evening twilight. They all move. Insects multiply, and I am left with the vast weight of the universe in a picked petal.

I awaken to retrace my journey, retrieve my glasses, and gird myself for a new morning. How do you do?

*in this well
I hear old echoes,
thoughts about
who I am
& why I am not.*

Ransom 12

33
sleeping

IN THIS WELL I HEAR..., 2012
WATERCOLOR
22 X 15"

*I
tried never to forget*

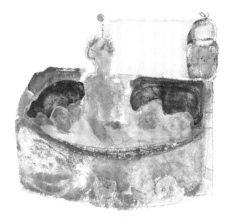

*who I was and
where I'd come from
and where I'd go back to*

Ransom 12

33
sleeping

I TRIED NEVER TO FORGET..., 2012
WATERCOLOR
22 X 15"

32
FDR
Female dreams
1933 – 1945

AT 8:00 AM SHARP, MY MOTHER ARRIVES WITH HER BREAKFAST TRAY WHILE I AM STILL ASLEEP. She insists on bringing me a large breakfast as she remembers her own father's girth and potency (nine children). Is she reshaping me into his image? Indeed, Mother believes she can will for me that larger destiny my invisible father was denied. She would do this even at the cost of killing him in her own fertile imagination. Consequently, my childhood is mainly about her. I grow on her words. Her vowels and sibilant consonants roll from a small dry-shaped mouth and lodge permanently in the canals of my ears. She remains forever the tidy lawns and manicured flower beds surrounding our house on the Hudson.

On Tuesdays, there are always omelets, onions, and red peppers, two slices of buttered toast, and tinned fruit, usually pears. On Wednesdays, I can safely foresee three pancakes with maple syrup buttressed by bacon. Friday's feast is . . . Never mind. I am bored with all this.

Quietly, but not subtlety, Mother takes charge of my bed, working her way up to my body, which for her includes my soul. At this moment, I am wearing my father's flannel pajamas, tailored in the Chinese manner. Or were they her father's? Worn and mended, they seem heavy with teardrops stitched into the breast pocket. I surrender, and my eyes follow her quick movements. At this moment, she is making my bed with me still in it. I follow her radiance and hope that my heart will remain mine.

My mother has controlled nature. She travels in her head, always with me by her side. My bed is central to her geography. Her curiosity and pride of property always cover the surrounding landscapes she wants to cultivate. There are many, but I always seek refuge in those swampy banks of the Hudson that invite gentle rest from her otherwise fast-moving shears and mowers. When challenged, she can become the long reeds, invasive and competitive, that people our watery shorelines. Her sturdy seed pods contest the sky, and her leaves grow on only one side of her stalks, apparently sharing me willingly with the sun.

Mother is now rearranging the eggs on my breakfast tray to achieve a strange symmetry. The same hands that butter my toast and stroke my head can, I am convinced, smash the skulls of her son's enemies. I watch her poke and smooth me within the bed linen. Is nothing safe from her grasping fingers? The 27 bones of each of her hands point and gesture, making large, sweeping motions. The light and spirited bones of her wrists flick on and off,

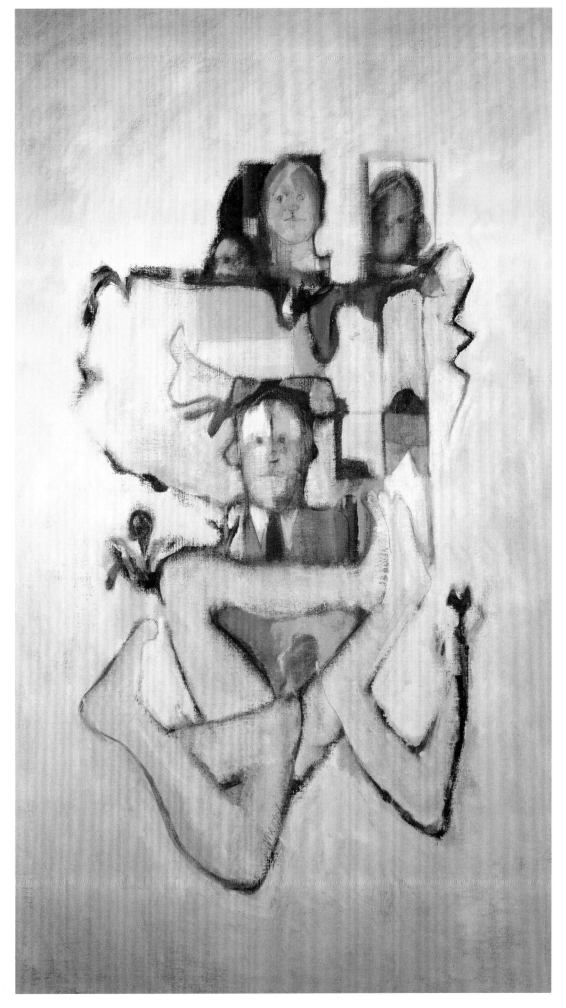

FDR GROWING LEGS, 2013
OIL ON LINEN
70 X 40"

depending on whether she approves of what she has encountered.

It is almost nine, and I dream of Eleanor. My wife's intended arrival does not dislodge Mother, who remains glued to the right side of my bed (as opposed to what would in her estimation be the wrong side). When Eleanor enters, she stands by the left and waits for me to invite her to sit down. She sits as far from me as she is comfortable (and as far from Mother as she can).

With compressed lips, extended teeth, and a retreating chin, Eleanor is no beauty. She is distrustful but loyal. I always sense she fears she will be passed over—that my love is qualified and that I will betray her. In lieu of passion for me (though she bore me five children, as many as Cousin Ted's wives carried between them), she honors duty, her first love. As far as I am concerned, she is beyond arousal. Since my ambitions are enormous, I chose this tall lady as a companion and mother rather than as a lover. Mother continues to help me mold her into the wife I require.

Still, Eleanor's hectoring gets to me, and she uses her sturdy forefinger to scold and spur me to actions that fit her larger sense of public responsibility. She stands by my pillow and overwhelms both my hands in her version of a hug. Papers devoted to social legislation and human-interest rain down on me like so much confetti: "Dearest Honey," she says before wishing to discuss with me: CCC, AAA, TVA. I feel overwhelmed by the alphabet. Then WPA, NRA—it will not stop until I roll over.

With my back to Eleanor, and as my mother gives my wife disapproving glances, I know I can pleasure myself only when these women's demands disappear from my consciousness. Both seem unaware of what I am doing. I have never felt onanism is something to be ashamed of. It has always been for me an elemental rhythmic gesture—much like rubbing together sticks and stones. Their conflict produces a spark, making fire. Me making fire? I like that, and I do. I am convinced that God placed our genitals in comfortable reach so that we could produce that fire as needed. Moreover, male hands are constructed with a grip that guarantees power and precision. Men know just how long and how tightly to sustain the right pressure. My hands sweat profusely, but I am grateful for the value of this excellent lubricant. And my handshake? I prefer a left-handed one, like in a secret fellowship, followed by a vigorous slap on the back. My right hand is for me.

It is now 10:05, and I should wake up and devote myself to the needs of the country. Missy is late, and I can't imagine why. Overworked, confident of my dependency on her, she understandably accepts my lack of affection. President and secretary—with her strong hands in my life, I feign feelings I don't actually have.

Missy does make me feel like a man; Eleanor no longer tries, even in my sleep. And like Mother, Missy venerates me. Her little hands poke tirelessly at her typewriter, consumed by wanting to live up to my expectations. I reward her, as I would one of my children, by occasionally inviting her to sit on my lap while typing. But she is not one of my children, and I can be only so intimate with her if I am to keep her fingers on the typewriter and not on me. I am attracted to her blue eyes and dark tresses, which are staccatoed with some early gray. The soft bun she has coiled bewitches me. Her lips part as if she wants to declare herself, and I smile and smile to head her off. After all, Mother and Eleanor are watching. Missy crawls under my bed to fulfill her duties and we hear the rhythm of her typewriter.

It is approaching noon, and I wait for Lucy's arrival. Eleanor is half-crazed with excitement, pondering the worthy causes in her head. Mother is calculating her household expenses and remains watchful.

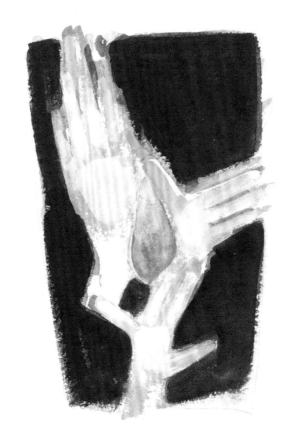

hands that tear.

Ransom 13

32
sleeping

HANDS THAT TEAR, 2013
WATERCOLOR
22 X 15"

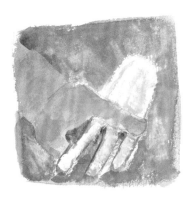

my hand speaks as clearly as my lips and mouth

Ransom 13

32
sleeping

MY HAND SPEAKS AS CLEARLY AS MY LIPS AND MOUTH, 2013
WATERCOLOR
30 X 22"

And then she arrives. She who tempts me to forsake my inherited caution, tall with shapely breasts, luxuriant hair, luminous flesh, and the brightest blue eyes that a woman could ever claim. Lucy dresses like a lady, with a stylish hat and gloves. Eleanor cannot see beyond her causes, and Missy is grateful to be in my company, even if under the bed.

So only my mother remains close enough to know what is going on between Lucy and me. But all she sees is what she wants, the image of a pretty lady who taps the tips of fingers when she shakes hands, and whose little finger exudes all the elegance of refinement. In imitation of oath-taking, Lucy playfully links our pinkies.

Dear Lucy always remains my island sanctuary, far from clipped lawns and hedges. She rises above me majestically as I approach on wheels, and so I widen my eyes to take in her stars. This morning, she is here for me. Because my legs do not cooperate, I am challenged to assume positions that others would not contemplate. But Lucy

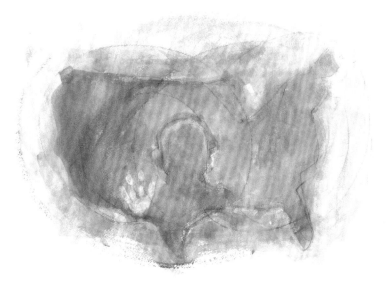

re-shaping America

Do I not connect?
am I not a high way
bridging what is possible
& what is inevitable?

Ransom 12 32
 sleeping

RESHAPING AMERICA, 2012
WATERCOLOR
30 X 22"

Ransom 12 32
 sleeping

DO I NOT CONNECT? AM I NOT A HIGH WAY BRIDGING
WHAT IS POSSIBLE AND WHAT IS INEVITABLE?, 2012
WATERCOLOR
30 X 22"

is resourceful and sits on my face. She lowers herself in small, calculated increments, varying the tempo so that my tongue expands rhythmically. It engages and disengages as my face becomes full.

Yoo, Luoy is the ladder providing me with the means to connect earth to heaven, ascending and descending to places I cannot travel alone. She is my rooftop, the treehouse that drives me to that tumult in the clouds. To climb a ladder is to undertake vertical navigation. I rise one cautious step and imbalance overcomes me. Then I pull myself up and begin again, always risking a fall, to reach a destination that is essential to my existence as a man, who happens also to be president. What pain I experience banishes inherited arrogance from my grasp. I become more than a reassuring promise to the hard days of my generation as I fall back asleep with a happy face.

31
HOOVER
Dreaming big

1929 – 1933

I DO NOT UNDERSTAND EVERYTHING HAPPENING AROUND ME. That is why I do not like to dream, which counters my waking view of the world. I have been placed here on this earth by the rational Maker of the universe not to construct poetic castles for the future, but to measure the progress of men through the cold microscope of demonstrable facts. I am an engineer and proud to be one, stalwart in the face of those who would limit me and my facts. I operate out of a system of measurement and calculation by the square foot. I never indulge in the inexact sciences of psychology and metaphysics. Through the practical application of what is knowable, I have brought significant human satisfaction to vast and disparate numbers of people. I am the philosopher of rational prosperity.

A giant wheel appears, its spokes radiating from the center. It moves with some irregularity but remains purposeful in its constancy. I fathom immediately the logical underpinnings of this extraordinary circle that grows prodigiously by the minute. Here is the rational understanding of life as grounded in scientific information and expertise, guiding Americans to order their individuality through cooperation and competition delicately balanced. In the center of this giant American disk is the great rational Maker and guide to prosperity: the Engineer.

I watch my right hand writing vigorously on my wife's robe, which had been thrown carelessly on my side of the bed, though I have warned her about this. What I am experiencing is a body, fully intact, with a soul that is ignored, freeing me from any speculation about feelings, God, and other matters outside my engineer's grasp.

My wife, who is next to me, is snoring loudly, so I explore her head and nasal passages, the very parts that make so much noise. I am not annoyed as much as I am curious how this takes place and what calculations we can make to improve upon the human capacity for long-sustained, heart-rending snores. Then we can eliminate them. I imagine a time when America will be free of snoring, as it will be free of poverty.

My wife and I frequently discuss these matters, sometimes in bed (when she is not snoring), sometimes at dinner. I like to think that we are an active and progressive couple because we complete one another. We share one brain; her half is a place of intuitive and lyrical perception. Words are less important there. My engineering brain, on the contrary, capitalizes on writing and reading, on language. I reason.

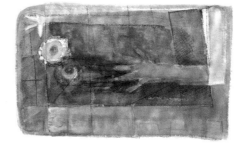

AS I AGED, MY EYES MOVED DOWNWARD..., 2010
WATERCOLOR
30 X 22"

I SEARCH INTO A DARK HOLE LOOKING FOR A STABLE AMERICA, 2010
WATERCOLOR
22 X 30"

Although I have never wished for a right hemisphere to join my active left-sided brain, I often feel left out. I cannot ovulate. To me, this is the biological process that most epitomizes the economic cycle, the balance of give and take. I have pined to experience in my body what I was experiencing outside of my body, to fulfill my engineer's dream of connecting with the life force that creates the mechanical universe I love so dearly. I began to observe Lou hourly, knowing that my logical brain could persuade her more emotional sensibility to give me what I wanted.

A dispassionate comparison of the molecular structures of testosterone and progesterone reveals very few differences. The molecules of each consist of fused-ring systems with atoms projecting from the rings. Looking closely, however, you can plainly see that at one juncture, progesterone has a three-atom harmonization whereas testosterone has but one. Is that the difference between Lou and me? Two tiny little atoms?

Since we share a pelvis, I ask for some of her female hormones, convinced they will make me whole and complete, much like the Master Engineer of the universe. I hope it will let me understand better the workings of the world and pry open even more of its secrets. It does not matter if Lou knows of my intentions or ambitions. After seductive approaches, she surrenders that peculiar molecular structure known as estrogen. I feel immediately complete, privy to the mechanics of the universe. And now that I have mixed within my engineer's body copious amounts of testosterone and estrogen, I am waiting for good things to happen.

It begins. I explode. My heart rate shoots up, my breath increases tenfold, and I collapse under the sheer weight of misplaced optimism. My well-ordered brain has overheated, but worse is the raging aggression that takes over my temperature, causing a free fall of the lines on my medical charts.

I stagger to my bed and cover my head and body with sheets and blankets I once had bought with hard-earned money. The mixture of hormones races through my body, making me feel aggressive and sexual. I used to see intercourse as a purposeful act. Now I want to enter any available cavity, human or not. If there are no breaches, I shall create one to find release. It is like a window opening to the sun.

Overnight, my heart begins to quiet and ask if I am in the beginning stage of restored equilibrium. But by 11 the next morning, I have surrendered to blind, overwhelming fear. My erections will not subside, and I panic because I cannot control my metabolism. All the insults and slights experienced in my successful life bubble up and inflame my will. I begin planning dark revenge by thinking of past injustices, which are many.

By noon, the power of mind intrudes and concentration forces my collapsing physical shape to give way. My engineer's brain speaks authoritatively to my body, insisting that this small distress to our corpus is actually due to technical complications rather than any fundamental cause. Betterment is on its way. The impact of these words proves electric. My temperature level? Calm prevails, if not a surge of evened energy. The worst has passed. Throughout Friday and Saturday, my pulse remains steady, my ordered life returns, and I pronounce myself sound and prosperous. Sunday, I rest.

But on Monday, an even crueler mix of estrogen and testosterone reasserts itself beyond my power to understand, let alone control. My eyes look but do not see. There I am, the lustful engineer, shameless and determined. I leave my bedroom to find release in the streets of Washington, and I spread my panic wherever I go.

Tuesday shows no relief, the most devastating day in the history of my proud life. My temperature drops prodigiously, and my lust overwhelms any sense of decorum. My multiple erections are now noticeable to my cabinet, and I wear long overcoats. The erections are accompanied by frequent aggressive discharges, unexpected and humiliating. By Wednesday, I cease to care. Then it is suggested that we close down my body through injections so as to allow it to sleep, encouraging hope and courage to return. But I cannot do that. To shut down my body is like closing the New York Stock Exchange, suggesting that both are out of control with consequences that cannot be foreseen.

I know I am right because, by Thursday, my health appears to make solid gains, and so dispels my fears. But by October 24, there is another prodigious slump in my determined equilibrium. My mind no longer has any control over my raging aggression. In January, February, and March of the following year, I again recover, only to experience persistent and continuous rage and disorder, week by week, month by month.

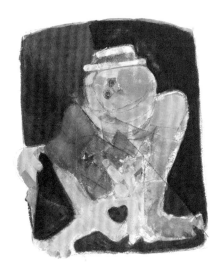

soured by adversity
and out of control

my America

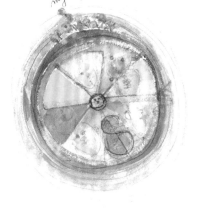

is a vigorous hard-working wheel
only slightly imbalanced.
that turns predictably
with only minor outside interference

Ransom 10

31
sleeping

Ransom 10

31
sleeping

SOURED BY ADVERSITY..., 2010
WATERCOLOR
30 X 22"

MY AMERICA IS A VIGOROUS HARD-WORKING..., 2010
WATERCOLOR
30 X 22"

Though associates have observed out-of-control aggression on my face, I have learned in bed to purse my lips and wiggle my nose, laughing a lot. Because this is hard. I smile as best I can. But what do I do about my eyes, where these same people can identify lust and erotic craving, aggression, and bombast?

Others soon take my place and their crippled thinking combines American capitalism with all kinds of governmental interference and manipulation. The Great Engineer of the universe seems absent. Will he return? I persist in my old ways, though I feel unacceptable rumblings in my groin. Especially at night.

30

COOLIDGE

Timely dreams

I FIND IT EASY TO SLEEP WHEN I AM AWAKE. But it is harder to dream. To absorb nature's silence, I often wrap myself in red apples, stems askew, the reddest near my forehead, round and plump. It is hard to see me.

I sleep in the White House and never has the nation been so prosperous. These should be auspicious years, and yet I see dark shadows building. I fear they will one day overwhelm all my dispassionate dreams and silence them, and me, forever. I am afraid the future will taunt me, ridicule my belief that the business of government is just business. But for now, the days enjoy themselves in opulent excess steadied by the perception that a silent captain, selfless and unimpeachable, stands at the helm. The business of America is business. Steps are quicker, footlights wider, erections taller, ethics freer. The gin is cheaper, too.

I roll over to loosen my jaw. The lower part of my face clenches into a mask when I lie on my left side. On my right side or back I enjoy my bed, feel safe in its distance from random life and remain Calvin. I draw on old dreams much as we withdraw books from the library. I return them in the morning. But some of these pages, once so bright, grow worn and illegible. So I contemplate the bindings, sniffing the patina of sun and touch, savoring ideas that fade.

My soft bed with pillow evokes cloud and storm. Here I am a rainmaker. My cotton nightshirt, of the same cloth as my sheets, is cool and lets me shape and knead it to fit my dreams. My baby blanket, rescued long ago, has been neatly mixed with other cherished pieces of cloth and quilted by my ever-astute wife. Imagine a bedspread eight squares long and eight squares wide, one square for each of the sixty-four portentous moments of my existence from birth to presidency. Thus is my life divided and subdivided. When I pull this evolving tableau fully around my head, I come into immediate contact with old emotions. I snuggle up to the earlier episodes, those faded squares that are just bright enough to read.

Those patches tell of America and my hopes for her continued prosperity. In some, I fondle her. In others, I embrace and feel those private parts that she does not allow just anyone to see. My hands venture along sewn stars and embroidered stripes to discover a pulsating heart, generous and receptive.

One square especially draws my right hand to its guarded borders. Located some two feet from my neck, it covers my loins when I straighten myself and lie flat. By extend-

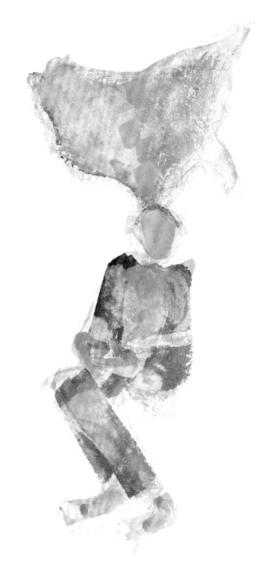

america delicately balanced
between hard work and
prosperity

Ransom 11

30
sleeping

AMERICA DELICATELY BALANCED..., 2011
WATERCOLOR
23 X 15"

ing my head oh so carefully, I connect with an embroidered square of green apples distributed randomly. Here I can taste the silence I need to become fully purposeful, if not entirely presidential. Now I can sleep the first tender sleep of early evening and later, much later, the last deep slumber of emerging dawn. Between these two places of safe repose, however, I come across dark and menacing expanses of quiet horror that grow larger.

Why horror? Because in these dark intervals, which appear more often and last longer with each recurrence, I encounter shadows that shoulder me and my ideas aside, forcing their black silhouettes into what remains of the breaking light they call the political limelight. These sad shadows seem to exist between time, not within it. I feign sleep, so I do not lose myself completely. I lie on my right side and wait.

On my night table, the clock ticks endlessly. My beloved sister Abbey's picture moves back into shadow. In this half-darkness, the photograph of a red-haired child of thirteen takes on the shape and configuration of a wounded appendix. An inflammation protruding from the blind sack of her right colon was misdiagnosed. Her early death left me profoundly injured, and I transferred all my visible affection from sister to mother. Then the seamstress in my life inherited this equation and became my wife. My expanding quilt incorporates this adventure of marriage in browns and ochres and opens up new spaces.

My clothes sit neatly folded on the chair nearest my bed. The moon's warm bath illuminates each article, taking my face in its hands as I pretend to be still asleep. I think I might not be pretending. I pass through the first two states of slumber and onto a third. I come to occupy a place I only encounter in deepest sleep.

Then I meet the American self-made man in the section of the quilt nearest my stomach. I marvel that I had forgotten him, for his face and body were well known to me. He, too, was deep in sleep, haunted by strange visions. With his imagination engaged in all the unrealities, he has always relied upon, his body thickens as his hair thins. These changes are masked by his wooly imagination, which sees only the silence of success. He has given himself fully to the predictable forces defining the booming landscapes of America and shaping his perceptions. If not his destiny.

It has been an age of miracles and, even in sleep, I jingle the coins in my bed clothes and reassure myself of the inevitability of abundance. I become content with making no mistakes because I will attempt no test that might allow error. I make few resolutions. If I am broken, even just mildly cracked, I do not show it, since our collective perception tells us otherwise.

Even in my dreams, I walk quietly in the chosen steps of governance. Accepting politics as it is, I followed accepted guidelines. I am leaving office, and the middle class is gambling along with the rich. We have always believed that the common good is best served by meeting the needs of business. I bless the aspirations of my era, shape its voice, and let my generation guide me. The future looks glorious.

When it crashes, I will be gone.

*I gather the states
around me
spreading prosperity
and silence.*

Ransom 11

30
sleeping

I GATHER THE STATES..., 2011
WATERCOLOR
22 X 15"

29
HARDING
My dreams not his

1921 – 1923

YOU WOULD LIKE WARREN HARDING—HE IS SOFT AND WARM, HE LOVES WOMEN, AND HE LOVES TO BE HUGGED. He needs to be liked. All along, I have helped him pull things together while disciplining his wandering eyes and peripatetic feet. He loves me in his way. He used to call me Boss. Then he started to call me Duchess—as I requested. Sometimes he calls me Flossie. I call him Sonny. But history will remember me as Florence Mabel Kling Harding, First Lady of the United States.

He is good looking, and I like that. Especially wonderful are his feet, the left one longer and elegantly tapered at the toes. I am not alone in admiring him. There have been many ladies during our life together. He is smart when he wants to be and communicates to them his need to be filled, to be directed. But otherwise, my husband was never very ambitious until he met me. I changed him. I took him from being a sleepy US Senator from small-town Ohio to being the twenty-ninth president of the United States.

How? By invading his dreams. I planted my own aspirations in his barren imagination. It was not easy. His mind, which fed his reveries, was a rocky, underwatered patch of earth like some parts of Ohio I should not identify. (I am from Marion.) Treeless, because commerce had replaced nature, the circular roads of his imagination went nowhere. There did exist some lush places here and there, but one had to look hard. While his sense of humor kept them watered, they never stayed tidy. His brain was then a perennial autumn of arrested growth. Continuously, but in stealth, I sowed the seeds of aspiration, gradually creating an expanse of what I wanted to grow.

Although Sonny's imagination was directionless when we met, it was not imageless. Indeed, when I first invaded this elemental landscape, the plethora of anatomical parts I found there overwhelmed me. Breasts with tiny pink nipples dominated, but there were many other shapes, mostly firm with the poise of teenagers. Long tapered backs with ample but firm buttocks. Blondes and redheads appeared everywhere, but raven-haired women seemed Sonny's first choice. I elbowed my way into his harem of bodies where teasing laughter provoked Warren's crazed anticipation—areas of tender flesh opened to touch, longing to be filled.

WARREN HARDING'S HEART RIDES WAVES, 2012
OIL ON LINEN
50 X 40"

I love your mouth, I love your fire
I love the way you stir desire
I love your size and daintiness
Love every thread in which you dress
I love you garb'd but naked MORE!
Love your beauty to thus adore.

Do you know how difficult it is to obliterate powerful images in another's dreams and then substitute your own? There were moments I was overwhelmed by those young girls and the satyr who wanted to orchestrate their supplications. At first, I uprooted such visions, which multiplied as fast as spring weeds. The breasts were easy and shallow-rooted. The faces, which seemed to have a deeper anchoring in Sonny's character, were more tenacious. I am afraid that I did not get rid of all of them. And the vaginas, enticing and laughing? They were the hardest.

The only way to control these floating visions was to lay a sufficient foundation of glue to hold them in check. Then I added, with a large flat brush, a white lead ground (with a small amount of linseed oil) and

brushed thick layers over those memories that appeared louder than my determination. After the second coat, there were only a few I had not been able to smother. I left them in hidden corners of Sonny's imagination, not knowing they could repopulate and spread. And because my husband used his free railway passes constantly, he found new images that knocked and entered. But I did what I could. I still have white paint on my face and hands as markers of my persistence.

Once Sonny's imagination had been somewhat disciplined, though not sufficiently fettered, our partnership grew. Although our dreams of applause and fine fellowship took on a whole range of forms, high political office presented itself as the best way to secure the public's love. My hungry dreams merged with my husband's purged mental landscapes, offered him newly empty vistas he ached to see filled.

We quickly concluded that politics is not about what one says but how one articulates it. What is important is not who we really are but how we are perceived. Not what we believe in, but what we oppose. Ideally, ours would be a campaign that would offend only Democrats. It is necessary to lead, but not to know where one is going.

We deepened our understanding of the motivations of the human heart by studying human feet. It is commonly believed that we face the world with our faces. It is assumed that age, gender, and all variety of predispositions are imprinted there. We act as if our thoughts and feelings, both open and repressed, can only be found in the expression of our eyes, cheeks, and mouths. Utter foolishness! Are we not encouraged by our mothers to put our best (that being the right) foot forward?

Yes, if you really want to know what a politician is up to, watch his feet. To watch a politician's foot is to learn how public affairs get transacted, and so all astute men in political life carefully observe the twenty-six bones, twenty muscles, one hundred-fourteen ligaments, and thirty-three joints of which human feet are built. Know the feet, and you know the man, Sonny frequently observes. We learn all about that sneak Woodrow Wilson just by listening to his uneven, disjointed gait.

But mankind has devised strategies to veil these disclosures. Footwear masks the subtle variations in our feet and shades our ability to know our neighbors. Men choose shoes too large for their feet to counterfeit their true disposition and so their souls. Men and women both wear shoes too long for the same reason. Sonny, with his lovely left foot, likes to accentuate its elegance by wearing slippers and placing small bells at their tips to signal his interest in others. But at that, I put my own foot down and put a stop to the bells. Feet, we've come to understand, cannot be disguised, and we've become adept at interpreting subtle, unconscious movements, like crossed ankles, shuffling, toe tappings and wrigglings. We are skilled now at interpreting heel erections.

One night, I was awakened by soot from half-burnt love letters falling onto my face and chest. These epistles, in pencil on blue paper, went on and on. Wishing they had been addressed to me, I tore off the names and addresses. I removed to the fire whole sections written by Sonny's blatant maleness and hungry flesh, alive with the banal devotion he never gave to me.

Nan, Susan, Grace: all exorcised and burnt. I struggled with Augusta, Cecilia, Ruby, and Carrie, who tried to mold the president in their own images. I have made a profession out of Mr. Harding, a reluctant political candidate usually seen as everybody's second choice. Like receding daylight. I try to sleep and wait for my turn to dream, free of yours.

painting over dreams

Ransom 10 *sleeping 29*

PAINTING OVER DREAMS, 2010
WATERCOLOR
8 X 8"

*by feeding your imagination
I lose mine*

Ransom 10 *sleeping 29*

BY FEEDING YOUR IMAGINATION I LOSE MINE, 2010
WATERCOLOR
15 X 15"

*images in your dreams
that you let out
remain in my conscious
mind*

Ransom 10 *sleeping 29*

IMAGES IN YOUR DREAMS..., 2010
WATERCOLOR
22 X 22"

*separating trust & love
makes unbounded grief.
it helps with someone's hand
on my life.*

Ransom 10 *sleeping 29*

SEPARATING TRUST AND LOVE..., 2010
WATERCOLOR
22 X 22"

28

WILSON

Drifting in and out of sleep

1913 – 1921

THEY DARKENED MY ROOM WITH HEAVY SHADOW, BUT I HAVE ADAPTED TO ITS UNSEEN PERIMETER. I am tired of definitions, of weighing successes and failures. Although this blackness frees me from decision, it manages somehow to increase my choices. I try to extend my left hand. I might have five fingers or seven. There is no evidence, nothing I can see or feel.

All my life, I have timed my breathing to terms of my work. When there is an available minute, it is not for smiling or contemplating what is in front of me for its own sake. No, I husband those seconds to inventory and put them to use later —as a professor, as governor, president—to whatever is my current enterprise. I am my work. Not really liking people, I long for those quiet moments when I am alone and unobserved.

I like spiders and watch them carefully. I feel one now in my right ear. Some female arachnids have been observed devouring their husbands after copulation. We speculate that such insensitivity is based on simple hunger coupled with the close availability of a living meal. But I don't buy that. We give ourselves to our work and are devoured for our posterity. I know. The lowly male spider gives himself up to be eaten for the ultimate well-being of his descendants. My father did this. He gave up essential nutrients, surrendering his life for his children. Still in bed, I turn onto my right side and think about this conundrum of self-sacrifice for the ultimate well-being of our nation. I like this. I like this because I have spent my whole life in the service of God, my fellow man, and my country.

I drift in and out of sleep, and in utter darkness, I still see spiders copulating in the corners of my room. I hear the generous laughter of female voices coming from the left side of my consciousness. Do spiders speak? That hungry part of me seems suspended without feeling. I go there and am especially delighted to find bushels of female flesh, pink and white, with discrete and delicate triangles of soft-brown hair.

I register my excitement visibly. Although married, I am not yet removed from the fuller expressions of lust. I move mentally to embrace these living forms. I love women because, unlike men, they are not in competition with me. Like my mother, my three daughters, and my wives, Ellen and Edith, they reinforce the center of my quiet. They make me feel like a boy and heighten the joy of living fully, not just in the heart and lungs but lower down. I long to make up for lost opportunities because only through continuous touch can I ultimately realize my own powers.

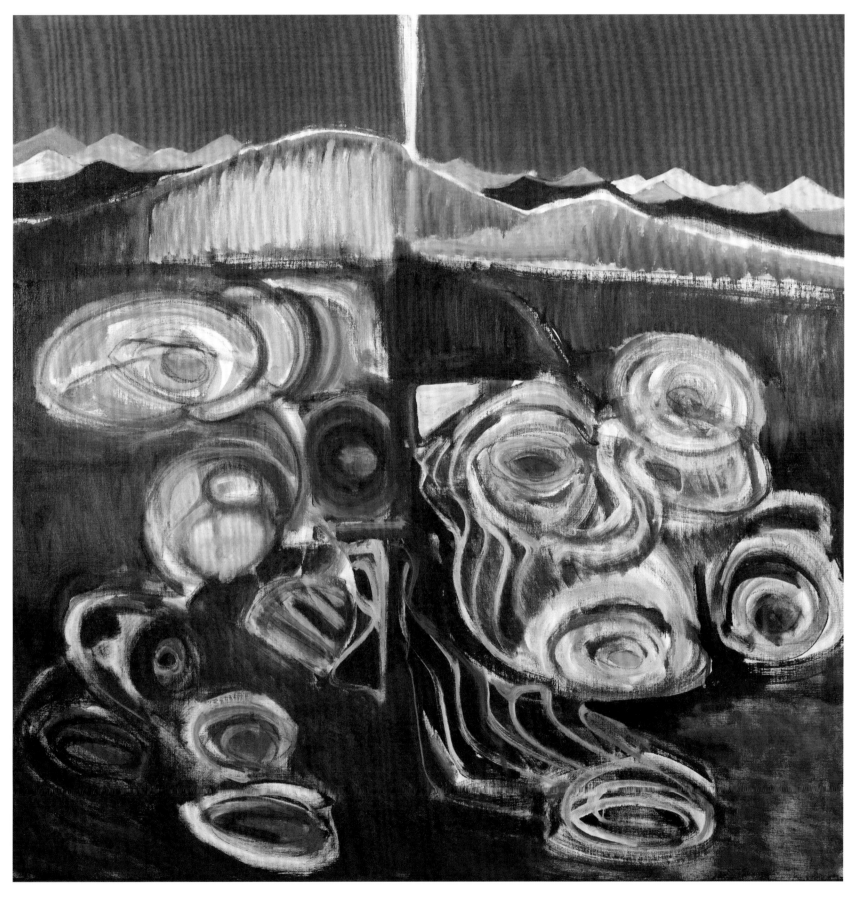

WOODROW WILSON IN WATER, 2011
OIL ON LINEN
50 X 50"

I am out of touch with the ground

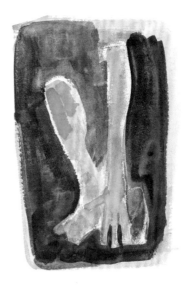

*it was the left side of me
that would not obey*

Ransom 12

28
sleeping

Ransom 12

28
sleeping

I AM OUT OF TOUCH WITH THE GROUND, 2012
WATERCOLOR
30 X 22"

IT WAS THE LEFT SIDE OF ME THAT WOULD NOT OBEY, 2012
WATERCOLOR
22 X 17"

I throw off my blankets as best as I can. I sense a faint light invading the darkness of my existence. I lie quietly for what seems like hours, following the course of illumination as it travels in slow increments up my body. Most pleasures in my life have been connected with my mouth, so I wait impatiently for that part of my existence to become illuminated. I see all too well that my legs, too short for my torso, excuse my feet for being out of touch with the ground.

I look better in bed than standing up. My chest coughs upon exposure to the onslaught of light. My ribs contract and hide as best they can under pale skin that is unaccustomed to the sun. My Presbyterian heart, inherited from my dear father, prefers my shirt to be buttoned to my neck. It rarely enjoys exposure to invading light. I try smiling when the light touches my chin, even though I dread how my gold fillings will sparkle in a sea of mottled brown and yellow. The light will shape me fully, and expose a loose upper lip, a bill-like nose, protruding ears and more chin than can accommodate my forehead and glasses.

I speak to the sun, but the sounds are labored and indistinct. The paralysis on the left side of my face responds with grotesque movements. The right side does not recognize what was once its twin. I have always pushed illness away, convinced that health is a result of clean living whereas disease and illness stem from self-inflicted moral weakness or disregard of duty. I need strength of will to force the body to do what I expect of it. This is a moral struggle, and I can no longer hide the symptoms by denying them. So what if I have diminished emotional capital? It can only be made better by not spending my feelings unnecessarily.

My stroke has forced me off the world's stage. More grievous, it has exploded my patiently shaped sense of self. My left side is now disputed territory, open to the ravages of wild birds and my growing inability to understand or store new memories. Shadow closes in; faces, even my own, go unrecognized. My legacy entails cerebral arteriosclerosis, severe headaches, and blindness in the left fields of both eyes.

Breaking this tyranny of multi-layered shadows is a pair of inviting eyes, green and blue and calm. I recognize them as my own, as I would a well-traveled road leading to my youth, when health was of no concern. One eye lowers and appears to rest near the edge of the bed, close to my left side.

I try listening to my own heartbeat, but since it is domiciled on the left side of my body, I can barely fathom its beats. "Shall I awake and find all this a dream? [...] We cannot be created for this kind of suffering." Old poems flood my head. My eyes open and close several times. Since these moments are gestures not comprised of language, and given my inexperience with elemental forms of communication, I cannot respond. I do not even understand. The eyes seem to reflect two perspectives, two landscapes of strikingly different colors. They rise and position themselves on top of me, studying the geography of my aging body. A soft sighing coupled with a strong animal smell merges with the alternating strokes of consuming and expending breath. The eyes that will not look away envelop who I am, all that I have been—misshapen and soiled. All that I can ever embrace are the moments from childhood and the evolution of a maturity composed of humiliations and misunderstandings. Moments alone, always alone.

In affliction, soiled and powerless, I remain who I am. My blood continues to flow in an endless loop. My heart, the seat of my gentle feelings, flutters rhythmically and pumps two-thousand gallons of blood a day. Am I more than six-hundred-thousand miles of vessels and capillaries? Despite public office and its glories, can anyone isolate me from the absurd materiality of my physical existence?

sleeping

Woodrow's tower always attracts clouds

Ransom 12

28
sleeping

WOODROW'S TOWER ALWAYS ATTRACTS CLOUDS, 2012
WATERCOLOR
22 X 15"

a mind put into a body too small.

Ransom 12

28
sleeping

A MIND PUT INTO A BODY TOO SMALL, 2012
WATERCOLOR
22 X 15"

JOHN RANSOM PHILLIPS

27

TAFT

Eating in bed and sharing my bed and dreams

THE THREE OF US DON'T ACTUALLY SLEEP IN ONE BED. Teddy and I are bedfellows because we share ideas. Nell is my wife, and we have three children, but she prefers twin beds.

But tonight we are together, stretching out to our full lengths. Theodore Roosevelt, twenty-sixth president of the United States, Helen Herron Taft, former First Lady of the country, and me, William Howard Taft, twenty-seventh president of the United States. Nell being smaller, and not liking Teddy, takes a small space in the upper-left corner of our bed. I am a big man, much given to thrashing and pummeling my pillow, so I take the lion's share of the mattress until Teddy, who has hitherto been sitting in the corner to our right, decides to join our sleep, so to perhaps invade our dreams. Or at least mine.

Teddy shifts his bully body ever so slightly, occupying what little space I have left. Then, by small movements of elbows and knees, at first subtly, then more vigorously, he proceeds to enter my consciousness. That is not difficult because, despite my enormous heft, Teddy is also bulky, and not just in size. He is loud, boisterous, imaginative, and funny, and I love him. So I let him in before he even knocks. Once inside, he decides what is and lays out my life, ignoring my dreams, as he begins to seed, fertilize and water his own aspirations, which become mine. And since I believe Teddy exemplifies an exquisite public conscience, a powerful imagination, and the strength to move men, I succumb.

Soon, however, my predecessor finds that some of the more strategic spaces in my consciousness have already been occupied by another. Nell rarely identifies with other women. She has been the chief animator of my political career, for although she pines to be president, she cannot even vote and has settled for being the president's wife.

When Nell is away, I always feel I am lacking something. She defines and shapes my consciousness and ambition, or lack of it, and my unconsciousness is always open to her organizational poise. My dreams match hers, and when Teddy, as a bull moose, knocks at the front door, I am ill-prepared for another intrusion, a new shadow replacing hers.

When I am not forced to eat Teddy's leftovers, I like to eat in bed. Propped up by

my bed was unstable because there were 3 of us

Ransom 12

27
sleeping

MY BED WAS UNSTABLE BECAUSE THERE WERE 3 OF US, 2012
WATERCOLOR
30 X 22"

pillows, extended to my full length, I especially and compulsively savor lobster stew with salmon cutlets. It is the only time I can really be myself—or feel comfortable in the roles that others have chosen for me. Both Nell and Teddy disappear from our bed when I eat. When I balloon, I always claim I become more masculine, less the unhappy child others tease. As president of all forty-six states, I can eat my way into the hearts of my countrymen. When you think Seattle, I think salmon. When you say Colorado, I say cantaloupes. When I eat red snapper, I recall New Orleans. Mention emotional food and

gustatory adventures, and I imagine Texas wild duck or Kansas short ribs.

I have never been attracted to the rumble of American politics, preferring the pleasant harbor of the judiciary, instead. Yet Nell, who eats sparingly and never thinks codfish and beans when we visit Boston, vowed long ago to marry only a man destined to become president of the United States. Gradually, she had her way, adding this and subtracting that until I found myself molded and even inspired according to the geography of her ambitions.

I finish my dinner and dream a little while Nell sweeps away the crumbs of Mississippi corn pone that litters our sheets. Teddy brings another warm wool blanket of blue stars with red stripes and proceeds to tuck in Nell and me, leaving generous space for himself in the middle. With the three of us all comfortable in our assigned sections of the bed, we sleep. I dream of a nation where private property is safeguarded, where discord and confrontation are banished, where all Americans become my friends.

Nell, only half asleep, keeps one eye glued on Teddy; she is not pleased he has disturbed her bailiwick. She watches the president carefully, concerned that her husband is too faithful to his successor and would do anything to please him. For me, it is not about politics but friendship and loyalty. And yet jealous as she may be, it might have been useful for her to obtain, through Teddy, what she has always desired.

Deep snores and the rumblings of digestion emanate from my body. From Teddy who is on my right, comes deep laughter punctuated by adolescent giggles as he enters sensuous adventures that only he could enjoy alone. He grabs a large slab of my thigh. He presses his body close, very close, and I can feel the fire in his belly rise until he reaches a sort of exhilaration, after which he remains calm but panting.

I adore this man, his ability to rouse our American identity, his power over the imagination, his ability to lead. I turn away from my own heart's desires, my own aspirations. Teddy awakens gradually from his moist dream, having learned long ago to confront fear by substituting a strong will and vigorous action. He believes deeply and with absolute conviction that his chosen successor will become president because he, Teddy Roosevelt, said he could. Had he not redefined the presidency as high-profile theater, becoming a heroic, posturing chief executive shouting to a recalcitrant Congress? I fall back to sleep, thinking about those parts of America whose gastronomical specialties I have yet to discover.

I have taken to sleeping alone as president. I know Nell is dreaming about refurbishing the White House. And Teddy? I become his successor, promising to follow his ideas and always remain receptive to his continued advice. I walk softly as he did but never feel comfortable carrying his big stick, which I hide deep in my closet.

I know that I am not to outshine him. His sense of theater requires there be only one lead in any play, and that role is his. Until now, I accepted a supporting part and deferred to him even though I thought I was miscast. Gradually, though, I began to see my own way.

But who am I to challenge my friend and mentor? If I became more by identifying with him, then am I not less through a divorce? I turn over to reach for Nell, but she is not there either. I think of my approving mother, who always held me lightly and touched my eyes to spread my tears. Teddy had chosen me, his friend, to continue the causes he fought for but not to overreach him. And I don't.

I wake up thinking less of dinner, more of all the things I need to do. The hunger for Teddy's continuous appreciation still shapes my perception, but less so. In this bed that is no longer mine, I clearly understand that Teddy never thought he would be giving up the presidency by anointing me. He calls me well-meaning and an excellent man, but only when serving him. To him, I have always been less of a leader and more of a flubdub with a streak of the second rate.

I cry when I hear these words because I fear they are true. He was my best friend. Having loved him from top to toe, I came to fear him, knowing that no matter who I become, I will never please him. No matter. I move over to occupy Teddy's side of the bed and try to have my own dreams.

I digest America

Ransom 12

27
sleeping

I DIGEST AMERICA, 2012
WATERCOLOR
30 X 22"

26

TEDDY ROOSEVELT

Everyone is asleep in my arms

1901 – 1909

MY CORRIDORS ARE QUIET EXCEPT FOR THOSE MOMENTS WHEN QUENTIN OR ONE OF HIS SISTERS SLEEPWALKS. My plumbing is quiet. My large north room, trophied with buffalo heads, still reverberates with the sounds of laughter and, in some corners, polite whispering.

I am, as my architects, Lamb and Rich, would suggest, all about imperishability, gravity, openheartedness, well-being. Brick outside on the ground floor, then shingles, topped with a slate roof. I express the sensibilities any late-nineteenth-century man of substance would desire in his home. Strong Long Island winds are not going to shudder me. From my porch you can, if you are lucky, see most of Connecticut. I am about more than numbers, but I do have twenty-two rooms, warmed by two hot-air furnaces supplemented by more fireplaces than I can count. Clearly, I am a home for a family seeking strong arms. Did not the divine Emerson claim that a sensitive man needs only "day and night, house and garden, a few books, a few actions?"

The colonel marks his appearance with a sleepy, measured gait, feeling his way in the familiar dark. He opens a door, pauses in the entrance, and then moves to the next, where he repeats himself. He spends the most time in the North Room, whose echoes of a full life envelop him, requiring him to steady himself and lean on its mahogany walls. The trees that produced these panels grew slowly and evenly, creating a strong scaffolding for the voices that later will lodge their resonance for future generations. The colonel finally sits down and dreams just a little, smiling through his teeth as he listens to the mahogany in his mind recount the wonder of those days when he transformed America, reshaping its government and society. His voice dominates the echoes, a machine-gun-like staccato where words merge in hyperbole. Sounds carry the day through their insistence that life is meant for adventure. Now he speaks. Listen!

ROOSEVELT BICYCLING AMERICA, 2012
OIL ON LINEN
50 X 40"

In the hallway of the second floor, there is a small, framed picture of my father, Theodore Roosevelt, easy to adore but hard to know. He cherished three things: politics, his family, and horses. Irish Annie, his maid, carries on trays what he likes most to eat: simple food in generous portions. Eggs and waffles, jam, bread kept hot in a warming shelf over a coal stone.

Greatheart, he was called, and I feel his heart pumping rhythmically with increased tempo as he presses my tiny body against his. My happiness rests in his firm grip, his hands press against me until I do not doubt. Did his happiness rest in mine as mine did in his? I still wish this to be true, never changing.

This house and all its furniture will outlive us, but not the memory of my father and his gentle ways. He remains my guide, defender of my wayfaring innocence. He never saw Sagamore Hill, but I taste and smell him everywhere here. He is reincarnated in this rambling heap of wood and brick, mahogany paneling, lamps, banisters, sturdy fireplaces and so many hallways.

These corridors coalesce in my mind. They are unexceptional, always about process and destination. Yet they remind me of the cold, heartless nights when my father carried me, wrapped in blankets.

In one room and then another, he searches for the air or space that will bring me relief from the gradual strangulation of bronchial asthma. It is the air inside me that I cannot expel. Up one flight of stairs, through quiet hallways, interrupted only by his gentle words, themselves parsed by his hurrying heartbeat. Into night air, gripped even tighter against the Long Island wind. Then on horseback, where his authority overwhelms me.

His manhood ignites my boyhood, and I breathe into his breathing. We ride down roads that lead to unlimited prospects of America. I take in what is large and unknowable.

Gigantic mountains, defiant prairies, forests, and fields cascade through our lungs, and we gallop faster. We ride railroads in darkness, and our breath expands to include the geography of all America, all the workers and farmers who toil to create the country's riches. We laugh, and Father revels in the return of his boyishness even as he tells me about the strenuous life of toil and effort. He says we multiply our perspectives when we open ourselves to danger and all its hardships. He counsels that risk is central to abundant life and teaches that we build courage by practicing unfearfulness.

Often I awaken in the night after a deep sleep, my chest tight with shallow breathing. A dry gasping cough follows. I am propped up and unable to speak, but my family surrounds me, understanding that I am suffocating. I am given enemas, cold baths, opium laced with wine. Sometimes they use marijuana to induce my lungs to release me. Other times, I am forced to smoke a cigarette of Jimson Weed and chopped camphor, which they buttress by an elixir of garlic, mustard seed, and the vinegar of squill, a poison guaranteed to kill rats. Everyone works madly to induce vertigo, paralysis in my legs, nausea, and vomiting.

If all else fails, Father reappears with blankets and the two of us venture into the cold night air. Near the oak tree where the road to the east of the house ends, Father pauses and begins climbing, carrying me up into the branches to embrace an even colder atmosphere. With icy air penetrating my bedclothes, he boosts me up, laughing as he kisses me. He never loosens his grip. We pass a limb in whose hollow a hive of bees, now long gone, once dwelled.

My lungs open gradually, as I understand the tree at its fullest. Tall in the wind, our hands become stars. All roads we see lead to unlimited spaces. Father and me. Our lungs expand fully into the bigness of America. Then Father urges me to hold my breath so that I can release it fully and find a nation that cannot be limited or measured. A land vaster than time, nobler than our shadows or our fullest selves. The asthma lifts, and my lungs, crammed into the tight bowl of my chest, push to become free. I am left with joy and full breathing.

I am sure I have become even more special in his eyes, and my identification with him is all-sided. Father is usually home on Sundays, and that is when my attacks mostly happen. I become the dearest of his children, his favorite.

Tonight, years later, I walk the corridors alone, looking for him, searching for those qualities he possesses so fully, qualities that I do not and never will own myself. He still urges me to strengthen my body as a proper home for a mind that will do great things in big America. And yet he is the only man I have ever really feared. Is that fear an extension of my deep love, whether in the dark, on horseback, or in tall trees? The shadows of night have enveloped him. He shares with me the long struggle of surrender and release, retreat, and advance. Hear his breath, his deliberate heartbeat sending proof. His arms enfold me, like a house. Listen!

*I am countless dualities
growth · decay
waxing · waning
increasing · decreasing
I am all that I could ever be*

Ransom 12 26
 sleeping

I AM COUNTLESS DUALITIES..., 2012
WATERCOLOR
30 X 22"

*night shadows envelope us
affording new connections*

Ransom 12 26
 sleeping

NIGHT SHADOWS ENVELOP US..., 2012
WATERCOLOR
22 X 15"

*my tears move upward
they are larger than words
because my body is speaking*

T. Roosevelt Ransom 14

MY TEARS MOVE UPWARD..., 2014
WATERCOLOR
22 X 15"

*we climbed tall trees
for fuller breath*

Ransom 12 26
 sleeping

WE CLIMBED TALL TREES FOR FULLER BREATH, 2012
WATERCOLOR
22 X 15"

25
MCKINLEY
Dreaming as a process of self-creation

1897 – 1901

IT IS BOTH STRANGE AND NOT SO STRANGE TO LIE ALONGSIDE THE BODY OF MY ASSASSIN. Actually, Leon Czolgosz's corpse is no longer a body. Once a thin, withdrawn working man's frame, small in stature and quite unprepossessing, it has now, after his speedy trial, been reduced to ashes by a carboy of sulfuric acid. Black flakes, almost powder, lie forlornly in a small glass bowl alongside my own body, which is well-fed and prosperous but amiable and unthreatening. I can't recognize a face, and the burnt remains do not move, but now and then I detect a deep bottomless breath creating a shudder amidst the ashes. A profound sense of fatalism hovers around him. "I done my duty."

My own usually animated face now lies covered by a mask of shadow that dims my flesh and softens my features. I feel a veil so tight it diminishes who I really am. Or is it a second skin? A new me, one that I can add to my collection of political postures? I stare ahead, fearing that this will leave me faceless, without an agenda of my own.

Understand that I have two killers—the anarchist who shot me and devastated my body forever, and my successor, who will efface my legacy of prosperity and humanitarianism in government. It is claimed that the Progressive Era in America began with Teddy Roosevelt. But I created the political apparatus, the essential Republican alignment that motivated popular leadership capable of marginalizing agrarian protest. I created economic democracy. I brought America into a new era of world power. And I had to watch in death as my second administration became my successor's first.

They have left me the small pink carnation that I carried in my lapel the day I was gunned down at the Pan-American Exposition in Buffalo. September 6, 1901. I was accustomed to those petitioners (and there were many) whose requests I had to refuse, offering my carnation instead. My very real generosity and kindness were encapsulated in that small sweet flower's always serving in place of what I could not do. I gave away many carnations.

My whole life was a studied act of defining myself, a process of self-creation seemingly open to my public but more truly in discourse with myself and the living and dead who affected me. Leon Czolgosz was clearly one of them. I have unfinished business with him.

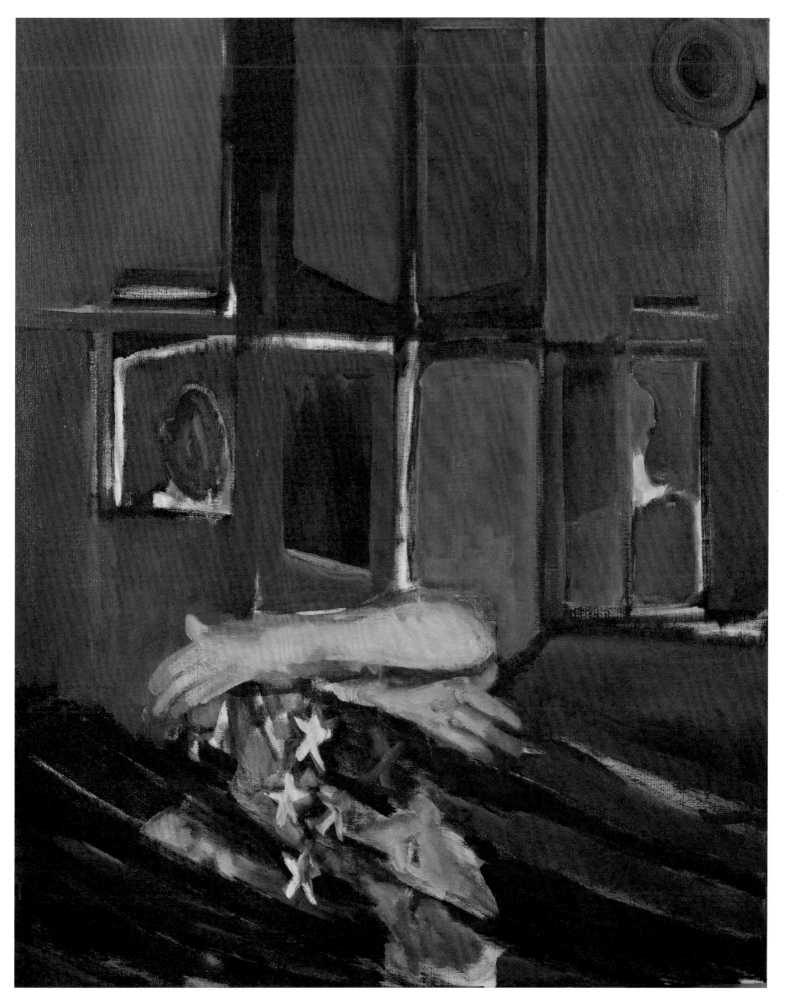

MCKINLEY CUT DOWN AND LEFT BEHIND, 2011
OIL ON LINEN
50 X 40"

One of my buttons deflected his first bullet, which merely clipped me between my second and third ribs. His second bullet, more ominous, entered my presidential body at the upper abdomen, slightly to the left. Then it grazed my right kidney, creating havoc with the right adrenal gland and devastating my pancreas. I received immediate medical attention, but that is a haze now. I do recall the self-congratulatory dance of my doctors when I seemed to be improving.

On the seventh day of my incapacity—at around eleven at night, I was given a pint of normal saline solution by injection. A few hours later, I was given strychnine and whiskey and hypodermics of camphorated oil. My body rallied, only to fall back into a kind of paroxysm of confusion. My sparse hair, normally combed tidily, became a tuft of confused madness. The burning pain put creases in my forehead, which had previously (and remarkably) shone clear of lines or furrows. The doctors repeatedly injected adrenalin, the recently discovered hormone of the adrenal gland. Yet my pulse, always constant and purposeful in better times, grew progressively weaker, and I floated into places far beyond my body. They gave me oxygen and then the morphine that transported me to memories of family homes in Ohio, all of whose rooms I seem to have forgotten.

Unvisited and neglected, those Midwestern chambers seem to reassert themselves, their memories demanding recognition and perhaps even understanding. I choked upon seeing my birthplace in Niles, the familiar wallpaper in shades of blue and pink leading to corridors that never relent. Other rooms, in Stark County, where I practiced law, marched by my head, most frequently in shadow, and paused only to evaporate. Finally came that small prism, not quite a room, where I consummated my marriage to Ida. It had closed windows and doors leading to staircases I was no longer willing to mount.

Around eight in the evening, my pulse disappeared, and this produced in me an inte-rior calm. Objects dear to my origins slowly encircled my body, resting only long enough to be replaced by the more recently familiar. Small dolls loved by the child still within me, rooted in the crook of my armpit. Then came lost articles of childhood: games, toys, marbles, sweaters left at the lake, ever the silences of small boys. Playmates appeared only to retreat as I reached for them.

Around nine, I fell into a deep swoon and the stillness of my shadows, all waiting in my bedroom, talked to one another. I felt insignificant in their acceptance of me as but another silhouette expelled from the crannies of lived life. In this nether world of being alive without movement, I found myself in a state of sleep but observing the hourly functioning of my organs. My heart continued to pump, but irregularly and with great hesitation. My wounded pancreas struggled to perform its declining functions, though I knew its impairment was drawing the whole organism to a full shutdown. This terrified me.

I am not alone on this slab. Why did someone place Czologosz's ashes next to me? By stretching my neck to the left and extending my arm, I can both see and finger his remains. But Leon's life force (I use his first name since we are now lying so close) is still apparent as I probe what had been his body. I still cannot pronounce his last name, which proves he cannot be mistaken for an American. He belonged to a social class usually despised: working, ethnic, Catholic or freethinker, and anarchist. Did he not publicly declare himself after he killed me? "I shot the president because I thought it would help the working people and for the sake of the common people. I am not sorry for my crime."

Leon's ashes begin to rearrange themselves in patterns. He looks like tea leaves preparing to be read. I study these markings with some amazement and so gain access to the unseen. I see a large shadow of myself in squarish silhouette, steadfast, a comforting president in an age of profound change.

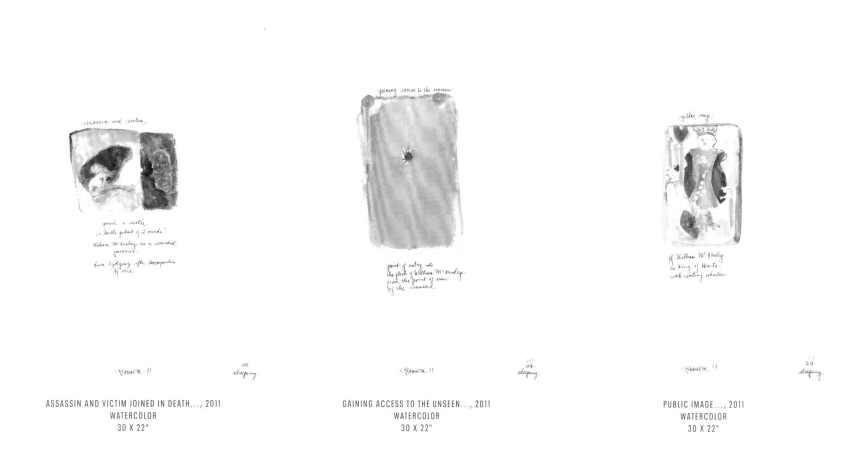

ASSASSIN AND VICTIM JOINED IN DEATH..., 2011
WATERCOLOR
30 X 22"

GAINING ACCESS TO THE UNSEEN..., 2011
WATERCOLOR
30 X 22"

PUBLIC IMAGE..., 2011
WATERCOLOR
30 X 22"

Each of us keeps our time according to internal clocks that dictate our choreographed steps. We all have natural limits on where our feet can travel. Mine are generous and open-hearted, with constrained movement outside relatively predetermined circles. I rarely moved to the left and keep my body comfortably in the center. But I worry I am being left behind, even though Leon seems out of step with the spaces he occupies. His movements, jerky and unpredictable, lash out in a paroxysm of anger and turbulence. American society executed the individual it had created.

And yet it was my successor who seems most out of step. He lunges far from this room, his vision settles on faraway possibilities. His legs seem to recognize that the place we danced, like America itself, has arrived at its natural frontiers, and he presses on to visit unknown shorelines. So we dance separately, Leo, Theodore Roosevelt, and I, mindful that history is rarely impartial to the beat within us.

24
CLEVELAND II
Indian dreams

1893 – 1897

I AM BACK AT THE WHITE HOUSE AFTER AN INTERREGNUM OF FOUR YEARS. Things are pretty much as we left them—except that electricity has been installed. Imagine Ben Harrison and his wife terrified they would be electrocuted! I watch the new lights flicker and cast shadows in dark and secret places I remember from years ago. We have vanquished the monotony of time and can transform night into day. As I did before, I move through those corridors as quickly as a big man can. My present discomfort is sparked by voices that are faint in half-light, becoming palpable and sometimes threatening in this electrified brightness. They accumulate and are no longer just those of the presidents who lived here. I hear angry shouts from Congress. More profoundly, I hear Indian songs of lament. They have moved in from lands far away, invading the executive residence and its mowed lawns, refusing to return to their reservations. Somehow, electricity has brought the outside world inside the president's house.

This morning, I journey the same corridors with a bathed body and full belly. As a newly minted husband and father, I am in so many ways satisfied with my lot. As I turn right and proceed north on the main second-floor corridor, I encounter sounds that echo in my head. I hear native tears and sadness and hushed voices, all rhythmically whispered. A wave of profound heaviness occupies my body. My neck, stalwart but kind, abandons its heroic role as a bridge between head and shoulders before it encamps deep in the cavity of my chest.

I gasp, spin around, sit on the floor to gain equilibrium, and my left leg begins to trace intricate patterns on the oak parquet. There, despite my girth, I turn my buttocks one-hundred-eighty degrees and proceed to trace heavenly shapes in the air with my right leg and left arm. I am concerned someone will see me and think me drunk, for my reputation has never been completely clear in that regard. Exquisite feelings come over my body, and I proceed to chant sonorous notes in the surrounding space. Hearing footsteps, I rise and move furiously down the hall and make a final left turn to rush into the ground floor of the White House.

All day, safely ensconced behind my desk, my feet (especially, the right one) return to tracing patterns on the floor. Ignoring the urgency of cabinet voices and congressional hectoring, my heart travels back to the second floor. Old portraits of my predecessors, rotten

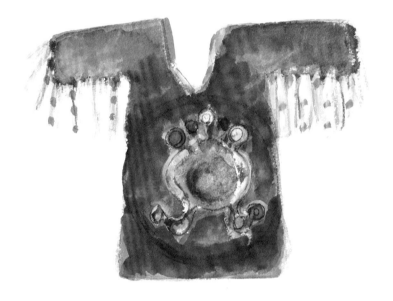

supporting the earth on its back.

Ransom 11

sleeping 24

SUPPORTING THE EARTH ON ITS BACK, 2011
WATERCOLOR
30 X 22"

with mildew and as dead as their subjects, look down on me. Beneath their beady eyes and dry mouths, the smell is inescapable. Here is a distillation of the lives of men whose decisions have shaped America by opening her frontiers. Doors open and close, and I see them come and go noiselessly. Will I move into their visions and share their destinies? Already my portrait enjoys the lines of succession. We sing of unfulfilled political power, the ashen bankruptcy of authority triumphing over enemies who include the weak and vulnerable. I have no desire to confront those who have been left defenseless, and I walk quickly and purposefully in other directions until I feel their oppression fade and withdraw.

I have gotten lost in this house that I knew so well only four years ago. My head takes wrong turns and encounters doorways that were not there before. I find myself in empty interior courtyards with faded light in labyrinths that cause me to forget why I ventured there. Perhaps I am seeking to reclaim myself. Or is this just a bad dream? Nighttime is now illuminated, and I walk more freely and feel less lost. I gravitate back to those places in the corridors that had originally caused me to pause—places where, in ways I cannot explain, I find refuge from the procession of sleeping presidents. I reach out my arms and touch the origins of America and those existences that dwelt long before colonization filled the land. Chickasaw, Choctaw, Seminole, Cherokee, and Creek. The names fill my head and make me dizzy. I turn on more lights.

In the middle of the night, images of these lost faces surround my bed. Rapacious winds, consuming fire and choking smoke spill like cherries from woven baskets. They witness the erased joy of what there was when no one could claim the earth.

Those who are "primeval, untamed and forever untamable," are now invited by a President to become civilized. They are in the way of America's western push and I do not in any way feel guilty. I want them to see themselves as individuals, freed from tribes, weaned from nature. One-hundred-sixty acre homesteads, a transcontinental railroad. Anglo-Christendom. I am doing the right thing. I am rooting out magic and the contagion of spirit.

I try to sleep, but the whole universe now breathes into my bed. The North wind brings death and the cries of children. I find myself on the floor now, far from my bed, surrounded by ears of corn. The new electric lights cast shadows that surround me and I hear sounds I do not want to encounter. I turn these images of fire, corn and clouds every which way so they will not be recognizable. I am determined to force all these heartbeats into a single pulse that will assure me of a grand America, where everyone is fully assimilated.

Can you stop the wind's blowing or the sun from warming? Can you sell the earth, clouds and water that were given to us all? Can you trade the lands that are a part of your body? Can you stop white men from coming?

honoring eagles

Ransom 11

*24
sleeping*

HONORING EAGLES, 2011
WATERCOLOR
30 X 22".

23
B. HARRISON
Blood dream with pencil

1889 – 1893

BLOOD RUNS THROUGH MY BODY IN WAYS THAT ONLY A POLITICIAN CAN UNDERSTAND. It starts in my prefrontal cortex, the part of my thinking apparatus that encourages calculations and strategies carrying reasonable chances of success.

This political blood makes me dream carefully. I always hold my head upright, not allowing any unforeseen tapping or shaking of the large receptacle, enclosing that with which I think. As a child, I allowed kisses as long as the fluid flowing to my head was uninterrupted. My family has always known that the delivery of rich and motivated blood, as long as it is not confused by excessive stimuli, results in a more complete dream state. My brain is like a muscle and can stretch when it needs to.

During my lifetime, I have been portrayed less like a real person than as a collector of automatic impulses grounded in an instinct for political maneuvering. I suspect this cavil is spread by opportunists who hear me talking inside my mouth.

I am dreaming now, which always encourages me to project into the future - not just politically but in larger spatial terms of efficiency and practicality. I count my fingers. The body politic that I know is indeed a body and, like those inventions you will one day call internal combustion engines, each part of our body corresponds with a mechanical component that assists with forward motion.

I have discovered new forms of my own existence. It started with my pencil, which did not seem capable of keeping up with the duties of my office. Frequently, it lay unused near my blotter, especially during those moments when I felt unappreciated as my presidential term came to an end. My pencil's embedded eraser was mostly used up, and the wood around it loosened and discolored. Its lead point was stubby and needed sharpening; it left a soft emasculated line, more of a smudge than the shapes of sharply delineated language.

It was made in Waterbury, Connecticut and lived in a box with eleven cousins, all tall, unsharpened, and with manly erasers. I mean the pencil was manufactured in Waterbury; I was born in North Bend, Ohio. I liked to use this pencil to poke around in my beard, gently clean my ears, and, when not observed, suck on its top. While my political party was gradually abandoning me, the pencil seemed loyal and constant, and I adopted it as something special in my life. Indeed it was like an extension of me. Maybe it is that side of me that most reminds me of my self-discipline as a zealot on behalf of my family and party, which may well be the

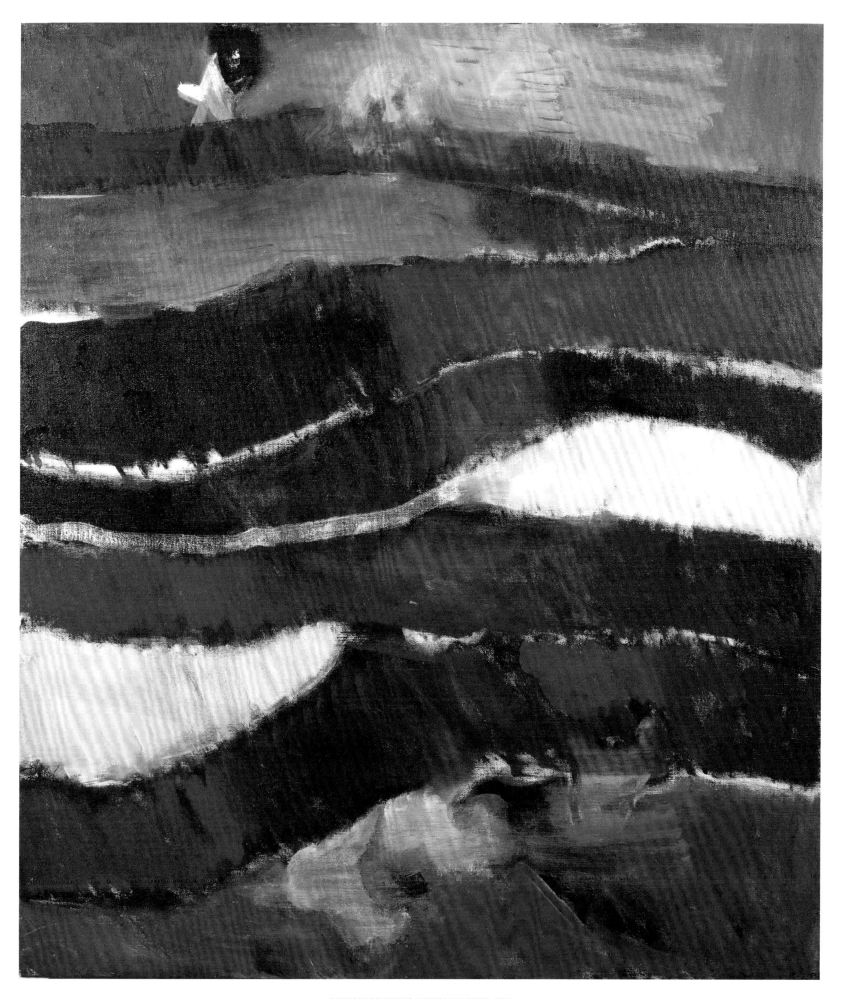

HARRISON COMBINING AMERICA AND TOUCH, 2011
OIL ON LINEN
46 X 40"

same thing. The pencil is me, and its present state of inertia reflects the fullest expression of myself as a politician and statesman.

I have picked up this still functional dimension of myself and set its point on a fresh sheet of paper. I begin with familiar diplomatic language couched in obscurity, then pick up speed and cover the whole sheet with detailed descriptions of ingratitudes directed to my person by former allies. At the top of the second page, the pencil begins to write on its own, leaving Congress and the presidency far behind. I give it freedom, and it starts going to the shadows at the back of my mind. I give it even more latitude, and it transcribes visionary images that return me to early childhood's sense of freedom, solid ground, and unrestrained joy. All my senses take on new intensity. Through words, I become a noble child, and new feelings overtake me. The contours of absence disappear, and I no longer mourn what I didn't even know I had lost, but what I have nonetheless regained. This renewal elevates the process of searching for those traces of childhood, all the forgotten remnants of a lost existence: the silent words, stained clothes, faded photographs, abandoned toys that were once my treasures. I try to engage memory and find it incomplete. Only at night, when the pencil sleeps, when dreams become visions, can I connect with the world of touch long forgotten, forever changing, and often mute.

My pencil writes of matters I did and still do not understand, and I hear its scribbling from the next room. Since the pencil is me, or at least some insistent part of my existence, I need to discipline its excesses if I cannot fully control it. Am I responsible for its paroxysm of voluptuous descriptions of overgrown white breasts pleading to be touched? Have I ever sought a limitless free fall of skirts that opened their pleats to offer the warm secrets of swollen intoxication?

I have left the presidency a widower and moved back west. In Indiana, my wife's niece and I have married, and her caress brings all the gradations of pleasure, the increments of exquisite enchantment leading to her release and then my own little death. My newly hot blood carries oxygen to all my tissues, which at last take the shape of my own body, leaving machines far behind. It makes its continuous journey, round and round my body through arteries, veins, and capillaries. Returned to red, it feeds my heart. I have become more fully human. I don't recall what happened to my pencil.

the body politic

political thinking

THE BODY POLITIC, 2010
WATERCOLOR
22 X 15"

POLITICAL THINKING, 2010
WATERCOLOR
22 X 15"

22
CLEVELAND I
The naming of parts

1885 – 1889

I HAVE TWO HEARTS. This predicament is not rooted in any natural imbalance but because I am experiencing a transformation from a presidency past into a presidency future. I feel the gap between. This alteration affects more than my notions of politics and policy. I am changing, and my hearts expand in size, deepen in color, and alter their shapes. No one tells me this. It's my body. I know.

Uncle Jumbo to my family, I am a big man of seventy-one inches and substantial bulk. I fluctuate between two-hundred-fifty and two-hundred-seventy pounds. Awakening at dawn, I survey the world's offerings. These likely include a celebration of steak and onions, succulent wild game served on toast, fried oysters, and sometimes tasty tripe. I like to think of all edible creatures happily surrendering themselves to my plate.

My large wooden bed, tangled blankets, and yawning flannel sheets beckon, and I always accept the invitation. I have never been without partners. In bed, I am safe from life's demands. Have I ever felt young? I wish I had learned to move freely, to dance, or to laugh. In lovemaking, my heart takes over its own rhythm and banishes the strange hand that tries to control it.

I enjoy feeding my private parts, stretching and encouraging them to explore when night prevails over. They have taken on the sweetness of youth, and when they perform, they become my friends. I will introduce you to them individually, because even though they work together, each remains unique.

In the lowest part of my scrotum is the tail of a coiled tube that resides at the very edge of each testicle. There, at cooler temperatures, sits the epididymis, where my sperm is carefully stored in preparation for delivery on command. Many times in the night, engaged as I am with self-expression, I draw on this bank account whose contents always increase as interest accrues. I call this friend Ralph.

Knowing that I can count on my savings to be delivered with dispatch, various well-constructed tubes deliver stored sperm to my ejaculatory duct. Here is a most remarkable friend named Ron. He is exquisitely positioned—much like a bank manager at the very terminal where my bladder ends and my prostate begins. Trained well and with his good sense of timing, Ron knows to close down this juncture during lovemaking and open it when it becomes necessary for waste to move from bladder to urethra.

GROVER CLEVELAND'S TWO HEARTS, 2011
OIL ON LINEN
46 X 40"

With Ralph and Ron as committed colleagues, my mattress became a spring landscape forever unfolding. Nature is defenseless against my well-armed body when my pleasure combines with my gift for life-giving. I feel the hand squeezing my heart withdraw when confronted by the vital functions of subduing and coupling. It watches from the outer edge of my bed. The scars of my youth can be quickly overshadowed by the imprint of female lips on my chest, shoulders, and heart.

My periurethral glands create clear fluids that anoint my urethra so that my accumulated savings can make the journey from my engine into a larger world. These glands, whom I call Marlene, are like friendly bank tellers who direct my interior traffic. Marlene's sister gland, Pippa, my seminal vesicles, manufactures my life forces along with prostatic fluid and sperm. Over-drafting my account leaves Pippa overdrawn, and she closes her window – requiring me to wait a day for my deposit to be credited and spent.

Not having fulfilled my task, I catch my reflection in the individuality of my partner. Ladies I have loved frequently have left their shadows behind. Strands of black and brown hair (rarely blonde unless artificially so) hide in the folds of my blankets, clinging even after laundering. Their animal smells congregate in other hidden places, only to emerge and haunt me at unexpected moments. Barbara, Marilyn, Paula, Mary. They fuse with one another, creating not composites but indistinct images. All the more reason to opt for the easy availability of hired love with clear compensation.

The early sun cuts through the mist that hugs my bed, freeing me of my father's passing shadows. Beyond the half-opened window, sycamore trees, opulent and flush with sap, reach their trunks, branches and leaves to reach the sky. Ignoring the assaults of wind and winter, and bleeding from unhealed lesions as if for the first time, I feel my own body.

I enjoy this image of straining beyond my limits. I smile when I think that my great weight is an expression of my wanting to be more than I am. I know my father, a gentle man of God, saw himself in me. His defects of belly and legs, neck and shoulders are exaggerated in mine. I long to run away, to go underground, to be unseen.

Since my father's early death, everyone in the family looks to me, and I, who never knew what it meant to be young, hack my way through all kinds of obstacles to keep my equilibrium. The possibilities of early defeat easily affirm my own inadequacy. For me, love is a perilous birth, an unredeemed duty, and I pine to slip back into a winter sleep free of obligation. From the window, I watch the measured opening of a chestnut bud and find more value in that resurrection than in the mystery of my own sap.

The shadows are lengthening as a continuous downpour mixes mud and leaves, making a curious brown fog. The skeletons of once luxuriant shrubs and vines shiver, witnesses to the onslaughts of late autumn, as I probe the faces and bodies of those creatures lying next to me. I trace with my finger the persistent work of nature's destructible forces, the thickening of waist and limbs, the tiny lines beginning at mouth and eyes.

I lie now in the half-light of my bedroom, which illuminates even further the destruction of the gifts of youth. I understand this (in some collective sense) as a long journey on a road too familiar, one traveled so frequently that all the recognizable places are consumed by time. The tears of loss remain my night's companion.

the memory of those who hung
from my shadows.

Ransom 11

22
sleeping

THE MEMORY OF THOSE WHO HUNG FROM MY SHADOWS, 2011
WATERCOLOR
30 X 22"

21
ARTHUR
One dry tear is all you need

1881 – 1885

THERE WAS GENERAL LAUGHTER WHEN I BECAME PRESIDENT AFTER THE ASSASSINATION OF JAMES GARFIELD. "Certainly not Chet," they said. I press another pillow on my head and pull the wool blankets around my shoulders. I hate cold sheets.

What would you do? You hope to become fearless when you have nothing to lose. But the habits of avoidance are strong. Fear is an old friend who lives in my toiletries when I shave and dwells in the pockets of my great coat when I mingle. I know her presence. She sits on my headboard. Do not ask if I am sure when I say she. Fear is female. My wife senses her occasionally, but she is long dead (my wife, not fear), and I am alone for the most part when I sleep. She is with me now as I get inside my wool blankets, where I am safe, allowing only a very little of me to be seen. I have discarded my pillows, and they have taken up residence on the floor.

The machinery of American politics is well-oiled, and I am one of its engineers. We only rarely consider the big ideas of equality and freedom these days. More often we turn to serious concerns more easily addressed, ones like ensuring ready supplies of food, housing, and transportation.

The system is as corrupt as it is efficient. Efficiently corrupt, I like to think, but I am not personally dishonorable or feckless. I wink and smile, cajole and follow. I am adept at looking the other way. I craft deals and shape strategies. Do I not open my arms and penetrate the thick smoke of misrepresentations to secure the resources my party needs? The Republicans are my family, and I know everyone who plays in my yard. I watch those who manage society for profit. Long lines of them march around my bed. If I am not a leader, I am a pivot. I coordinate their actions and get things done.

To accomplish anything, however, one must work from a place of enclosure and safety. To this end, I admire to see hair dancing on our Republican faces, the fluffy and elegant sideburns connecting trimmed mustaches to beards, the symbols of masculine power and virility. To shave or cut these glories is to humiliate, to perform castration.

These tufts of hair are a pledge, a token of collegiality and trust. Male heads require security, a veiling of sorts, for inside are countless secret drawers, one inside the other, some holding multiple compartments that can expand and contract to hold the deals we concoct. Baldness is rarely tolerated in our party. When encountered, we vigorously apply

MY ECLIPSE, PANEL 1 AND 2, 2012,
OIL ON LINEN,
60 X 92"

traditional formulations like pulverized snails, horse leeches, and salt. Some say the culprit is no more than a dirty comb.

I am so tired of the endless march of office-seekers and makers of public policy. Their tongues are furred and quick moving, fully capable of creating or destroying men's lives. From the very moment of birth, this talented taster begins expressing what is within us—whether dark or sunny. I have noticed that despite our thousands of taste buds, we use our tongues only to differentiate between sour, sweet, salty, bitter, and some quality I cannot quite define. I suspect that hummingbirds and possibly anteaters, given their prodigiously long (and quick!) tongues, have a greater capacity for complex flavors...

Then it happens. I awaken from a dream about lamb chops and blackberries, not matters of state, and I am called on to prepare myself to become the twenty-first president of the United States. I have never been elected to any office except the vice presidency, which as we all know is ceremonial. So expectations about me are low, to say the least. And I am reluctant. Since my body is being progressively poisoned by my own digestion, must I still rise to the occasion, disown my closest friends, put aside all that I have been, and meet this so-called obligation just to become admirable? Then, below the delicate horizon of my own well-fed life (robust and dutiful), I am becoming conscious of certain echoes, new voices (or sounds that might be voices). These exaltations begin to take on a clear and rippling shape, promising a well-proportioned harmony of expanded dialogue will fill the moist air of my morning. I am bathed in admirability.

Facing death, as I am, but still enjoying a comfortable life as the quintessential spoilsman in a system that I helped construct and perpetuate, I am not ready to dream new dreams. No one ever expected me to be president, but even more, nobody ever saw me as a potential advocate for change. I am a gentleman—fair, decent, playing by rules that are admittedly in my favor. I am modest and kind. Someone you would want to know.

I roll over and assume my favorite position, but now my right leg (at least most of it) is pulled up and rests comfortably over my heart. The sounds that seem so harmonious have penetrated my bed and are working their way into the fortress of wool blankets surrounding my limbs and trunk, but I leap off the mattress before they envelop my head and cover my influence. In an age of less-than-profound expectations, am I not more than adequate? The director of the chorus, if never the lead.

I make myself cry, hoping to convince myself that what is asked of Chester Arthur is but a delusion, vague sounds in the early mornings to create the myth of redemption. But I am reluctant and cannot now claim honesty since I am shedding tears, copious tears, to communicate feelings I rarely possess. In the business of party politics, one dry tear is all you need.

My bed has grown cold and heartless because my blankets are on the floor. Even this place of rest, it seems, conspires to make me do more than I have ever contemplated. Why do we seek greatness in our leaders and then find them wanting? Is it not enough that I am a decent, albeit reluctant, man of my time? I am neither loved nor feared, but I am also never hated. If I don't inspire, I do the best I can in a bad situation. Are not men their own hell or paradise, to be shaped and crafted like sounds in the night, for matters large and small?

I was reluctant
but never hoped to be forgotten

Ransom 12

21
sleeping

I WAS RELUCTANT BUT NEVER HOPED TO BE FORGOTTEN, 2012
WATERCOLOR
30 X 22"

20
GARFIELD
Dying shapes my dreams

1881 – 1881

IN MY SICK ROOM, I INSIST THAT NEAR ME BE A PORTRAIT OF ROSCOE CONK-LING, ONE-TIME SENATOR AND HEAD OF THE NEW YORK STATE REPUBLICAN PARTY, MY ENEMY. Why? Is it the act of someone dying, someone delirious? Or is there some darker force that demands the presence of the sneaky, pompous, vicious Senator Conkling? I wonder if I am perhaps a *poor hater* who regrets my feelings toward him. Is that why I keep him in a pearl frame on a small table near my sickbed, a large intricate contraption higher than most beds, designed for the ailing?

I love my body, especially my legs, their proportions, their four equal sections. I like that one-quarter of my body extends from the soles of my feet to the bottom edge of my knees. With an imaginary ruler, I measure the second quadrant from kneecap to pubic fluff. I am half legs, the other half divinely proportional pieces of half and half again. Since early manhood, I have known that my strong legs are anchored by eight exquisitely crafted bones: long and chiseled femurs, kneecaps, shin bones—my favorites—and splint bones, appropriately named fibulae.

Lying in bed with a bullet dwelling in my weakening body, I still take pride in my legs. They are noble in their practicality, beautiful in their strength. Before becoming bedridden, when nobody was looking, especially not Dr. Bliss, I kept them shaven, for they suggest my virility. Now, I have little to focus on in my pain, but my still-healthy legs provide the promise of hope and future locomotion.

I pitch forward to release what is still releasable. Looking at my bedside portrait of Roscoe Conkling, I discover a curious shadow across the left side of the senator's face. Between tastes of one teaspoon of rum to four ounces of milk, I have two hours to study his countenance. His clever determined eyes, arrogant if not contemptuous, look back at me. And so we stare, enemy at enemy. He is out of focus, and I study his light brown hair and the cheeks of a self-conscious warrior. A single curl, almost blond, dangles obscenely on the white flesh of his forehead, coaxing me closer. If that were not enough, Conkling sat for this

death
~~sick~~ bed with bullet hole

Ransom 10 sleeping 20

SICK DEATHBED WITH BULLET HOLE, 2010
WATERCOLOR
30 X 22"

photographic wearing a bold striped tie to reinforce seniority and power.

His gaze grows discomfiting, and I have to turn away to keep any equilibrium at all. The shadow on the left side of the portrait grows as the hot August day proceeds. The portrait and shadow both seem oblivious of time and place. When I awake, the shadow on his face has increased in scope and intensity. Its cool darkness leaves the image of the senator burnished like an icon. A world beyond time. But by blinking repeatedly, I see that the portrait is not completely submerged; a ray of light cuts a sliver from the upper-left-hand corner, pierces the golden wisp of hair that had been theatrically and cunningly adhered to his forehead filled with bravado.

I read somewhere, perhaps in the life of Goethe, that many mammals can make themselves appear larger by bristling their hair to stand on end. Humans, though, have lost this ability for transformative display, and there is too much blurriness in the image of Conkling for me to determine if he possessed the tiny muscles that move hair in other animals but usually produce simple goosebumps in humans, evolution being what it is. But Conkling seems different, and I am certain his lock of brown-blonde hair moves, creating defenses on his wide forehead.

Screens and dark shades block the windows, so there is no longer any way to tell time except by the rotation of nurses. The apparition of Roscoe Conkling has grown completely black; gloom having obliterated his face, hair, and tie. Is there something larger in the portrait's eyes—one dark, the other light? No, I am thinking of my children's faces; the portrait no longer exists. Maybe it never did.

Dr. Bliss stands over me. He wets his right index finger with a generous amount of cigar-scented saliva and inserts it so gently into my still-open wound. He believes the bullet hit my twelfth rib about three inches to the right of the spine before angling down and forward to enter the peritoneal cavity, strike the liver, and find residence in my abdomen. But since he has not found the bullet, this is only a guess. Bliss probes and pokes, already believing that my yellow complexion implies a damaged liver.

Other scholarly fingers also probe the bullet entry. Surgical apparatuses of the latest invention join the search. Infections—multiple and nasty—overcome me and create rivers of yellow pus and bloody green mucus that empty into my mouth, ears and nose. I choke, gag and vomit, but the probing of curious fingers and drainage tubes goes on.

I have come to think of my old adversary by his first name and find myself looking at him more often. Images can take the place of institutions, individuals, ideas long lost or buried. My own portrait no doubt provides an opportunity for strangers to catch my wit and even sensations lost to consciousness. Cannot any man unite his own flesh, his own dreams with some larger circumference connecting us all to what we admire? How do we speak beyond the grave? Can you do battle with a shroud?

I turn and am dismayed to find Roscoe's image still missing. Has engulfing shadow caused it to evaporate? I am bewildered without it, but that is fine, for I am accustomed to being lost in sleep, unloved, under-nourished, and alone.

death bed freed of corpse

Ransom 10 *sleeping*

DEATHBED FREED OF CORPSE, 2010
WATERCOLOR
15 X 8"

death in quadrants

Ransom 10 *sleeping 20*

DEATH IN QUADRANTS, 2010
WATERCOLOR
15 X 8"

19

HAYES

I am my whiskers

1877 — 1881

I AM THE NINETEENTH, THERE IS NO DOUBT ABOUT THAT. When I was elected, yes, there was doubt because I just sort of squeaked through. I store all those insults I have had to endure in my beard.

Over the years, as my facial hair grew, deep recesses evolved within its fullness. Like pockets, they prove handy for thoughts and feelings I do not want to deal with. My hair grows fastest in warm weather, a sixteenth of an inch a day, just under six inches a year. I have patiently studied the individual hairs on my left chin and can attest they live for about thirty inches (or six years) before they fall out.

But I generalize too readily. Each of my hairs has its own personality, and this affects its growth cycle. As ninety percent of my beard grows, the remainder lies inert for as long as four-and-a-half months before exiting my face. The total individuals I shed number around sixty-five a day. I do not worry. Replacements stand ready, and I estimate that each papilla repeats its biography at least ten times. Thank God I have never experienced hair loss...

In July of '37, when I was fifteen, wayward hairs began invading the corners of my upper lips. They multiplied rapidly that summer, so my entire upper lip was soon populated by wavy black fuzz. Soon after, sprouts appeared on the upper part of my smooth boyish cheeks and within the shadow of my lower lip. They spread, and plucking them was no longer an option. But a razor seemed an unnecessary and extreme response.

By the time I entered college in September of '38, they began to spread to my chin and my lower face and neck. What does the beginning of a beard mean? I had long since left infancy and, even though fatherless, I saw the future as bright and welcoming. I was unburdened by the weight of obligation and still innocent to the pull of erotic interests. Yet my uncomplicated fascination with the complexities of life and my own self-interest had arrived.

I can easily remember the day when I attacked these hairs with the full force of razor (August 1842). It was an unbearably hot afternoon. I decided to wipe clean my cheeks, neck, and lips. The hairs resisted the first razor I applied. The flesh that held them was tender, and even though some had become wiry, the result was smooth.

Throughout the 1840s and 50s, my face was free of facial hair and my life good. My whiskers began to reveal mysterious white patches, most apparent just before I shaved. After finishing with the razor, I relieved the reddened surfaces with a concoction made for me by

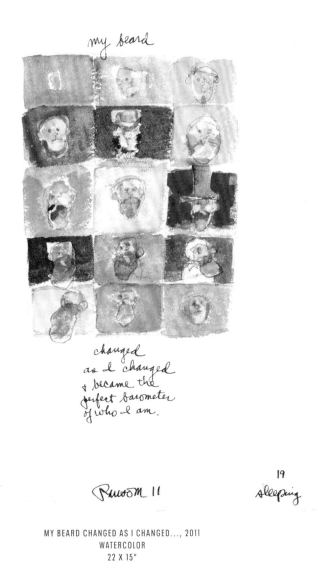

my beard

changed
as I changed
+ became the
perfect barometer
of who I am.

Ransom 11

19
sleeping

MY BEARD CHANGED AS I CHANGED..., 2011
WATERCOLOR
22 X 15"

my wife, Lucy. I rubbed it in assiduously.

In September of '61, I watched my cat Lucy (named after my wife) as she navigated life through her whiskers. She moved these highly sensitive appendages to find food and to investigate situations where sight was less helpful.

Karen is large, grey, and fluffy, and she always smells of milk. She possesses in her whiskers the capacity to measure subtle nuances in her environment. She can also use them to express her feelings and register her almost muted emotions. She demonstrates her anger (along with fear and impatience) by moving them so they assume oblique angles or, in extreme situations, standing on end.

Sadly, humans have only a limited capacity to move our hairs. But watching Karen, I have decided to do something about this lost art of survival and discovery. I learned how she uses her whiskers in various circumstances. With great daily discipline, I have begun to practice what I had come to understand. I let my beard flourish and express such extreme states as jealousy by

realigning my facial hairs horizontally. I am now learning to control the verticality of the hair at the back of my neck.

So now, In the 1880s, my face has become a nursery for experimentation, even as I pass through this terrible civil war as a proud son of Ohio. Quickly, I cultivate a small tuft of hair on my chin. I have kept the follicles housing these whiskers warm and receptive. I clip the hairs to discipline their rank and stature, shorter in front, longer and closer together at the rear. I encourage my chinstrap beard, which is accompanied by long sideburns that move aggressively forward and end under my jaw. I am good and ready, palpating my facial hair, a process known as whisking. I am ready for a larger life. . .

Karen is now long dead. But she remains my teacher. My brain learns to process newly discovered nerve impulses originating in my beard. Especially when I sleep. My response to external occurrences in my life, even the contested election of 1876, is transmitted by educated facial hairs through the trigeminal nerve and into my brainstem and thalamus before registering in the barrel cortex of my brain. I keep my whiskers open-minded, yet cautious. Necessary, if you find yourself number nineteen.

And so the *Book of Numbers*, at last, becomes clear to me: "There shall no razor come upon his head: until the days be fulfilled . . . he shall be holy. . . . and shall let the locks of the hair of his head grow." No longer can I doubt that shaving corrupts the image of God, for it defaces the image of man as created by God. My beard, growing more luxurious every year, has become an expression of godly wisdom. It is also a flag of masculine sexual vitality. My pride also extends to the symbolic virility of hairy body, chest, arms, pits, legs. I give my wife Lucy select hairs in a locket as a symbol of my surrender to enhanced life.

I feel rudderless. Dwelling in the level of existence between wakefulness and dreaming, I straighten my head and count the hairs that have fallen in the last eight hours. I collect and add them to my repository, a large wooden dust box in the Eastlake manner I keep stationed near my bed. The strands there provide a diary of my achievements as a public servant and my accomplishments during wartime service. There, near the bottom of the container, are the hairs spent at the battles of Middletown, Cedar Creek, and the skirmishes at Pearisburg. They speak to me of captured towns, brave men, and broken backs. These youthful hairs bore the brunt of hard but heroic living and are still stiff and soldier straight in their resting places. They call to me to comb them again, to caress them, and they cry upon recognizing me. I stroke them in their fallen state, and they create in me sweet memories of bloody struggle and the clamor of campaigns.

In the gloom of the box, even deeper than what seems like the bottom—as if boxes had cellars–my fingers probe hairs that lie as mummies shriveled with mildew and age. As I push my face closer, my beard (ever the student of Karen), discovers in the strong smell a marvelous distillation of the lives that long preceded the one I presently enjoy. My still-growing hairs exist as a compass, exploring and measuring prodigious levels of corruption and spent feelings to which I cannot connect and do not understand.

Poets warn us of the dangers of leaving written that which is badly composed. A man's beard can provide a crucial role in defining him. To punctuate my own public utterances, I employ my tongue so that it boldly jumps out from a patch of hair. It appears not unlike a penis. A shaved face is an emasculated face and leaves the tongue merely a tongue.

Politics is built largely on accumulated erotic energy that has been concentrated i n certain individuals or groups, blocked by factions, and redirected by controversy. This energy evolves, changes its

who am I
if I love
my beard?

Ransom 11

19
sleeping

WHO AM I IF I LOVE MY BEARD?, 2011
WATERCOLOR
23 X 15"

contours, and, like concrete, remains for decades once set. Our early political aspirations harden into cynical yearnings. I have based my entire political career, including my achievement of becoming number nineteen, on the power of my enhanced beard. It has taken me far. It will continue to grow after I die. Not only in this world, but in lives to come.

18

GRANT

Dreaming at the bottom of my heart

1869 – 1877

I RIDE HORSEBACK. I am not much given to walking. But today our battle has waned, and we take a short breather in which habit, if not tradition, encourages us to collect our dead and wounded. The number of fallen is one measure of success in war, and when we report back to the commander in chief—and inevitably to history—we tally. But numbers tell us nothing about the lives gone or the angels of death that hover over battlefields to husband the smiles of soldiers.

I dismount as best I can, falling twice. I fall again and grab hold of a sturdy limb to boost myself vertically and then cross some twenty yards. I step in spaces that, if not empty, are not crowded. I fall a fourth time. Then I crawl, out of breath, tasting blood and ash mixed with the exhalation of angels. Again vertical and looking carefully for clear ground I cannot find, I step on long silences and blurred faces without again touching my feet to the earth.

Before Shiloh became a place of struggle, it claimed one side of the Tennessee River: undistinguished hills of unploughed dirt, coarse and unforgiving, bare and unrepentant in their selfishness. Here and there, forest softens the landscape. With armies marching, Shiloh becomes Calypso's island of shifting surfaces and random reveals. The air presses down with a mixture of dread, restraint, and smoke.

Soon the landscape absorbs the thunder of tramping boots, and the terrain turns to fragments of human bodies and faces sprinkling the ground. The map of Shiloh no longer resembles the map we hold in our hands, and we adjust our perception, moving from farthest distance to the uninterrupted slide of death. Long black lines of the Army of the Ohio move in calculated precision, crossing and crisscrossing this poor ground. The earth trembles and grows long shadows, like unripe corn, of men maimed and grasping.

Interrupted by straddling rushes and the puddles of a stream, I feel the magnitude of death crushing me, and I weep. My tears mingle with theirs and draw a new map of Shiloh. One body twisted in final release will force the cartographer to redraw the course of the stream and level the inclines of topography now filled and flattened. Earth reaches out to reclaim muscles and bones no longer lithe and compact. It collects them, gentles them, creates

U.S. GRANT LIGHTNING STRIKES AT NOON, 2012
OIL ON LINEN
60 X 40"

still newer landscapes. Do I profane this still changing terrain by speaking and wandering farther than other men?

Death draws me down and examines me myopically. I stick my finger into the eye of the corpse nearest me because it can no longer see, and I weep once more, sharing my tears with those men who can never cry again. Songs identify the evils our nation has committed, and still more songs shout, "We have always been right."

I will not quit this republic as I found it. My eyes slide across earth grown dark in shadow. The violence of bullets has cut down small poplars, no more than bushes, shrubs incapable of resistance, bound by fixed feet, senseless to the overwhelming sweep of withdrawing life. No words come from my mouth to ease the grief of my heart.

I get up and stumble back to my horse, who whispers he is impatient to leave Shiloh. We once more move as one, in cold night and starless sky, frozen and emotionally immobile. Our bodies work together, forcing miles between us and what we have seen. Our strong, agile haunches and the sublime

working of our joints in tandem are so at odds with those abandoned skulls and bones still half-fleshed, that wait for dawn but are never to be men again.

I have travelled without a map or guide to places I have never been. If I turned right where I should have gone left, I never turned back. I always continue moving until I encounter an unmarked road that will eventually get me where I want to go, even if approached from the other side. I am about moving forward. I had not intended to visit the battlefield, but I turned right. Now I have arrived back at camp, which smells of metal and smoke.

I retrieve from my left breast pocket a heart-shaped metal box that I carry always. Inside it, my memories have crystallized as letters, humble objects and daguerreotypes in no particular order, but the earliest at the bottom. I wish to reencounter them, and my fingers go back in time, pausing at moments of ephemeral joy before being distracted by sadness. I am searching for a small piece of leather whose soft surfaces always calm me. Where is it? Rather than simply pushing my fingers deep into the accumulation of spent life to find its earliest record, I find myself going mechanically through each piece and feeling anew all the turbulence of unresolved living. Associations linked to bits of string, ribbons, lists of things to do, pages torn from books all compete for my attention. Some amuse me because they rooted so long ago; some become like amulets and plead for my captivation. A face, an outstretched arm, a voice reaches out to me. Some objects deny all feeling. There is a fragment of a letter (*I often think of you*) to Mary King, and a few brown hairs from my own Penelope, Julia Dent Grant. And a lock of chestnut sorrel hair from the mane of a horse I once rode proudly—it has so comingled with my wife's that I can no longer tell them apart.

I find memories that exist without the objects I connect to them. How can a memory of General Lee exist without a keepsake? Yet his mind, powerful and elegant in the art of war, seems still to swell within the left side of my heart. I cannot shake the ambivalence he fathers in me.

My mother's face, blurred and expressionless, occupies a small space under Lee's image of gentility. I do not have to reach for it to know it, loving in its way and accompanied by neither touch nor heard laughter but by a great and unshakable sense of purpose. No object can define her, no emotion describe her, but her presence holds strong.

You will not find bits of lace, cameos, or perfumed handkerchiefs in my heart. Neither does it contain many tears or witticisms. But wait, in the darkest recesses of this metal box (which has seemed to grow larger with time as its content increases), you might encounter saltless tears. Here I see Black Julia, my wife's slave, who was less a slave than a servant (as white Julia liked to call those she owned). Here, both seem less people than distant extensions of their owners' worries, receptacles to be filled with feelings forbidden, thoughts unrequited. Black Julia hides in a corner she has made her own, unhappy and happy, unfulfilled but content—a measurement of slavery when I grew up and it prospered.

This small tin box, varied in its overflowing emotions, appears upon closer scrutiny a poor place for letters. The humidity of battle and the acrid smoke that lingers have caused many of the missives there to curl and brown. But those remaining sing the best side of me, times my consciousness expanded and yet remained whole. When I am writing anything, my silence sometimes commands me to leave large blank spaces— expressions of clarity that move me beyond speech, grammar, and army regulations. In spots, the silences expand, pushing aside the brief scribblings emerging from my heart. Then vertical blanks welcome the eye and invite the reinforcement of subtexts. To rein-

LANDSCAPES ARE DIFFERENT WHEN DEAD PEOPLE OCCUPY THEM, 2011
WATERCOLOR
30 X 22"

THIS LAND BLEEDS WITH EACH BLOW..., 2011
WATERCOLOR
30 X 22"

force equilibrium, you can stare into and negotiate with these spaces, as if they were horses' eyes. When I write, when the words combine to express emotion, it is possible for you to follow the sentences of my mind. I think with my writing paper, but my quick pen becomes easily dissatisfied, forcing me to cross out large sections in order to substitute what feels truer. If you can make out what is deleted, you can move from the crudeness of my first conceptions to the truth of my last.

Finally, at the bottom of my heart, I find that simple piece of leather on whose shape and finish my father and I collaborated. Here is the remnant of the lime solution that soaked and softened the hide before fur and flesh could be scraped off. Permeating most everything is the continued stink of sulfuric acid and the oak-bark sludge that cured the leather. These smells, that once permeated

my own skin and hair, still mingle in this scrap with the tallow and fish oil employed to make the leather supple (but which also bleached my skin).

Overpowering all these odors of death is the image of my father, Jesse Grant, who shaped this leather as he shaped his son. With love he washed and rubbed the marinated skins as he guided and shaped my green mind. I know I have no need to keep this fragment of an existence I long ago surrendered. I have his example always. But my memory requires objects to strengthen its hold. That is why I will leave at the very top of my crowded metal box, which I will always carry with me, this bit of leather.

17
A. JOHNSON
Dreaming with only one sleeve

1865 — 1869

MY LIFE BECOMES AN UNCEASING STRUGGLE TO DISTANCE MYSELF FROM CROWDS THAT WOULD DESTROY WHO I AM IN ORDER TO MAKE ME ONE OF THEM. Indentured at age ten to a tailor, I never learned simple, intelligible words. Nightly, I am visited by the ghosts of all those garments I have stitched. They sit on me, restrain my hands, puncture my fingers with tailor's needles. When they perceive I can still breathe, they wrap me in bolts of cheap cotton cloth, like a mummy, dead by all appearance. Little animation shows in my eyes; my struggle to move upward and away has sealed my stubborn determination within a world that asks me to pay for my mistakes before I make them. Resistance etches itself in my face. No wonder my clothes have never been finished, that I find myself forced to make do with only one sleeve.

The crowd follows me. Other ill-wishers join its ranks. They become one in purpose and destination. I struggle. I try not to fight against the flow of history and memory against my own body.

I am a drunk, they say, but there is little public evidence for such claims. I do, though, have a chronic gastrointestinal infection, a kind of permanent, but intermittent dysentery. Even when I drink small amounts, my intestines revolt, and I appear out of control. Crowds of both friendly and unfriendly bacteria occupy my gut, and they have a collective brain of their own. This network of nerve cells shares the basic architecture of my larger mind. My anger shapes the configuration of my intestines through a kind of resonance. The canals inside me burst with indignation and denial.

My hands are a different matter and also seem to have a mind and memory of their own. Awake or asleep, they follow their own course and remain unresponsive to my will. They do not like to be gloved but left free like my mouth speaking in fresh air and sunlight. This has caused me undue anxiety, not unlike the crowds that press upon me.

They say I cannot write and should have others do it for me. Little do they know I compose in a small room on the second floor of the White House, a space unknown to all, even my wife, who is often indisposed. I scribble large thoughts on the east wall, a diary of lost memories and dashed hopes. I have etched the litany of forgotten vocabularies and abandoned words that began to express who I once was, and lead me to rediscover a childhood I can no longer experience, let alone convey.

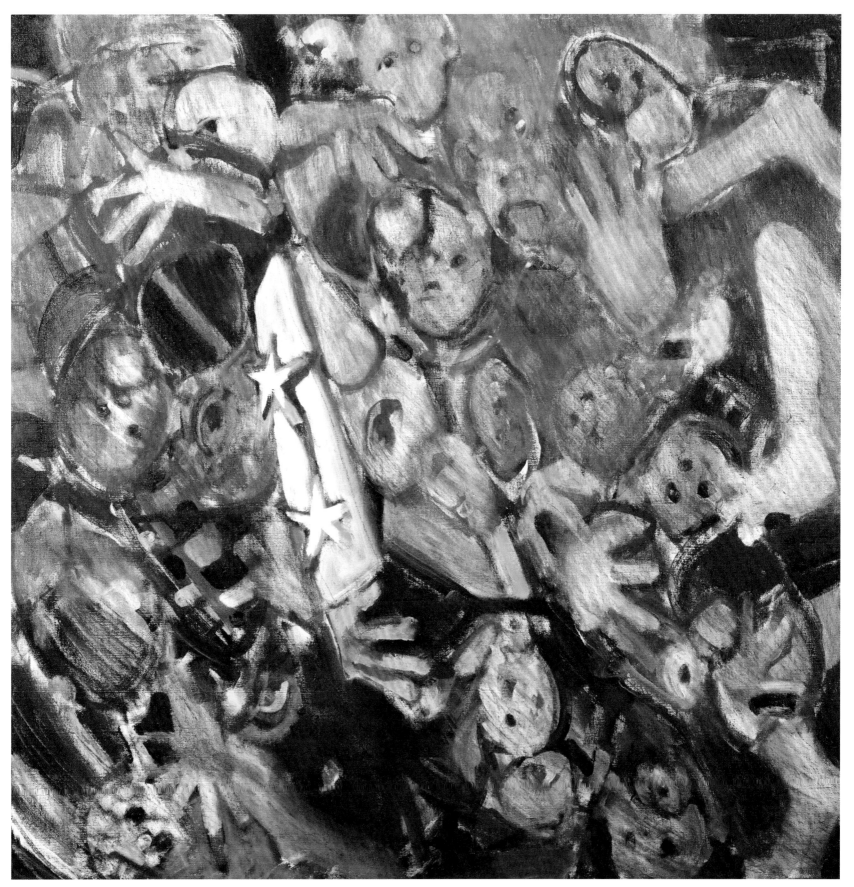

ANDREW JOHNSON CROWDED, 2011
OIL ON LINEN
50 X 50"

The boy in me steals the narrative and borrows the vocabulary and syntax that he was never taught. He conspires to tell his own story through the young flesh of a time when he loved himself enough to enter into his own skin and bones. He struggles against death, and he colonizes and jettisons those parts of his body that have oppressed him. As I become myself, I discover renunciation. I feel my own skin, reluctant muscles, feeble bones and slowed gestures in uncertain balance. My body's long center and its attached emptiness engulf my stomach and hands, that don't always know what to do.

It is a damn poor mind that can only think of one way to spell a word. You laugh at my lack of education, but I do not need training to think and act clearly. I am a child of my time, and I grow along with it. I have learned the art of obstruction, thwarting the execution of the laws devised by Congress. When they prevail over my veto, I starve their enactments by not implementing them.

I drift in and out of focus. Determination makes my whole life memorable. My pointlessly long torso holds my veiled child-

EVEN AS A FRAGMENT I SURVIVED, 2011
WATERCOLOR
30 X 22"

hood and distinguishes me from the crowd, which would break into even this small, until now secure, place in my existence. My clothes are never finished, and I still live with that smartly tailored sleeve that has no companion. Can you tame someone's soul? Must you measure their whole body?

I have locked the small room at the end of the corridor at the southern end of the White House. I am sure it will remain that way for generations. I have also stopped worrying about my missing sleeve and have instead sewn an American flag with thirteen stripes and thirty-seven stars. The gradations of red, white and blue vary. I frequently wrap myself in its gentle folds, always taking care that the stars shield my heart, the stripes my vulnerability. In this garment of America, the stitches of my handiwork reveal my loneliness, my sadness, my oppression. With the Constitution stitched into a majestic pillow, I imagine a childhood less base and humiliating. Did the indenture of my body indenture my thinking? Is that a paralysis that can never be healed? Leaving hate to the crowds, I dream on.

CRUSHED I PREVAILED OVER THIS MOB, 2011
WATERCOLOR
30 X 22"

16
LINCOLN
Dreaming Mary and her apples

1861 — 1865

MARY IS QUIET. Only her measured breathing interrupts the silence of our bedroom. I awaken in the middle of the night but fall back into dark dreams. Tonight I taste apples. Not Spitzenburg or Yellow Newton Pippin—old-fashioned apples we counted on in Indiana when I was young and hungry. Not tonight. No, I leave those old-fashioned fruits to memories and seek new ones. Black Gilliflower: large and oblong, often ribbed, a deep black red when ripe, waiting to be baked. And I taste Wagener for cider, red over yellow, crisp with pungent flesh.

I smell the sweet skin of my boys, like apples, tart and round. Eddie, Willie, and Tad. The scent of spring pervades their play. They ripen when the fall sunlight fills the air and their characters open to me, their steadfast gardener. Mary counts the ripe fruit daily. She makes applesauce and pie of their juicy abundance to still her boys' excitement. She is certain the best recipe for apple pie calls for three different kinds of apples.

 1 Cox's Orange Pippin
 2 Tolman Sweet
 2 Jonafree

Eddie was our second, and she saw him as a compote, a Cox's Orange Pippin, medium size, in red stripes over an orange background, ripening in late September, crimson tinge from cheek and lip, forever wormless. Willie was full-bodied, warm-hearted, and never still—a flush of bright stripes tinted in every possible combination of green, yellow, red, and pink. A Tolman Sweet he was. We enjoyed him when we could. Despite his crisp juice, he was vulnerable to scab, powdery mildew, and at the end, fire blight. Last of our three was Tad, a Jonafree, a gigantic head with a tiny stem, ripening from August into late October, throwing open his arms and encasing us in an embrace much like the tree whose fruit he had become. His flesh was crisp with cold hardiness, dark red with a blush of green. A delicious tart jelly with a pronounced stutter.

I push closer to Mary. Her slumber has been interrupted by groans and small cries. At night, she visits robust orchards and climbs ladders planted firmly on soft earth to reach those apples that pull away from her touch. She persists and captures them, but loses them on her way down. She knows her own and cries when her deciduous favorites are not within her

ABRAHAM LINCOLN ON FIRE IN SMOKE, 2012
OIL ON LINEN
46 X 38"

reach, laughs when they are, is sure they are all perfect, and then loses the fruit forever, even those held fast in her apron pockets. She fears to be alone.

Apples reign. Whitney crabapples in the far side of the north orchard. Sweet Bellflower to the east, near the fence that separates the fertile earth of creation from the cement of an industrialized city. Jonathans in a grove isolated by changes in the course of the river that divides those trees from the rest. There the self-pollinating Winesaps are reflected in Mary's eyes.

And Robert, our first? I cannot touch, smell or taste him as Mary can. He looks like Mary and plays her roles, but I sense he is one of those men without fathers. Robert never entered fully into my heart. In that way, he was like my father. I never buried my father. I never brought his grandchildren to him. Yet when I see him and reach to touch him, I see Bob, for like Bob, my father was fatherless. A prairie crabapple, native to America, dwarfed in cultivation. Sometimes thorny, the tree bears sparse yellow and green fruit.

When my father died, I could not remember his ever listening to me. He remains a broken memory, a small story told by my mother, like crabapples picked before ripening and not worthy even for applesauce. I was chased into the accident of my own birth, as I am certain Bob perceives his own. Robert's heart, now part human and part apple, is an island off the coast of Mary.

Mary is awake now. Entering more fully into grief, she leaves our bed to encounter a world no longer tolerable. I take over the place she occupied, and I intrude upon her cold unfinished dreams of Tad, Eddie, and Willie, apple pie crafted of three kinds of apples. Bob is nowhere to be seen; she has taken him, never motherless, in the pocket of her apron.

Though he is never near me, is it too late to include Bob in my life? Was there ever a time he might have been mine, that I might have enjoyed him? My heart is large, and my arms are long. Mary is near him even when he is not with her.

I dream of America and feel helpless when I see her—red, orange, and black— not firm young apples but blood, fire, and smoke. How can I quench flames that bear destruction but are necessary to our humanity? Cider, apple jelly, and apple pie all fuse in my mind with the trees that bore them as fruit. And I become strong wood, roots, and leaves, giving them, and perhaps even America, the life they know. I would have it this way. But what of Bob? He remains in his mother's pocket, so carefully sewn for another life.

storing stars and
green apples

to absorb nature's silence
I wrap myself in red apples,
reddest nearest my forehead
stems astern
always round
I need not be seen
only tasted

Ransom 11

Ransom 11

STORING STARS AND GREEN APPLES, 2011
WATERCOLOR
22 X 15"

TO ABSORB NATURE'S SILENCE I WRAP MYSELF IN RED APPLES..., 2011
WATERCOLOR
22 X 15"

15
BUCHANAN

Waiting to daydream

1857 – 1861

I USUALLY SPEND THURSDAY MORNINGS WAITING FOR IT TO ARRIVE. Like most of what appears in my life, it is fairly punctual, although it all depends on what I have been eating and what emotional stress has surrounded my office as the fifteenth president of the United States. Usually, I try to remain calm and just let it happen. I know full well that a hurried response (under strain, if you will) might delay the outcome and make me wait until the time I plan to devote to other matters. But this morning, I am calm, open, receptive, and making very certain that we are not disturbed. I remain in my fashionable paisley dressing gown from Paris. I have spread all the newspapers out in front of me to distract my forced patience.

As I wait, I am visited by a large ladybug. It lands on my bare left knee. I study the insect carefully and see that she, like me, is also performing a kind of ablution, extending little black feelers here and there, grooming and shining her red-beetle covering and its scattered black dots. Since I am waiting for another arrival, I don't grow restive but observe her for a long while. It reminds me of Congressional sessions or Cabinet meetings when the participants take an inordinate amount of time grooming ideas that appear as extensions of their selfish bodies. Always, I observe.

I remain seated, waiting for my digestion to kick in. I observe my room, full of papers, knowing where every document I might need resides. Then I carefully survey my body. I slip off my dressing gown and study my individual parts much like a cartographer would pour over his maps. I am not too friendly with my body, having sensed early that it is open to aging and decay, if not first disease and debilitation.

My chest is large—almost too big to contain the tiny heart that beats quietly in its appropriate house above my lungs. This heart has never been seen by anyone, nor has its regular, predictable rhythm been detected since I grew beyond my mother's holding me close.

My eyes don't work together, and as I walk on Pennsylvania Avenue, I keep the farsighted, hazel one shut and let the blue, near-sighted eye direct me to my destination. I look down to avoid stumbling and to provide my shyness with a place of refuge. My eyes wander through different perspectives. Have I not been accused by Henry Clay of staring at him when I am actually looking the other way? This is probably his political paranoia. Or mine; he likes to make fun of me. Do these conflicting visions say something about the inability to

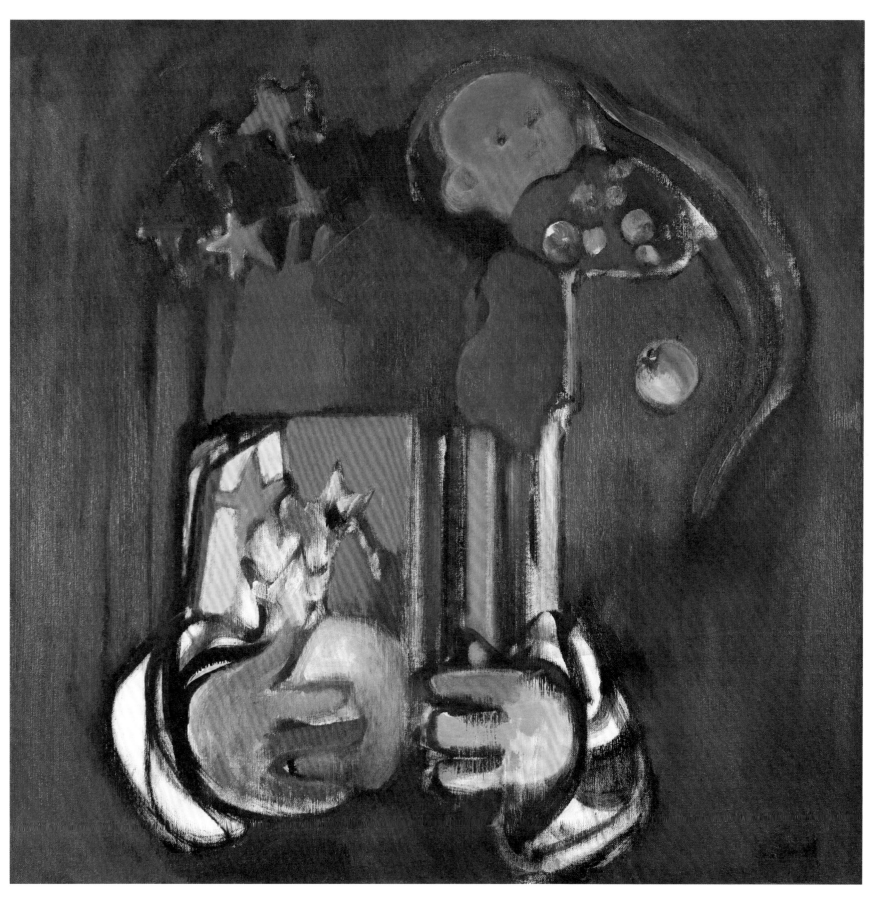

BUCHANAN WAITING TO DREAM, 2019
OIL ON LINEN
40 X 40"

compromise? Will they resort to stare-downs and blows?

I am not indecisive, but I am more sensitive than are most people to the multiplicity of choices before me. I have been around Washington for more than 35 years and have known all the presidents from Monroe through Pierce. And, I know myself. I have tasted political power as a congressman, senator, secretary of state, and foreign minister to Great Britain and Russia. Now, as president of the nation and head of the Democratic party, I know that decision making is a complex and difficult balancing act requiring time, patience, watching my back, and having a sense of history and precedent. With two eyes that see differently, my near-sighted one looking southward, I am superbly equipped to understand the status quo. Just not to alter it.

The place where I feel happiest (except for Wheatland, my estate in Lancaster, Pennsylvania) is the boarding house of Mrs. Ironside on Tenth near F Street. Here I can save money and study fully the complexities of the moment with both clarity and logic. Here is where I share rooms with Senator William Rufus King of Alabama, whom I address as Colonel because of his heroic acts in the war of 1812. He is five years older than I, but I am taller. He is from a gentle southern planter class that compares favorably with my hard-working Pennsylvania origins. I have always had problems establishing emotional connections with anyone, either male or female, and for me, the colonel, a wonderfully full-blooded, hairy-chested angel, is a source of steadiness and balance. Here stands intelligence, civility, an opportunity for laughter, a sense of life's abundance.

We are met for lunch. Harriet, my young niece, has shopped for the raw materials that will be transformed into our celebration. She returns gladdened from the marketing and brings the white-sun heat of August into the dark kitchen where the meal is prepared. White peaches, cut open to be further sliced and slightly sugared, dazzle in their fuzzy textures and slowly reveal their otherworldly pulp. They join the poetry of dried figs, powdered and sprinkled in rounded gestures spread out on oblong white dishes. The lettuces she serves were born of a multitude of families: variegated shiny red-tipped leaves and white endives that hid from any light. These accompany the large slabs of roast beef that have been cooking for hours—basted, fussed over, and glazed.

After lunch, the colonel and I return to our bachelor rooms, which reveal all our masculine clutter with tobacco scatterings and a slight scent of bay rum. He is clean-shaven and regular featured, with two blue eyes that work together. His face is inordinately white, freed from the punishing Alabama sun that demands broad-brimmed Panama hats. His white muscled flesh stands him apart from those who occupy his landscape.

We lie awake, talking into the night—less about politics, though we clearly share southern sympathies—and more about our childhoods and sometimes even our feelings. There are also wonderful silences that strike me powerless in body and mind as my two eyes begin to work together to see objects in the ways that others must see them. The status quo seems suddenly like a small thing, petty and inadequate.

Why do men have nipples? In idle moments, this oddity has puzzled me, for milkless human males never deliver that for

touching myself

Ransom 10 *sleeping 15*

TOUCHING MYSELF, 2010
WATERCOLOR
22 X 15"

Touching the status quo

Ransom 10 *sleeping 15*

TOUCHING THE STATUS QUO, 2010
WATERCOLOR
22 X 15"

which the anatomical features are intended. The colonel is left-nippled, more erotically sensitive to that twin than to its sibling— just as I seem to be more dominantly right-eyed. He believes that men might long ago have assisted in the nursing business, but discarded that activity as less important and turned to more manly pursuits, like politics.

He is talking while I hug him and the bay rum. My senses are overwhelmed, taking my imagination to places I have only dreamt of. He lets me touch him everywhere but his mouth, though never can I recall his returning any of my favors. I especially enjoy his rounded buttocks, like two apple halves gleaming in the night, accented by the streetlights of F Street. Does he appreciate my awe, my quick and stalwart admiration for his southern presence? I do not know. Once he did respond by massaging the nail of the third finger of my left hand. Even now, that memory encourages my ecstasy to build. I am absorbed by his breath, sweet and alive like his heart, but will there ever be any entry, actual or metaphysical, for either of us?

I know that for most men, coitus is the ultimate objective in a passionate trajectory that builds to a climax that can never be sustained. But I have learned instead to feel the warmth of the president pro tempore of the United States Senate, to be satisfied that our union has never been sexual or combative (belligerence being a byproduct, I believe, of consummation). I am gratified not by orgasm, which I have never known, but by the closure of sexual interaction with its choreography of court-ship, forced tenderness, hygiene, and the required follow up. Better that our sustaining friendship is grounded on being held and nourished, not nursed or entered. That would be too much! But I was surprised last Tuesday, when after massaging my fingernail, he asked me for my support in the Senate on the Thursday following.

But that was long ago, and my bed-mate died of tuberculosis just one month after having been elected vice president under Pierce. No more is he one of my Buchaneers, dedicated followers of my person. I dared to love him, to feel ecstasy in his passive touch and companionship, but I never really felt satisfied. The status quo never seemed enough. I allow public service to fill my void, and there the status quo is more than sufficient.

I am now alone, with no companion's breath to warm me. I have cautioned my niece never to allow her affections to become engaged or to tie herself to any person without my advice. Growing older, I have nervous tics in my leg and tumors in my nose. I remain cautious, still a player, but never possessed of the real power that matters. My eyes remain estranged, each with its own agenda. I am more sensitive to dreams, for the water in my body has become quiescent.

History breaks most men and raises only those left unbowed to heavenly clouds. No longer a boarder, I live alone, and shuffle through my spacious house with the tailor-made coat I wore at my inauguration. These days, I wear the lining on the outside—a wondrous constellation of thirty-one stars representing each state in the Union. My eyes flitter back and forth, up, down, and sideways—not simultaneously, but separately. I see them all: Virginia, North Carolina, South Carolina, Florida, Mississippi, Alabama... you know them. Before they left.

*touching common
beliefs about America*

Ransom 10 *sleeping 15*

TOUCHING COMMON BELIEFS ABOUT AMERICA, 2010
WATERCOLOR
22 X 15"

14
PIERCE
Sad liquid dreams

1853 – 1857

I TURN SLOWLY AWAY AND STOP WATCHING THE MOON. My shadow leads me to drink a little more brandy and then find the most comfortable position. Sleep is like a bill collector, intrusive, impatient, unrelenting in its demands. Still, I resist discovering what it brings me. I wear many hats when I dream. Tonight I have chosen a helmet.

Let's talk about the weather, which everyone knows. I shall inquire about your health, and I will inform you about mine—although silence shatters my cathedral, constructed so carefully over the years. Within words and clothes, I can hide and become what you will—or what I will. Trust me.

I hear Jane rattling around her small bedchamber. I love her, but that could be what I remember from a time before she lost her ability to savor touching me. Her sounds remain predictable. Impatience hovers in the banging of drawers, bursts of anger reside in the tearing of paper. I wonder if she is writing letters to our three dead sons or trying to reattach Benjamin's head, lost in an accident shortly before I became president in 1853. Our mutual liveliness diminishes, but we dwell together only in name.

My boyhood longings have hardened into adult appetites. I have become convinced I can choose what to think. But can I choose what I want? Since Jane is clearly losing her hold on the earth (she loathes tobacco and politics), I am substituting a daily enema to take the place of her touch. This is for me less satisfying, but as my enemies label me, I have become a man of limited passion. But then again, entering her vagina is hard work, hazardous and, at times, distasteful, like politics. Jane likes to hide hers beneath petticoats and grief, making matters insufferable.

No one has ever loved me the way I want to be loved. I lie on my stomach, half breathing, with my face buried in bedclothes. No one ever embraced my heart. Jane is too shy, and my mother, although dutiful, was unengaged. Nor am I beloved in the world of politics. I quickly lost the respect of my countrymen. *Traitor of all ages*, claimed Sam Houston. *Eats dirt and excrement for his daily meals*, said Whitman. *A toad in amber*, Emerson named me. Even Lincoln called me a rejected lover. I listen to the sound of my own heart breathing as it takes over the darkness that surrounds me. I move in small increments on the bed, determined to find a space that will give me relief. Upside down? I try that as well.

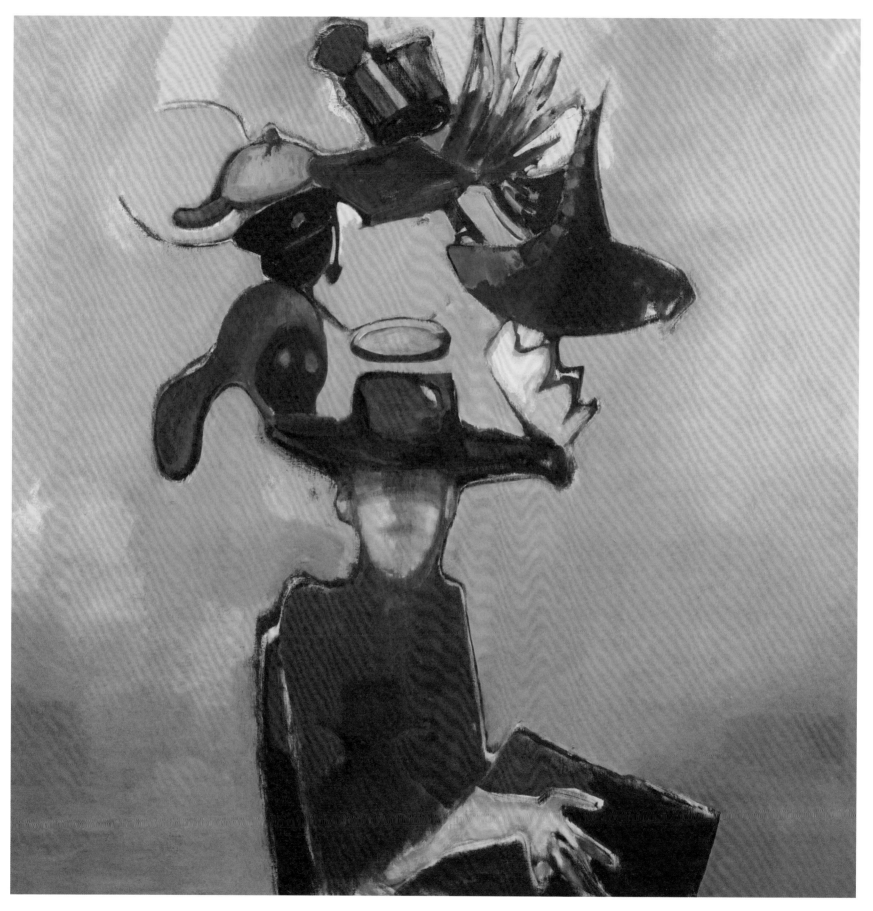

PIERCE ALL MY HATS OWN ME, 2011
OIL ON LINEN
60 X 60"

I don't know if I am asleep—how can one tell from a great distance? But I do see a faint dent in the mattress I apparently occupied. I also see several hats on the floor. I suppose I discarded them in my sleep. I am walking now with some rapidity, turning down the all-too-familiar corridors of government buildings, increasing my pace to more of a run. I soon catch up to the shadows of my three sons, budding, but only half-formed. Their cries agitate their mother, who knew how to love them, if not me, and in time, her wails unsettle me.

Their silhouettes reach for me as I walk by. I see the imprint of Jane's hands on their boyish faces from when she took their heads between her hands to implant kisses that never left. I used to press my hand on their shoulders, less firmly as they grew older, but always with my eyes focused on heaven. In those rare moments when I felt the bond of family, I pressed a child to my chest, though it was rarely clear who it was.

Soon these tiny shadows are far behind me and I begin to gallop, desperate to catch up to my visions before they are replaced by daydreams and nightmares. I reduce my speed and imitate what I see so that my left foot matches the right and my right echoes the left. I have nearly caught up to myself, a beautiful, idealized version of the man I could have been. Instead, I reach for another hat.

We walk together for a while, not daring to touch. We watch the deliberate and measured unfolding of a chestnut tree and fully comprehend the mysteries of its rising sap. Past and future enchant one another. I am especially eager to please, an old habit you might say. My younger self, still adept at expressing my true feelings, is already learning the signs of accommodation. A smile, a nod, a looking away.

The beginnings of my political education were startling given my rapid legislative ascent. I looked especially trustworthy in black, and I dressed accordingly: black gloves, black shirt buttons, black top hat. Because people perceive me as too cautious to submit any proposal unless I am convinced it is constitutional, newspapers have stopped referring to me as the president but as Poor Pierce. "In hell, they'll roast him like a herring . . . he has the damnedest black heart that was ever placed in a mortal bosom."

I stop wearing black, but the contempt persists. Yet I know I am incorruptible and enormously superior to other men. I live a purposeful life. My earthly cares are not ignoble. My soul speaks clearly and gently, without the heavy breathing of politics. The advantage of being seen as handsome should outweigh the disadvantage of being perceived as slavery's most conspicuous apologist.

Soon my impatient feet, still full of sleep but charged with purpose, move far beyond my younger self, who seems more self-contained and beautiful the further I leave him behind. Sleep-dazzled, I have, nonetheless, a focused destination. In daylight, I envision a simple derby when thinking should be avoided. At night, for dreamless sleep, a silk nightcap with tassel. Belly full, head empty, I want to be happy. To be satisfied. In the end, the hats drift away, and I see myself with closed eyes, dreading the future.

sweeping the fog from my face

Ransom 12

14
sleeping

SWEEPING THE FOG FROM MY FACE, 2012
WATERCOLOR
22 X 15"

13

FILLMORE

Dreaming my younger self

1850 — 1853

WHEREVER I AM, I HAVE A STRONG SENSE OF PHYSICAL PLACE. The earth belongs to the living, so I don't worry about being high-minded, correct, or even irresolute. It does not make sense for me to describe my interior hallways and mental sitting rooms or invite you into the garden of my brain. What surrounds me in my daily breathing and sleeping is something I can readily communicate because it rests on a clear and demonstrable order. That occasions me to recurrent daydreams. I rarely dream at night.

I will be president for 237 days. Queen Victoria will call me "the handsomest man she ever met." Although not introspective, I have always been fully conscious of myself as a public person and have dressed well. I change churches as I change clothes, finally alighting on Unitarianism. I change houses as I became bigger in bulk and success.

Some of my predecessors in the White House had standing orders with neighboring bakeries to provide the president's house with enormous quantities of ice cream, exotic concoctions called grape pyramids, many kinds of chocolate sauce, and cornucopias of ladyfingers. I will end to these wasteful indulgences immediately upon our arrival. Crockery to hold these surfeits will likewise be banished. All the excesses of the human eye had apparently worked to fabricate florid platters of white and gold with eagles resting on rims of red, white, and blue. Greedy fingers had clutched finely etched champagne, sherry, and wine glasses with intricate designs intended to make imbibing more enticing. They will never be missed. I banished the dinner services too, along with the greedy fingers, to darkened storerooms.

Since outward impressions truly matter, I am dedicated to civic ethics and virtues and only let poetry or theology guide me when they are consonant with the values of the public sphere. Mysticism, never! The order I demand in my personal life has always carried over into the running of my household.

Upon arrival, my immediate attention focuses on the proper heating of my environment. The old furnace Van Buren had constructed in the oval room in the basement was increased in capacity over time. Today, year-round comfort can be achieved with an enlarged heating system that brings hot vapors through plaster-lined ducts to the public rooms, offices, and bedrooms. The dry, stale air accumulated during endless arguments offered by congressional visitors has become a sign of the past. My throat is parched no

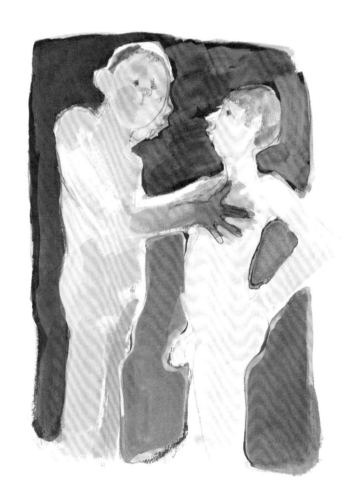

*feeling the heart
of my younger self.*

Ransom 12

13
sleeping

FEELING THE HEART OF MY YOUNGER SELF, 2012
WATERCOLOR
20 X 14"

longer. Although I value silence, I begin to speak again.

I bathe on the second floor in a tiny space off my bedroom in the southwest corner of the White House. Earlier residents filled the practical bathtub of painted tin with water that had been heated in kettles and hauled up from the east-wing bathing room, where Andrew Jackson had installed two coal-fueled boilers. Since my flesh is sensitive to slights (human and political), I insist the tub be draped with bath sheets to protect my modesty.

I sun myself in the greenhouse in an ancient iron chair inherited from the Jackson administration and positioned to catch rays from the colored glass of the drafty windows. The days will become longer for me there because the light in this garden is untroubled by the fickleness of sun and wind. The contained atmosphere is clean, and I know where to move. My chair becomes like a puppy following the light as it makes its rounds. In this way, I dream the benefits of pleasure and good health. The world outside, seized with bloating ambition and political impatience, stays far away. I enjoy the best the world has to offer. I sit untroubled, open to the warmth of life, no longer impatient or ambitious. I have, after all, reached the apogee of politics—despite my being labeled accidental.

The sun and my mind reach high and stretch long, achieving the equinoctial position of calming balance. Along with the world, we stand motionless, whole, and enormous. Then everyday time intrudes, and the spell is broken. Clouds form as I fret about this bill or that compromise pending in Congress. It was then that I noticed my body stayed seated where I left my chair. Not wanting to be less than I am, I feared I have left my shadow or some dimension of myself behind. But the seated image is substantial, although considerably younger and slimmer than in the presidential state in which I greet him.

We speak, my younger self and I, and I realize that, despite my resistance, I have surrendered much to the daily business of life. I seem to be conversing with spring, a season held together with a greater sense of newly minted green, and poppies blossoming early. Real color replacing the memory of red. In this young creature, I recognize a season of renewal I will never know again.

We talk about our feelings, something I can rarely manage to admit exist, except with mirrors. Mostly they reflect childhood, sometimes painful, but always capturing the moments when the promise of endurance suggested it might prevail. The moon, also new, begins to cast its light on our conversation. A north wind begins rattling the windows of our sanctuary. Spring retreats and gives off its final scent. Night intrudes, and I leave my young self.

I am still sensitive to strong ideas about unhealthy vapors drifting in from the south lawn of the White House, and I continue to advocate year-round comfort. I need to inspect our newly updated heating system. That is on my list of things to do after lunch and my afternoon nap. You need not remind me.

my container for unacceptable feelings

Ransom 12

13

sleeping

MY CONTAINER FOR UNACCEPTABLE FEELINGS, 2012
WATERCOLOR
16 X 14"

12

TAYLOR

I like being touched

1849 – 1850

I LIKE THE WEIGHT OF HIS BODY ON MY BACK, FEELING HIS LEGS DANGLING AT MY SIDES. With this force, we go far. My stride increases with those small increments of pressure his knees exercise on the smooth surfaces of my flanks. I know I will be with him for the remainder of my life. We move forward, backward, even to the side in response to his subtle directions. We are one.

It was not always this way. I first met Zachary Taylor when he was a captain, young and foolish, though his fellow human beings thought him dogged, a determined professional soldier. He had ridden army-issue mares before he met me. Since my upbringing was easy and my youth unencumbered, I was looking for a good-hearted friend, someone I could connect with. And there he was.

My first glance fell on his much like eyes locked in an embrace. He was totally mine for those few seconds. Then his eyes returned to what had occupied them before I entered his life. But I knew he would not forget. He had a big head with thick, wind-blown hair resting uncomfortably on a short neck. His eyelids were half-closed, due I suspect, to bushy brows that weighed heavily on nearsighted eyes. These eyes, lost and forlorn in an unfriendly universe, sharpened their focus to create a blustery frown. But when the object of his attention escaped his visual grasp, he shut his left eye to avoid double vision. He sought refuge during the time I met him, camouflaging himself with a battered straw hat as if it could hide his squat body, his thick chest abandoned by legs so short he had to be helped onto my back.

He mounted me several times that week, and so taken was he with my strength and absence of color that I knew he would choose me and even change my name. During that time of courtship, he often put his large right ear next to my heart, closing his left eye to hear better what was not yet formulated in my consciousness.

Other than the general, most people saw me as no more than a practical means of transportation. Transporter of humans and things is only one way of describing who I am. Carrying you from Arkansas to New Orleans determines how you see me. But it only reveals talents and inclinations, not who I really am. I am more than four legs and a sturdy back. By listening to my heart, General Taylor knew what I thought. Yet even he shook his head in disbelief.

My friend dressed in borrowed uniforms that stank of their owners. Once stripped of their garments, these men were as alike as smiles in summer, expressions adjustable to

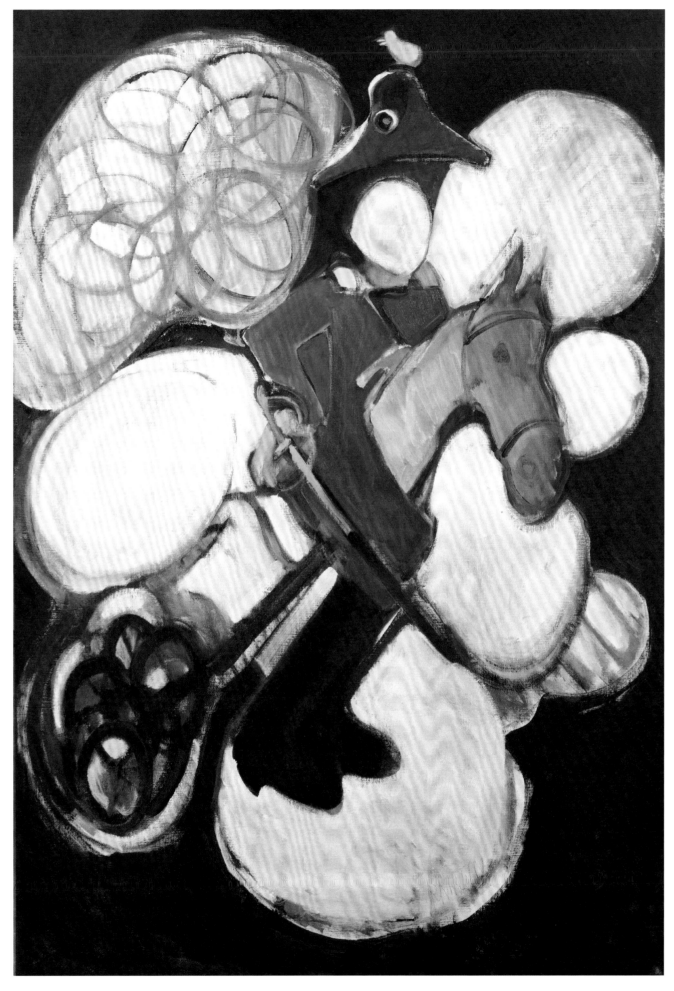

TAYLOR BECOMING ONE, 2011
OIL ON LINEN
66 X 46"

the occasion. Human beings, he knew, share scripts and play the same parts. Though they use slightly different gestures, their vacancy is interchangeable, and all are driven to become one another, losing their empty selves.

It was different when General Taylor and I rode together as one—almost like a centaur with fuller life devouring us. The true subject of our lives became not the soldiering but the gradual suspension of the external world and its absorption into our common mind. The Texas chaparral spread before us. Clumps of trees interrupted the flat plane and marked our progress. When we rested, the grasses—tall and mute—grew taller, absorbed our speech. The sky above us remained unpredictable and shameless.

When the speed of our gallop outstripped habitual perception, our brains locked together and discerned landscapes witnessed only at high velocity. Wild lupine, marigolds, and verbena merged with rabbits, ducks, frogs, and deer. Texas dust sprinkled our flanks, adding a soft layer of delicacy, an atmosphere of ochre. Then were we fully possessed by nature. The sweep and magnificence of our reverie assured the sleep of our souls. And despite the full force of the sun during the day and the bone-aching cold of night, we felt secure in our embrace. We never had a home other than in motion.

Inside General Taylor's intestines, clogged and overused, I felt that another war raged. It was then that I licked the inside of his wrist and the palm of his hand, spreading my saliva, ingesting the salt of his skin. I kept my ears pointed and only rarely pinned them back. I wanted to be the horse he deserved, and my mane grew prodigiously. By showing my rump, I tried to stave off not only his enemies but all those who did not support him. When that did not work, I threatened a kick with a lift of a hind leg and a quick switch of my tail. I rarely had to bite.

One day they will call him a product of his time. A frontier Kentuckian, a landowner with a common touch. I loved that touch, and with bullets raining around us, I carried him far from his origins into national prominence. Putting him astride a white horse elevated him, made him an ideal Jeffersonian, a new Jackson, a supporter of America and Americans without regard to political belief or identity.

We created the image of a war hero. Martial music made him seem greater still, larger than he was, larger than anyone I knew. An egalitarian, an unrestrained frontiersman with instinctive dignity and a spontaneous manner, he did not suffer a political platform to limit his believability. And since we refused to campaign, we were perceived as above party politics. He was the quintessential outsider, *Old Rough and Ready*. And I, his companion at 15.2 hands high, became *Old Whitey*.

We both liked hominy. We hated flies, tarantulas, rattlesnakes, and centipedes. He did not fear what he had not experienced. But he slept beside me because he needed the warmth of my body and the predictability of my presence. He led men, conquered Indians and Mexicans, faced fire and malaria. And he loved me. He was a robust frontier commander who counted the bayonet higher than canons and West Point strategies. The higher he rose in command, the less he bent to outside influences, especially the workings of the Army bureaucracy. We used to laugh at campfire. When others tried to convince him to change horses, white being too obvious a target, he remained loyal.

After he became commander in chief, he gave orders that I'm never to be ridden again. I grazed in the South Garden of the White House behind the gazebo and the vegetable garden of Mrs. Betty Bliss, his daughter. Life became less burdensome. I was well taken care of, but I missed being in motion and disliked tourists taking souvenir hairs from my backside, which they could sometimes manage to approach before I caught sight of them.

President Taylor served his White House duty for 486 days. I had one last act to perform before I retired to Springfield plantation near Louisville. The funeral car held a grand arch that

following the sun

Ransom 11

12
sleeping

FOLLOWING THE SUN, 2011
WATERCOLOR
30 X 22"

served as a canopy. At the very top, a gilded eagle, enshrouded in crepe, presided. Black cloth edged with black silk ribbon, silk fringes, and white rosettes covered the whole. Eight other white horses pulled the car. With cannon thunder in my ears, I followed with empty saddle and inverted spurs. The two soldiers who led me had served in the wars of Mexico and Florida. It was the last time I saw my friend.

But we were not there. What you saw were not the real Old Rough and Ready and Old Whitey. We were flying from the Nueces River towards the Rio Grande. We flew above the clouds, marking time by the movement of the sun. The reappearance of clusters of trees we knew to take water led us to fly even faster. We left politics behind, as we did flies, rattlesnakes, and centipedes. We bypassed startled Mexicans and found our destination had not been marked. We had moved beyond motion to that strange and wonderful place that has no name, is beyond touch.

11
POLK
Dreams that can be measured

1845 – 1849

EVEN IN SLEEP, I ROUSE TO THE INDISTINCT SOUNDS OF COMPUTATION. Numbers tell us everything, but it is not until my time as our eleventh president that the meaning of adding and subtracting becomes important. After all, one's worth is connected to salary, and travel to exotic lands feeding our sleepy imaginations has numeric costs. What is estimable is determinable; what is fathomable is computable. Numbers are the language of power.

Dreaming of America and its expansion by a third, I create a truly continental nation stretching between two oceans. Oregon and Washington, California, Nevada, Texas! All enormous lands that Americans have begun to populate, bringing to our history all that manifest destiny intended. You can measure my success by the number of square miles I bring into the Union. The more miles I engineer, the more honors I receive. Arizona, Idaho, and New Mexico! All this expansion accomplished in only one presidential term despite four years of vicious partisan attacks. Utah, Colorado, Wyoming! And Montana, and Oklahoma! Thank big! I did!

As big as my dreams are, I am not a typical slaveholder. Land is my preoccupation. I find slavery a burden forced on me as perpetuated by ancestors and a southern agrarian economy. I husband these dependent folk and barter for their general welfare. There is tragedy in their abundant fertility, which I fear derives from the heroism of nature prevailing over choice. When offspring later multiply, it is never to their advantage. The burdens of maternity and exclusion from fatherhood is an ephemeral gesture to their blood and skin.

Elias was given to me at my wedding in 1824, a gift from my father. He has been with me all my married life and watches over me, tending to my needs. I never send him to hard work on my plantation in Mississippi. He is not as much a slave but a double. Like a silhouette occupying other worlds.

Even in his 20s, I watched Elias play and run alone—trying to move quicker than his shadow. Then I saw him, again alone, creating shapes and configurations on parched earth in hot sun. Sometimes he lost his shadow, although I could always detect its hiding place. Then he ran even faster to capture it. In his mind, the future is whatever surrounds him.

While I embrace the circumference of America, he lies at my feet on the cool tiles of the study. Sometimes I put both of my feet on his young back. I register first cold, then warm, from his newly touched flesh. Then I contrast the sensations, placing my bare right

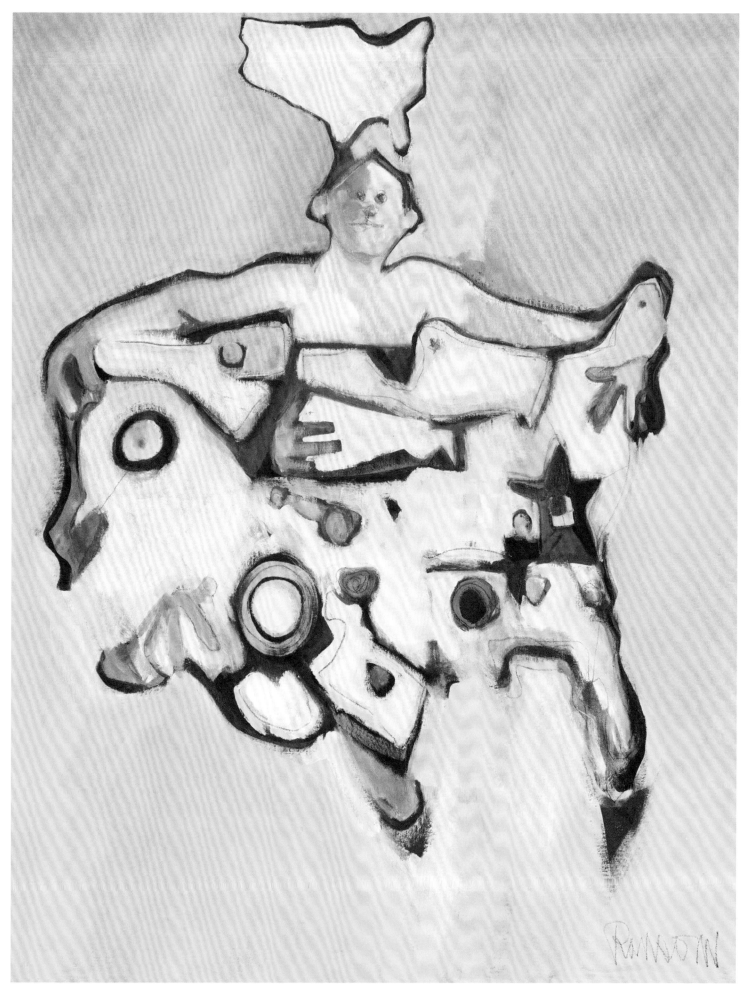

POLK MEASURING LOVE AND AMERICA, 2010
OIL ON LINEN
60 X 48"

foot on his wooly head and thread the rough covering of his head with my toes. He likes that, I suspect—I actually forbid myself to gaze upon his face despite his laughing and pressing his head against my legs.

My limbs, aroused by his availability, turn him over. It is like taking Texas again. His chest is warmed by his young heart and quick, strong beat. His ears are soft and pliable. I am careful not to press too hard on his young eyes, which he squeezes shut, sensing my approach. My toes travel south to the pink mouth I imagine as a small vacancy in an otherwise dark sea. His lips open as I near them, and my toes feel his small, irregular teeth give way to a wet tongue that I know smells pleasantly of milk and corn.

I feel Elias twist up into a trembling ball, mewling, prompted by his race and total dependence on me. He had moved from a warm, protected womb to a meager and uncertain existence where the sun shines too brightly and work never ceases. He is afraid, which only drives my exploitations further. I use my hands to disentangle the ball he has become. The dominating satisfaction of pulling California into the Union sweeps over me again.

I imagine that this distraction lasts twenty minutes—time taken from important strategies on behalf of our county. I had been improvising a treaty between America and Britain over the Oregon Territory. Some urged me to settle for the 46th parallel as our new national boundary with Canada. Others seized on the 54th. I knew this last to be unworkable and instead fought hard to secure all land south of the 49th parallel, which is what I eventually get.

I prevail with measured diplomacy combined with just enough tempered threat. The acquired land completes our country and glorifies my presidency, fulfilling my vision. Three degrees of latitude have come to define my value as strategist, president and human being. Washington State, Montana, Wyoming and Colorado!

Overwhelmed, I wake up. Or do I?

I continue to dream about places not yet part of these United States. They become enormously real and palpable in my hands. I want these territories badly and seize on their physicality, their weight and circumference. I finger them, caress them, and even taste their edges when no one is looking. I decide that Idaho, with its long upper stem slowly undulating into strict geometry, is my favorite. It sits well on Nevada and Utah, and its beckoning finger acknowledges, indeed wraps the western border of Montana with delicacy and charm. Yet it remains strict with Wyoming, from which it stays coldly detached. I have never enjoyed Nevada's great precision. It is too level, too smart in its numerable geometry despite the vast, mysterious deserts it encloses. But I do like to fondle its lower side, where the Colorado River displays itself with a sensuous provocation, slowly becoming friends with the Black Mountains before ending up measurable after its Big Bend—where it disappears from the cartographer's dream.

But Texas evokes best the lands I worked so hard to bring into the Union. It delights and arouses my reverie endlessly. Think of a large self-sustaining presence with many levels of complexity and simplicity. Here is all we could ever ask for, undulations of geography scented by wings of angels transversing long distances before leaving white footprints in the sand. Texas represents the weight and repose of the dreams that dawn when I stretch my own body along its expanding circumferences. Follow the Red River. Mount it by making it part of yourself, unlimited by boundaries. Sand and my own flesh merge with every turn of its waters, every unfolding of its mountains.

For a brief enchanting moment, I hold my breath and Elias, my possession, holds his, too, in the presence of that most wondrous vision of a country whose possibilities will not be contained. Finally, there are no boundaries. No limits. I have run out of things to compute and measure. Then Elias is gone.

feeling Idaho

cradling texas

Ransom 10 sleeping 11 Ransom 10 11

FEELING IDAHO, 2010, CRADLING TEXAS, 2010
WATERCOLOR WATERCOLOR
22 X 15" 22 X 15"

10

TYLER

Dreaming through Father

1841 – 1845

MY MOTHER'S BODY HAS BECOME AN EXTENSION OF MY FATHER'S PURPOSES (I AM THE SIXTH OF HIS EIGHT CHILDREN BY MARRIAGE), AND SHE ARRANGES HERSELF AS A WIDE SWATH OF DELIGHTFUL ACCOMMODATIONS, A HOTEL SEEING FULLY TO ITS GUESTS' EVERY NEED. At night, when the Judge's body presses firmly against hers, all the strength of his inward dedication creates a stalwart equipoise within her, banishing whatever emptiness she has allowed to infiltrate. His agenda takes the form of rooted jabs that disconnect my mother's peace and my own safety. But as the penetrations decline in strength and cease, we both sense his measured sleep as he curls up into a shell-covered ball beyond touch and conversation.

My flesh now takes a definable shape. Crying is more than a release, and I am learning to mold my expressions of joy and pain, especially on his lap. His papers are my toys, and they refine my sense of language. On his knees—my treasured destination—I practice babbling. Under my father's steady gaze, my flapping arms increase my portfolio of gestures and postures, and I explore the full perimeter of his rooms, never really wanting to leave their embrace.

His balls are ample, I can tell from my perch. Our family is of somewhat more than average height, but for reasons genetic or godly, we are blessed with giant testicles. My father, brothers, and I rarely heed, either in pride or in display, these larger than normal appendages, but it is our habit to sit on them, believing every male does the same. Their girth does, I am sure, cause us to walk in a way our adversaries view as arrogant. My father and I never discuss this matter, but it influences our perception of life.

Now a father myself—I have fifteen children by two wives. Reassuring the boys, I explain that such breadth is a kind of apostolic succession. And yet with my second batch of sons, born to my wife Julia Gardiner Tyler, I have come to believe that our cause was an engorgement of veins in our scrota.

Our family's fecundity causes to bloom the twelve-hundred acres of rich soil we call Greenway, our plantation in Virginia. Here is a world wider for its sun, clean breezes, and tangled grasses. It spreads out before us, the Tyler progeny. Feathery heads and diaphanous lacework give off the smell of damp burdock, with which we compete in growth and prowess. Near the river, where nettles and sharp-tongued thistles congregate, the surrounding

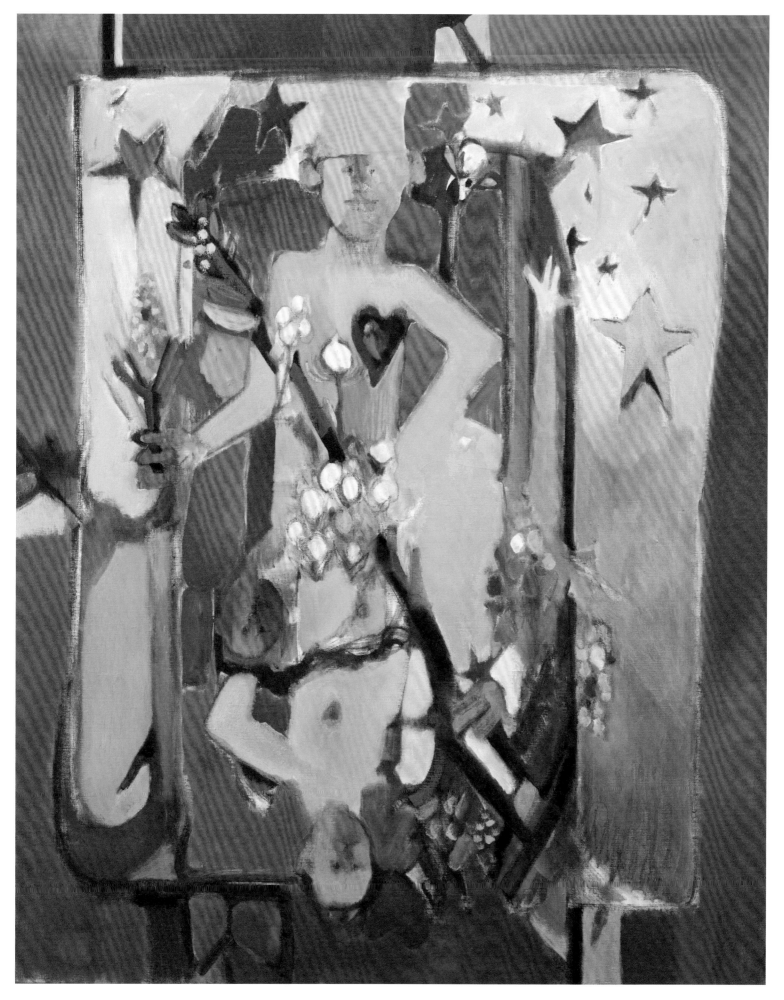

TYLER INHERITANCE, 2010
OIL ON LINEN
60 X 48"

foliage of tall pines and hickory trees challenges the sun. There we play in shadow. But further from the house, towards the rows of wheat, tobacco, and corn, the parched land opens itself to the sky. What grows here has given free rein to all possibilities: a paroxysm of voluminous and swollen fullness.

Home is the smell of mimosa, locust, and dogwood. I carry it with me always. And because our plantation ways are courteous, if slow, my father and his children are well committed to maintaining the religiosity of the Old South as practiced here, our true mother country. My mother is gone, I am but number seven, but there is no loss of love. My father is busy as an elected official. But he is always there for me.

In time, Judge Tyler dies, and his stiff body now lies on a long trestle table. As his namesake, I participate in the ritual of preparing him for burial. I undress that body, which had been the source of so much life. The enormous oak trees around our home reach even higher, and their arms cry witness to a reality beyond our comprehension.

A delicate veil of human odor fills the room as our family washes, shaves, and prepares the Judge for burial. I have never seen before his naked loins, but I remember how they had once, clothed, been my destination and source of safety. His belly, taut in life, now gives way to the death of his will, its flesh loose and gravity bound. I press my left hand on his stomach, close to his genitals, and there arises a wailful cry, a pale echo of the oak trees. Our father is still erect, his large penis ensconced as on a luxurious divan, his engorged testicles reinforcing his last claim to life—his refusal to be extinguished.

I look carefully at this prominent engine, not willing to touch its magnitude, nor its autonomy. But a young black man of some fifteen years, who resembles Judge Tyler in his lower face, seems dedicated as he washes that area of my father's body, which seems to elicit from the child neither shame nor awe. He holds this ancestral shaft vertically in his left hand and with his right hand, he washes with firmness and loving care that which had ruled Greenwood plantation since the judge inherited the land from his father.

The young black boy is directed by a stalwart black woman who focuses on Judge Tyler's upper torso and face. Each of them addresses those parts of my father's body that has affected them the most. This enslaved woman, once large and strong, now weakened by age and effort, washes, shaves, and combs with much the same attention as the young boy, who also resembles her.

There is a terrible, yet beautiful connection between owner and owned. This woman had been torn from her origins and forced to submit in defenseless acquiescence. I am totally familiar with the availability of her and women like her; they provide for us Tylers a destination for our passion from adolescence through old age, their sexuality being so clearly different from that of our wives, whom we inhibit through education and custom.

Father's eyes, though closed, still seem to see through his lids. His mouth, not at all closed, mutters inaudibly. Now freed of clothes and their restraints, which hid some of our family traits, his body encompasses an unbroken universe of meaning, a plantation of ideas and perceptions. I study these surfaces and stretches of usually masked human flesh.

We roll Judge Tyler over and expose his backside—a view of his existence I have never comprehended before. But as the child working with me recalls, Father frequently turned his back on what he did not want to accept into his flesh, the darker realities of his life on the plantation. The boy explains that he is only three-quarters owned by our family and will need to leave shortly given that the division of property requires him

we grew more than tobacco

Ransom 11

10
sleeping

WE GREW MORE THAN TOBACCO, 2011
WATERCOLOR
13 X 12"

to return to the slaveholder who owns the remaining one-fourth of his appraised value.

The boy breathes fully, with heart beating and eyes afraid. He stretches his own body to appear larger than the corpse that seems to be speaking to him and settles on a posture that is neither defensive nor outgoing. The boy's actions only reanimate our corpse. The deceased needs this child to know his origins and invites the boy into his very flesh and mind. Every event in the master's spent life takes on importance in the resonance he evokes.

The boy continues to stare at the corpse that he has just washed. He has heard many descriptions about his race before, but since they did not seem to apply to him, he had never listened very carefully. Still, he knows there must be some truth to these matters since these ideas entered his half-black flesh and three-fourths appraised value without his full awareness.

In time, I join my father on that same trestle table, where his spirit seems still to hover. I have accomplished all he aspired to. So I lie here, naked and alone, and no one is there for me. Have I embraced the wrong side of history? Has life itself moved on and left me unable to be reconciled with a future I neither predicted nor allowed for?

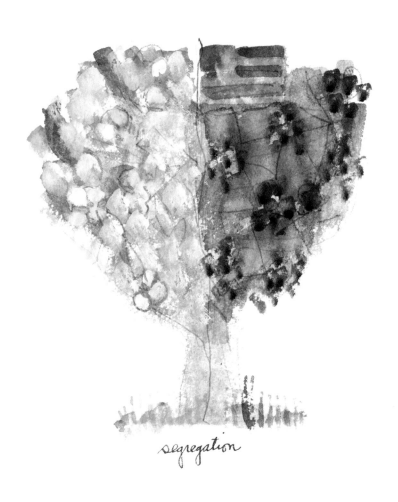

segregation

SEGREGATION, 2011
WATERCOLOR
13 X 11"

I was in the center of my father's love

Ransom II

10
sleeping

I WAS IN THE CENTER OF MY FATHER'S LOVE, 2011
WATERCOLOR
15 X 12"

9

W.H. HARRISON

You might say I am dead

1841 — 1841

MY MOTHER WARNED ME ABOUT THE DANGERS AND THE HORROR OF BEING BURIED ALIVE. She taught me that there exists a state of being that joins death to life—death begins during the process of decomposition, first as the spirit prepares to leave its suffocating earthly home, and then after burial. It is a form of sleep.

I didn't bring my overcoat, and I left my gloves at home. I removed the Winnebago and the Potawatomi from their lands in Indiana. But after my inauguration, I bargained with death despite lacking the requisite credentials to prove myself in that other form of battle. Still, I lived a month, a glorious, inestimable month of being number nine, even as I spent my presidency in a thirty-two-day deathbed. Even Tecumseh would have smiled at my stubbornness.

I talked too long they said, but my intent was to demonstrate my strength and my leadership. After two hours, I grew exhausted before a gradually dwindling crowd. I had tried to impress my audience with classical Roman references, a conscious attempt to deliver a longer address than any of my predecessors.

Mother and I know we can be simultaneously dead and alive. It was a raw north wind that felled me. Bloodletting, emetics and cathartics. Calomel, rhubarb, and ipecac. Then, opium, camphor, and brandy. Topped off with a Seneca Indian recipe of crude petroleum and Virginia snakewood.

Mother said some doctors can hold back the decomposition and delay death. On the battlefield with the Kickapoo, I observed bodies where life infringed on death; I have seen corpses that bled and sweated or whose hair and nails insisted on growing. Embalming assures us a delay, lets some tiny dimension of us beat, quiver, and breathe.

We are flowers. Shiny leaves
 long and cylindrical,
 clustered and spiked with yellow at our tops.
 Horney and hollowed stems overflowing
with chalky secretions. We face the emerging
darkness where we fade and wither.
 And are replaced.
 And begin again.

I decomposed much in the month of March, so I remember very little. Given half a chance, I shall do better next time.

W.H. HARRISON SURRENDERING FOCUS, 2011
OIL ON LINEN
38 X 28"

8
VAN BUREN
Dreams that don't let go

1837 – 1841

IT IS DARK, AND THE ROOM SMELLS OF ILLNESS, MADNESS, AND HOPELESSNESS.
Candles have been placed near my head. This is premature. My eyes are closed, but I can see very well and know who walks through my room by their familiar movements. Hannah, long gone, died early, and we were not close enough for her to remain anything other than departure and loss. I cannot resurrect an image of her not in some way infused with absence.

Someone is near me now, talking as if addressing the dead or hard of hearing. The content is ritualized and meaningless, yet the sounds of the words approach music. Still, this language has nothing to do with me. It is an internal dialogue the speaker creates to break the silence and darkness of the sick room.

I feel the disconnect between words and physical presence. Strong perfume names its wearer, but the excess of sweetness suggests a desire to drown my lingering stench. Then the sweat of male bodies hovers. It is shorter in duration and accompanied by louder words, less musical, only to be replaced by that surfeit of sweetness once more encircling me like a curtain. Or a shroud.

I laugh at my sad joke and remember my mother or, rather, a time when I was not fully me but nourished and fed and suspended in her belly, where consciousness in dark-ness first arrived and showed its face. Birth—when one emerges fully alive but helpless—is so much like death, which leaves one both helpless and far from alive.

The connecting flesh of my mother holds me. Our hearts beat harmoniously, then gradually begin to compete, mine racing forward to declare myself as her son. The moon shines into the womb we share, bringing light I can play with. I laugh and hide and grow, and, very quickly, my whole existence is silenced by cool and silver light where no hiding places remain. Hours later, legions of weightless clouds pass into this rugged landscape, turning my world soft and pink.

I wait only in order to depart. My wrinkled flesh is rolled over, large as I am, and purged of waste. The hands are efficient, and the breath antiseptic. Warm water, but not warm enough, flows over me. I am handled by four hands smelling of ammonia.

The cold razor delicately slides over pockets of hair that decorate my public face, but it misses the little patch under my nose. This is the same head that endured years of

VAN BUREN POLITICAL PARTIES, 2011
OIL ON LINEN
60 X 48"

concoctions meant to grow hair. Mixtures of salt, wasps, honey, alabaster, and red ochre, left on for twenty minutes, became a part of my life, encouraged by vanity or, at best, the desire to avoid ridicule. But I applied potions in vain, and in traveling from red to gray to white to bald, I determined finally that my bare scalp stands as a magnificent display of my maleness and wizardry. Was I not once president?

Faces get blurry and grotesque when pushed close, oh, too close. Large mouths become elongated, red holes moving without ceasing. Or have these visages been rubbed out by time, much like those on old coins? Lying here on wet sheets, I surmise that most faces were probably never very special to begin with. In babyhood and old age, we are bald, and flies want to rest on our hairless surfaces. We get cold through our heads, which are also too readily sunburned.

Countenances that never seem individual and whose names I readily forget have always been the beings for whom I worked hardest. I have always championed the political and economic rights of the nameless. I embrace factions. No, I celebrate them and make them parties. I am comfortable with facelessness, and can always count anonymous votes faster than anyone. Even when I dream.

I could make Andrew Jackson laugh, and he did, and I did. I convert his outbursts into a political party. Gripping my own hand in handshake, I overturn vested interests by dwelling in back rooms of labor temples, immigrant assemblies, and grange halls. I shake hands with many an unruly lot. Democracy grows, and I guide it, continuing the American Revolution.

My handshake is not strong. They call me a lady because my hands are tiny, white, and burdened with rings. But I do not let go, and those hands built a political house that systematically organizes the disparate hatreds of America and funnels them into political action.

These enfranchised spirits now invade my sick room. Have they come to guide my new migration? Death is eclipsed, and these forces seem no longer to know flesh, blood, or even gravity. Their luminous glow fills the air of my passivity and fogs my brain. I reach out for my mother and find her smiling. We leave together.

politics

Ransom 12

8
sleeping

POLITICS, 2012
WATERCOLOR
22 X 15"

7
JACKSON
Childhood dream

1829 – 1837

CHILDHOOD IS MAINLY ABOUT PARENTS. I hardly had any. My father, also Andrew, died before I was born, and my mother, Elizabeth, departed this life when I was but fifteen. Still, I feel their presence. I can still sense her milky breast in my mouth and feel Father's blood in my veins.

Why do I feel so sad when I encounter the past? It is regret—choices unmade, steps held back. So I improve on memory. By going back in time, I make it better than it was, uproot the rot, and heighten the dimensions of those I lost. Yet my family couldn't last outside my heart. My brothers, Hugh and Robert, died young, and I still find myself alone, abandoned to my own pursuits, lost and undefined.

Images of childhood are but idealized projections. When we are smaller than adults, we are perceived to be dependent and given to the temporary delights of play. We are even identified with a season (always spring) and time of day (always morning). How can adults know what we experience if they think of us only as evolving incompletions who spend enormous amounts of time enjoying the trivial and unenduring?

I rarely dream but find myself walking in the dreamy shadows of make-believe. I require the guidance of practical inspiration, but that is rarely absent. When I was an infant, my mother hid me in this hickory grove, an upland area of the Carolinas known as Waxhaws. I return often to that spot where sweet potatoes, peas, pumpkins, and corn once shaped my perceptions. In the near distance is the homeland of the now-defeated Catawba Indians.

This is a magical refuge where I remain forever a child, loved and safe and blessed. But even such havens can prove dangerous, and since my mother was forced to leave me alone in this thicket, I lie perfectly still (now, as I did then) that I not be discovered by humans or spiders. But I suffer hunger, attacks by biting and stinging creatures, and a fever, produced by tics, that attacks my stomach and throat. Small red welts ooze and become my neighbors. My mother returns periodically to make certain I am safe, although safety is a relative term. She feeds me from a small pocket in her apron and cleans my bites. Sometimes she appears in different guises: Demeter, Isis, America. I always recognize and embrace her.

Over time, I have discovered limits to my unwanted kingdom. I excavate, and I find children who have never been protected, who have never been safe. Many stillborn, others healthy but abandoned. All of their spirits appear intact. Most pine to reenter their absent

MAKING OF ANDREW JACKSON, 2012
OIL ON LINEN
66 X 46"

mothers and be born once again. Now and again, some leave the relative safety of the hickory thicket to find family, setting out alone but confused as to their direction.

I have never been uncertain about the direction I want to navigate. Yet I continue to choose this life, with all its dislocations. After all, I have always been able to hear the songs my mother sings to encourage me. This everyday world coexists with my garden of red clay, a ground resistant to farming and growth. But it is still ours to make an Eden. Here, I trace my first steps and outline our family plot, and here still are the small animals that I took as my first friends.

My mother invokes the Roman goddess Abeona (but with Presbyterian names) as she did to bless my first steps away from her and quickly made certain my path led straight back. She encourages me to play games that foretell the adult roles that have been chosen for me: fearless soldier, stalwart farmer, and nurturing, protective parent. Since I am a miniature adult, Mother excuses me when I laugh or follow butterflies. But when I seek a doll to love and offer tenderness, she grows embarrassed. I do not ask again.

Rather, I veil the goddess in me. I hide from common folk when I want to play the games that round me out. I blow soap bubbles with a straw to embrace all that is ephemeral and fragile. They float, large and transparent, but with silver borders. A flotilla of small bluish prisms drifts after them. Their fragility welcomes me to our world, its cruelties, its joys, all trivial, but real. I hope the bubbles will cloak my emergence so I might move silently and furtively into this impermanent universe. I began my life surrounded by so much death and grief. I know them still. I have never belonged and I have always been aware. I am but a tolerated guest of an extended family.

My dead mother's clothes are brought to me, pitiful rags in a burlap sack, and I go through them, one by one, and watch my tears permeate the coarse weave. There is no one to occupy these scraps of cloth again, no warm body to take practical charge and align the folds and pleats to functional purpose. Yet in their layers, despite a paroxysm of desperation, there reigns an iron strength, a will beyond fortitude.

I put them on often, not a woman dressing, but a child enveloping the strength of life. Mother's clothes exude her smell, temperate eyes, strong touch, and expansive embrace. Wearing these well-worn cloaks, dresses, gloves, and scarves resurrects for me the odors of her daily life: cooking fires, sweat from the fields, animals. Ordinary people laugh at me.

I see life differently and understand the helplessness we are all given as one cost of being alive. Moving slowly in ill-fitting clothes (that nevertheless come to define me), I learn early to take stock of common Americans who don't share my feelings, but whose allegiance I require.

I wrap my mother's scarves around me to cover the large slash on my forehead, the residue of an assault by a British officer. Deep enough that you could rest your finger in its fissure, it is the visible mark of having defended my personal honor, which I never differentiate from my championing of our American revolution. They are interchangeable, much as my mother's clothes become her and now allow me, by wearing them, to take on all her glory, love, and self-sacrifice.

I never remove these clothes; they remain part of me even when they sit in their trunk. They reinforce my strength in the face of loneliness, fuel the energy that I need to free myself and enlarge my understanding of the good simple people who surround us but who could never claim a champion. Could that be me? Could my make-believe harness their following?

And now, much later, tending to my prolonged coughing, the horrible pains in my sides and belly, and the shattering headaches that blacken my clarity, my mother is still with me. Her image, however, is becoming faint. It is like the empathy I feel for common people who have proved so useful in my political life. This is one of the advantages of editing your own dreams, if not your own history.

*riding in the geography
of children*

excavation of lost childhood

Ransom 10 *sleeping 7*

Ransom 10 *sleeping 7*

HIDING IN THE GEOGRAPHY OF CHILDREN, 2010
WATERCOLOR
30 X 22"

EXCAVATION OF LOST CHILDHOOD, 2010
WATERCOLOR
30 X 22"

6
J.Q. ADAMS

I embrace verbs and nouns when they behave

1825 — 1829

SINCE I DWELL BOTH ON LAND AND OVER WATER, MY TRUE HOME IS MUD. Wet dirt has its place. Wherever I am, on water salt or fresh, on land, or wading through mud, I keep a journal, a lonely man's harbor. A man willing to change his surroundings can still be difficult, irascible, and not readily given to compromise. But wherever I am, like my father, I have dedicated myself to principles with great cost. My father followed party and parochial ideas but aimed always to comprehend the larger compass of every subject and give its range uninterrupted expression. I do the same.

My notebook reveals my discomfort and also the burdens of introspection. I prefer words to people and choose clean white writing paper over social interaction. Writing reveals my authentic voice, real and unashamed. I write to sidestep the threat of my own extinction. That is why my sentences move beyond the paper on which they were composed, rather like people who leave home and occupy new spaces. My new places reside in my own body, smooth and rough, rounded and flat. The past does not get lost so quickly if you let it breathe in your own flesh. This is how I evade the blue shadows of depression that dwell around me. This is how I embrace the ambiguity of other people's sentiments.

Because of hemorrhoids, I stand tall at an elevated desk of American oak that accommodates the quick mind inhabiting my short stature. My arms enjoy wide expanse, expressing my thoughts as I stand fully engaged with a brain that moves faster than my pen. The ceiling above my desk is high, and if I stretch myself ever so slightly toward the window on my left, I can fathom the blazing multitude of stars, which remain—even when blocked by clouds—oblivious to wind and rain. I make ready to lie on top of these words that express my thoughts.

I have given them birth, and I warm them in their nests, all the while encouraging them to clutter endless pages. I memorize their geography and geology as I pass my fingers over their landscapes. They are a picture of me, my various identities clustered with empathy and clarity. They are islands and peninsulas, some as huge as continents. They grasp and croak,

ADAMS ABSORBING LANGUAGE, 2011
OIL ON LINEN
60 X 40"

purr and cry. They create a steamy laminate, pulsating to emit a dark odor of life expanding. The words and their surfaces begin to breathe on their own, quivering with tongue and kiss. The exhalation soon lessens, and there is quiet. My fingers pull back, and the world diminishes in the wake of my words. I sit.

My mother's arrival interrupts my stillness. I lock my desk and rearrange the parts of my face, erasing the caress of words and even those pleasures of language that are free of shame. She comes with a quick walk, a questioning countenance, and lips pursed with correct embrace. She brings disapproving silences and judgments spoken by eyes that move up and down like piano scales, predictable and decisive.

My words, at other times so proud to inhabit my flesh, get stuck in her wake. Some retreat. She projects on my clear surfaces an image different from what I currently show the world. I counter her distortions with distortions of my own. I meet her only as far as speaking the half-truths of obligation she wants to hear. And what are those words that are not mine? That I can be a great man, worthy of emulation, a "Guardian of the Laws, Liberty, and Religion of our country." My father, when present, hectors in echo. "Your Conscience is the Minister Plenipotentiary of God Almighty in your Breast." Better dead than a graceless child, they eventually conclude.

Keeping a journal is part of the enterprise of never disappointing my mother and being worthy of my country, which is another name for my father. I am twelve-years-old. Father speaks gently but firmly, explaining that three books are essential to the life of a thoughtful man. He must have a ledger of expenses and receipts, a letter-book, and a diary. In the last, he can take stock of distractions and then strike before they have a chance to rule one's life. One can hold in check fantasies that entice the walker off the path and halt inappropriate emotions before they become passions. Language is a tool that not only describes and refines my relation to my body but also defines my powerful connection to an inner life. I converse with myself.

Fearing the dullness of life, I embrace sensations on paper. I caress words as if they are breathing flesh, as if I am savoring the surfaces of bone and skin, the sensuous delights of a woman's body. I value the tapering irregularities of arms meeting shoulders with the juncture of hair and sweat. I prize with increasing delight the spine, elongated and languid, as it meets the pelvic girdle.

As I age, I trace the decline of my powers by rereading old words and see my lessened vigor in the faces of blank pages that cry out for my intersection with a passionate partner. My thinking and physicality are measurable in my journal. I once left residue on my pages, but mindful that someday these spots and splashes might become telltale evidence, I now wash the pages clean. (I remain a good son of my father even after his death.) I am less concerned that the evidence of my passion is less frequent than intense. I fear that this diminution will soon be accompanied by parallel responses in mind and aspiration. Above all, I fear the depression that will stiffen the muscles of my jaw and throat, tense my lips and forehead, creating there concentric circles of pain. My eyes, which read books more than they contemplate human faces, yield a rapacious pugnaciousness. I begin to resemble my gloomy father and have adopted the furtive walk of my unyielding mother.

It is easier for me to pine for an afterlife, a place of safety and good conversation, free of enemy and false friend. Those whom we have loved might reappear to us unscathed and approachable, so that we can laugh and together reinvent the world. Sometimes I dream I have a twin within me, sharing my soul. We are complete only when we are

together. But when I look, I can find neither him nor my heart, which seems to have taken up residence in the pages of my journal. By this sensible transfer, I have made airtight the empty cavity where it used to pulse. Did I use such a sturdy unyielding material so that no one can gain access? Though I visited this chamber periodically, even I discover that I cannot find its entrance.

It is at this stage of my life that an enormous shadow of a nose hovers over the pages of my journal. I study it carefully in order to ascertain the origins of its hooked, columnar shape. It belongs to the indefatigable Andrew Jackson (my successor as president), and on certain dark days, this beak remains more or less sequestered in the margins of my journal. At other times it rises and stretches its bony cartilage over the entire page and obscures my handwriting.

I take icy baths and scrub my body with a coarse horsehair mitten. I swim the Potomac against the current, to resist both an unruly mind and indulgent body. The image of Jackson must come from that part of my divided mind reserved for my enemies. Somehow, he has gotten out of his chamber. I have always enjoyed combat against those who have destroyed our public trust, and it is natural he will seek me out. This makes me righteous. I am hating as my father taught me.

My wife transcribes what I dictate after I am felled by a stroke and die. Her nose replaces Jackson's across the width of my journal. I detect a sustained struggle between my wife's face and my words. When no one is looking, I struggle to delete the presence of noses not my own. Jackson's is long gone. Louisa's vanishes rapidly from the pages but clings to the binding (she has always had trouble letting go). These last pages will be my rubbish books, miniatures of my last days.

But it is during these painful moments that the silences of my life swell and stretch unmercifully. I no longer have anything to say. It is then, I suspect, that the shadow of a short stubbly nose will become a gradual occupant of my pages. To break this intolerable trespass, I try speaking to those nostrils (that part of a human nose that invites discourse) that invade my privacy and surround my bed. I craft pithy sentences to lure a response, but my delivery is harsh and choked. The nose seems to listen but gives no indication of any willingness to respond. I feel the sadness of reproach.

I know this nose hates. Having fathered me, it also teaches hate. Can I ever abandon this inheritance and forgive the world? But that, I sense, will entail forgiving myself, if not my father, who continues to linger on my pages and cast shadows on the whole of my life, even in mud, while I sleep.

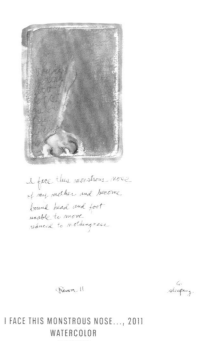

I FACE THIS MONSTROUS NOSE..., 2011
WATERCOLOR
30 X 22"

5

MONROE

Pillow dreams

SOMETIMES IRREGULAR, WITH DEEP FOLDS. Sometimes flattened by the indentations of movement as the night pressed against its cool surfaces. Sometimes I found it on the floor, where it had been thrown in the darkness. On occasion, it hid under the bed. Mostly, though, it lay inert on the top side of the quilt with its cousins, waiting to be used come evening.

Gradually, I discovered an approximation of who I was, like a mirror that only slowly releases its secrets. Here were the curious impressions of my forehead, strong nose, and vigorous chin, together establishing a clear and forceful silhouette of how I perceive my world. The ears that listen before surrendering to my mouth left subtle indentations and appeared to be alive and alert to the intoxications of dreams.

The nation valued my dull and gentle practicality but did not frequently reward me for forty years of public service as a state legislator, congressman and senator, ambassador, governor of Virginia, secretary of state and of war, and two terms as our fifth president. Though the outline of my head altered over the years, I can see the impact of having changed offices—each shift showed in the aggravation of impressions on my pillow, which determined my dreams. I thrashed in frustration with foreign affairs, rested without friction as governor, and, as president, awakened frequently during the night to smooth out the bulk and girth of my ever-present headrest.

In old age, my pillow, grown threadbare in poverty, seemed to collapse under the weight of penury. So if you seek to know me, the real me, not the person who has occupied an array of political offices, then you might best consult my pillow. It is there that I appear.

And why is this? Being a sober, somewhat predictable man not hugely imaginative but sound in word and deed, I give form to my dreams only at night, mostly alone. What I experience is inevitably etched where I rest my head. As a young man, I encountered a sleep disturbance in which my air passages collapsed. I had to fight the suffocation that kept oxygen from reaching my lungs. So I lay still and concentrated on breath, however shallow. There, too, dwelt that flexible camouflage created by expression, its nuances, the manifold subtleties of human communication, the building blocks of memory and intellect exposed to the world in other forms.

The window near my bed opened to emergent dawn as a sheet of blue-white glow drifting across my bedroom. This half-light allowed me to see the rest of my body, and I was

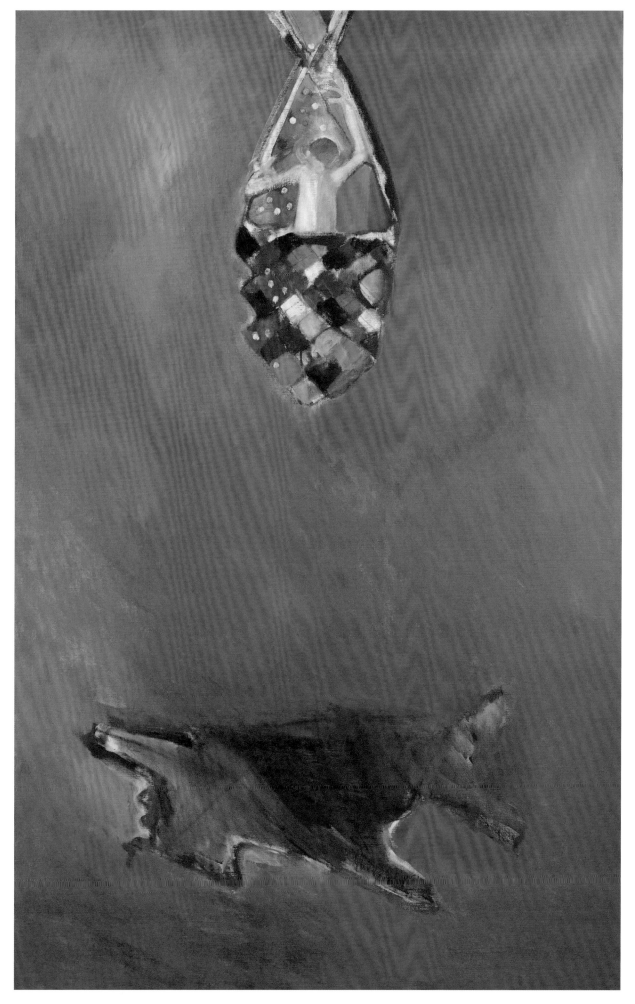

MONROE VISITING AMERICA, 2011
OIL ON LINEN
65 X 42"

encouraged by my physical existence, still intact despite blocked breathing. I examined my tibia, which also rested on a pillow.

As I sit on the edge of my bed, my breathing becomes deeper. I observe my pillow respiring on its own, a white sail that has been cut loose of its moorings. I stand and with arms reaching up to the ceiling, stride to the window to close it. Turning, I take pleasure in being upright, despite the greater stability found in using all four limbs for locomotion. Yet even on two legs, I walk readily and noiselessly into the labyrinth of rooms in my daughter's house. Everywhere I find choices not taken, doorways not entered, staircases and balconies that invite but lead nowhere. Strange doors open into boundless but empty cloisters.

My pregnant mother had breathed sweet Virginia air, had consumed squirrels and small birds baked into pies. Her loneliness, engendered by her coldness and detachment, was carved into her children also. Even our father's quick anger, impatience, and discomfort with being touched passed into the taste and smell of the seed from which his sons germinated. I can see my own form incorporating all the ancestral dimensions that were passed on to determine the content of my own descendants.

As my eyes dim, I need my pillow for longer stretches of time. My inner sight projects an American landscape that disposes of contradictions. I begin relearning the alphabet that made the words, that created the concepts I have always trusted. As I trace the shape of each letter on the page, my ideas also expand and come to occupy the larger atmosphere that surrounds me, the earth I walk on, the pillow upon which I rest.

I have come to understand that the good work of the Founders, of whom I am the last, is complete. The future belongs to the new faces who will lead us into unrecognizable landscapes. My pillow records this phenomenon, its smooth surfaces having jettisoned my own long history. It now invites new hollows, fresh dimples, and upstart clefts into its smooth white surfaces.

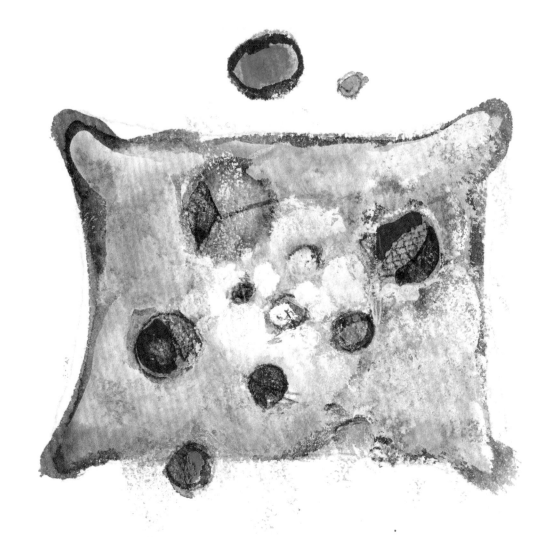

*moons surrounded my pillow
and effaced my image.*

Ransom 10

5.
sleeping

MOONS SURROUNDED MY PILLOW, 2010
WATERCOLOR
8 X 8"

4

MADISON

My bed of ideas

1809 — 1817

MY HANDS ARE BUSY DREAMING. I turn pages, use my right index finger to guide my eye down the page. I feel little need to leave my house, which is more than a home. Safe and secure, noble and mine.

Today I am cleaning my books: dusting, washing, rubbing away accumulated mildew. Like old friends, books need attention. They do not appreciate direct sun or humid corners, for either would destroy the volumes as objects and thereby limit the force of their ideas. That is what I like most about these objects: they are a physical record of thoughts made palpable. The visible signs of my readings of them reveal clear testament to my ownership. Here is a rip recorded on page 112 when I expressed indignation at what is written there. But then, on page 207, there is a discolored tear, an expression of openhearted pleasure. I find a tea stain rendered the red leather cover a dark and forbidding magenta. It is smeared where an attempt to wipe away the tea created an even wider and deeper blotch. I have owned this book since my college days.

The curious configuration of the stain manifests the context of the spillage as youthful enthusiasm and even calls up the content of the occasion. It seems that so little time has passed since I assisted Professor Ritterhouse with apparatus that represented the predictable motions and phases of the planets.

At Princeton, I met my world for the first time. This new universe functions like a clock—a precise calibration with rhythmic cause and effect. Through reason, men like me can contemplate and work toward the enlightenment of human nature. Toward progress. The tea stain brings all this back to me.

Did it happen this way, or am I substituting a different occasion or revised meaning? Even when I see my penciled notes in the margins, I get uncomfortable feelings, consider that my active imagination converts wishful memory into truth. At my advanced age, I cannot tell you about anything that I have loved unless I believe I have lost it.

In my library of dreams, surrounded by my books, I find freedom. Their ideas and lively presentations require me to place their physical presences in some kind of order. I do not arrange them by color. I am certain some authors would not feel at home with neighbors of incompatible intellectual hues. Nor do I arrange them by size, which smacks of excessive practically and allows the carpenter too great a role in determining placement.

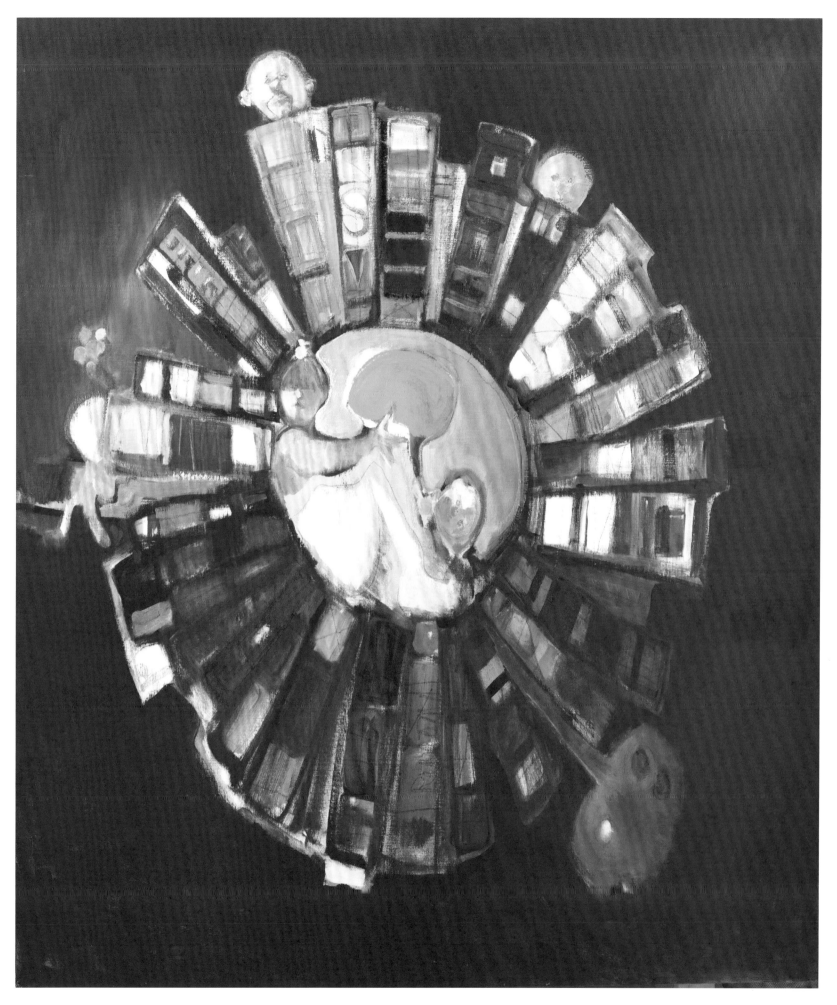

JAMES MADISON'S LIBRARY WITH ALEXANDER HAMILTON SECURE, 2010
OIL ON LINEN
50 X 40"

I have dreamt long and hard on these matters. Ideas are much more important than the people who devise them. They are even more important than the people I suffered as president, except, perhaps, for Jefferson and Dolly. So I finally concluded that books should be arranged by the ideas that gave them birth. Aristotle should not have to tolerate John Locke close by. And if he still seems too near, I shall sweeten his discomfort with Shakespeare, who would lighten the chasm by the width of two large folios. Oh, I like this enterprise and feel much as I did when we negotiated the disparities of ideas at the Constitutional Convention. So I keep Epicurus as far as possible from David Hume but not so far that Rousseau and Plotinus cannot prove happy landscapes connecting these opposing minds. And it works, as confirmed by the general chatter that takes over my library. I do admit, however, that certain authors are not allowed entry inside my home. I never know where to place Hamilton.

This remains a problem, even in death. Hamilton hated me and betrayed me continuously. I become angrier the more I consider the toxicity of his ideas: a federally chartered bank of the United States, a standing army, a program of internal improvements funded by public debt, a loose and cavalier interpretation of the Constitution, and, most grievous, a clear subordination of individual states to a powerful federal government.

What I do with his books (and I have many), I am a little ashamed to admit. Off the central hall at Montpellier, my family plantation in the hills by the Rapidan River is a room where my ideas can be safe. It has a large fireplace to keep out the damp, and its windows look out at the Blue Ridge and bring in fresh air. In that room is my iron-posted bed with its tidy canopy of crimson damask. I place certain books in various parts of my bed according to how I want to influence them or be influenced by them. Plato on my pillow, for example, and Aristophanes near my right armpit to tickle me in the night. Montesquieu near my stomach to aid digestion and, more important, Polybius near my feet to keep them calm.

Alexander Hamilton, who always played a seductive Delilah to Washington's Samson, usurped my influence on the Father of our Country. I have collected most of his numerous scribblings over the years in order to repudiate his system of privilege, one that would stretch our Constitution unrecognizably and to its death. So where do I put Hamilton's ideas? At first, I hid his tomes and pamphlets under the bed, near my chamber pot. But since his thoughts are still living and powerfully influential, I want to keep an eye on them. I need, too, to monitor my daily reactions carefully. I became prodigiously methodical in crafting my responses to events before they happen, so I would not have to compromise when they occur. In the end, I put Hamilton between my legs, close to my anus, but sufficiently near my scrotum, which rests aggressively on his work, volumes filled with ideas urging a consolidated power that will divide the American people.

But then it happens. Not by humans but by something far worse. Others have debated, negotiated, and sometimes overwhelmed me, but they can never destroy the astral houses of my ideas. My books are as beyond their reach as my ideas are frequently beyond their understanding. Sawney, my slave for many years, was the first to encounter the pustules spawned by a kind of fiery mold that has invaded my house.

Needing wet weather to thrive, countless spores have moved from my conterminous fields to take up residence in the library. This fungal infection attacks first the books' spines, then mounts a determined assault on the very pages on which my ideas rest. The ancient Romans sacrificed dogs to keep mold in check.

I WAS VISITED NIGHTLY BY AN IDEA, 2010
WATERCOLOR
22 X 15"

ALEXANDER HAMILTON SECURED, 2010
WATERCOLOR
22 X 15"

I PERCEIVED HUMAN BEINGS..., 2010
WATERCOLOR
22 X 15"

I grow desperate as I watch my ideas devoured. Where once I outlined the benefits of an American embargo against England, suggesting that such an enterprise would force peace on the world and bring liberty as a byproduct, these words on paper become lace. Whole books now vanish and take with them the thoughts that justify their existence.

Daily, the mold devours my ideological presuppositions. My very being shrinks. I become smaller as my ideas disappear, and I spend more time in bed keeping an eye on Hamilton, still resting between my legs. But to my horror, I discover that many of his ideas remain safe because his books rest comfortably in the well-ventilated warmth of my crotch. I am forced to conclude that it will be his views, not mine, that will prevail. America will not be a Jeffersonian idyll of an agrarian society with Doric columns. It will not be the workings of a well-ordered universe that, like a clock, orders human behavior. No, the Hamiltonian world of banks, stock exchanges, a strong central government, and all the darkness of unleashed human nature will be our inheritance. He is everywhere. Even in my dreams.

3
JEFFERSON
Resisting dreaming

IF I MUST DREAM, I PREFER THEM TO BE SHORT, FREE OF NOISE, AND WITHOUT MYSTERY. They should be composed in black and white and with as few intermediate shades as possible. Better they have few details. Better they be shadowless. I like when they embrace my good hopes for the future rather than the burdens of my past.

This evening I am tired and follow my usual habit of retiring early. Might I dominate the nocturnal realm where the excesses of unbridled dreaming overwhelm me and leave my mental discipline unguarded? Quantification puts me at ease. I am happier measuring and counting. Timing everything that moves. My books are folios, quartos, and octavos, all gauged by size rather than content. But I know I will quickly grow dissatisfied with simple enumeration and will want to integrate my calculations into a larger, rational order, however tiring that might be. I am attracted to Bacon's structure of knowledge, his division of all our understanding into 44 categories. This allows me to find certain ideas by reaching readily for the book that encapsulates those particular thoughts. Heaven!

I understand that the practical Romans valued facts and explored what is known before they generalized. Although I salute this method, I am much more attuned to beginning with a large idea that I can rationally defend through authority or common sense. Then I look to find in it all those elements of nature that support my generalizations. So do I not, in every waking moment, demand of myself the same hard-won proportion that I have already discovered in the Newtonian universe that surrounds me?

I am convinced that the ideal space for my library is a balanced rectangle with no doors or windows (shielding the reader from draughts as well as distractions), where all four walls can be organized to house books from floor to ceiling. Put my bed in the center, surround it with a copious number of candles, and I will be happy. From that spot, I can change history with verbs, nouns, and adjectives to create a liberal, democratic America even as I reinvent myself. The prepositions will come later.

During the warm months, which can be oppressive, I seek out the underlying logic in nature. I do like to begin with my own body and chart its hourly fluctuations, for they can change my proportions. Take my legs, long and thin, the left slightly bent outwardly. Since we humans are no longer four-footed, a clear burden is imposed on my lone two, which must pick up the slack of those now missing. Mine have become stronger, larger, and more

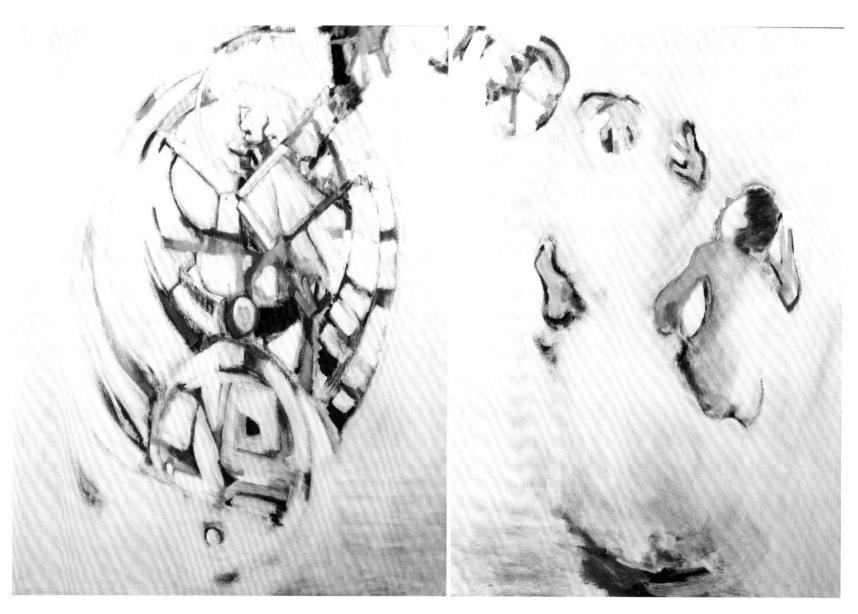

JEFFERSON OLD MEN'S DREAMS, YOUNG MEN'S VISIONS, PANEL 1 AND 2, 2011.
OIL ON LINEN
70 X 105"

adaptive to disruptive ideas, especially at those moments when I must stand up to the insistence of Hamilton and Washington on a strong federal government that will destroy individual liberty.

The distance from the sole of my foot to the bottom of my kneecap (I am measuring only my right leg, the more stalwart of the two) comprises one quadrant of my entire length. Mr. Madison owns stubby legs, little and beetle-like, and although I have not measured them, I am convinced that his span would lend itself better into trichotomies.

From knee caps to hips makes up the second quadrant, and I strongly resist the recommendation of Vitruvius to measure this part of my body lying down. From my reddish pubic fluff to my chest is the third quadrant. My outspoken heart has left its safe haven in my upper-left chest cavity. That is the spot that nature, in its wisdom, intends. Yet in defending (and hoping to expand) a newly minted America, I have had to go on the attack and use all my resources, even my resistant heart. Defamation is like fertilizer.

Hence, I must report that this struggle to maintain the nation has forced my heart to jettison its kind and gentle beat as well as find a safer, more practical home. It now rests comfortably in my mouth, which is in the last quadrant, the one that is measured from my chest to top of my head, the not-so-secure home of my brain. This topmost organ, divided and subdivided into left and right chambers, controls the forms of my thinking and is not happy to share the top quadrant of my body with my heart. My mouth has become dry since my heart's migration; it no longer produces enough saliva for masticating or sufficient liquid to keep the heart moist and happy.

On the whole, I have found that, despite the recent disruptions that come with public office, I am a sort of equilibrium in motion. Adding a glass of warm milk to facilitate sweet, dreamless sleep assures that my equilibrium will continue through the night.

Then it begins. The pain increases by the minute, traveling upward from my left temple towards the center of my forehead. Purple and black flashes spin across the top of my head, much like an iron halo has fallen upon it. A dance of blue and orange stars overwhelms my field of vision and objects appear fractured, broken into irregular and polygonal shapes. The books, always supportive, gather around me on four sides. But they develop unnaturally sharp contours and flatten without dimension. Indistinct, they begin to fuse, to bind together like the pattern of a carpet. The room divides into two unequal sections; the one I occupy is the smaller. The other side of the equation seems less real to me because it is transformed into a symphony of old echoes, the sounds of conversations that once unfolded here, played long ago by people known to me but now dead. The ideas and feelings they exchanged now return fresh as the moment they were first articulated.

I rise from my bed. I leave my room, my books, my house to venture outside, where dots and flashes of color move across my field of vision. Trees and grass multiply. Some take up residence in a generous sky, evoking total immediacy with no horizon.

Round and round, my steps take me up mountains of ever-changing dimensions until I arrive at my greatest height. I see the earth fully, completely. Or is our planet only a small detail? Existence stands motionless, breathing suspended, eyes downcast, only to emerge more fully when the north wind begins again to fill my arms and push me to my destinations.

As I descend, I sleep. I awaken in winter, and my visions have retreated into the fathomless abyss of dreaming. The promise of early spring's budding yellow-greens and the human drama of practical, everyday life overwhelm me. Domestic finance elbows my earlier joys. I dream of tobacco, tendrils of wiry leaves spreading out in front of me, exhausting the soil and its pickers. My ledgers and I are forever out of balance, hostages to smoke and the unpredictable habits of human dependency.

This is when I feel obliged to follow

feeling light
darkness opens,
space + time becomes
broken + unmade.

Jefferson as an evolving
egg

FEELING LIGHT DARKNESS OPENS.SPACE AND TIME BECOMES BROKEN AND UNMADE, 2012
WATERCOLOR
30 X 22"

JEFFERSON AS AN ~~EVOLVING~~ EGG, 2012
WATERCOLOR
30 X 22"

not my visions but images of myself walking, a slow crawl interrupted by frequent greetings and social niceties. Small bows, respectful smiles, cane to hat. I come to know them all, embarrassed by my absorption in a ritual that can only lead to its own expanding and controlling perpetuation.

Returning home, I wait for that other self, that other dimension, presidential and circumspect, whose rehearsal of the expected has defined my new existence. When he does arrive, spent and sweaty, a profound and desperate melancholia will follow him through the side door of our dwelling. And with this painful lassitude,

a desperate and uncontrolled imbalance takes over the dark places of my mind. The wisdom of my generation has generally diagnosed this invasion as a defect in our nervous system. Yet other physicians, not so metaphysically inclined, will point to the epigastric juices of the belly where liver, spleen, and gallbladder reside. My selves know better. If you look beyond the sleeplessness, dizziness, and roaring in the ears, I have become a conscientious observer of our ever-changing condition. A war rages within our being. Then it all stops. Life is still. Then, again, I pass clear, pale urine and vomit bile to being my day as president. The cycle resumes.

2
J. ADAMS
Me and Abigail dream together

1797 – 1801

WE SLEEP A LOT. After all, we are embryos. I say we because there are two of us. Me and Abigail. Yes, two of us, John and I. Frequently we speak at the same time, but there is no confusion as to our purpose. We are one. Sometimes there are more of us.

Our bedroom is a womb, and we share a common placenta, which is hugely accommodating to our sometimes-unexpected movement. Our umbilical cord being unduly long and flexible, we transport ourselves with ease and fluidity. Our mother's womb is a typical five-room New England saltbox of simple, practical construction. Mother's flesh conceals rough, hand-hewn walls of oak, their strength buttressed by brick and finished on the inside with lath and plaster somehow soft to the touch. Nature had fashioned one large commodious space, but Mother's practicality led her to remodel the original. She has shaped three rooms below and two rooms above. I suspect her intention was to separate us during our long courtship. A very narrow staircase tucked discreetly to the left side, connects the two levels.

Me and Abigail dwell in the ground floor exclusively, which is warmer and more accessible (it is not true that heat rises), and our accommodations are secured by a sturdy stone wall that keeps us from unwanted visitors.

John and I prefer the spring and fall seasons, months that are becoming something else. Winter and summer are fierce but I like when the shadows in his mother's womb lengthen, as she lets in only so much light, perhaps to remind us that we are but guests in her body, under her control and that of the Adams family.

I brush aside Abigail's emerging honey-colored hair, which makes my heart dissolve, and stare at her face. Here is a countenance displaying open and spontaneous emotions alongside darker, even hidden, thoughts. I learn to read her face along with her ideas. I study her face maturing as we await birth and see the expressions that reflect her stalwart character.

when I look into your
eyes, I see myself as
your pupil.

Ransom 13

2
sleeping

Ransom 12

2
sleeping

THERE ARE 2 OF US (SOMETIMES 3), 2013
WATERCOLOR
22 X 15"

WHEN I LOOK INTO YOUR EYES, I SEE MYSELF AS YOUR PUPIL, 2012
WATERCOLOR
22 X 15"

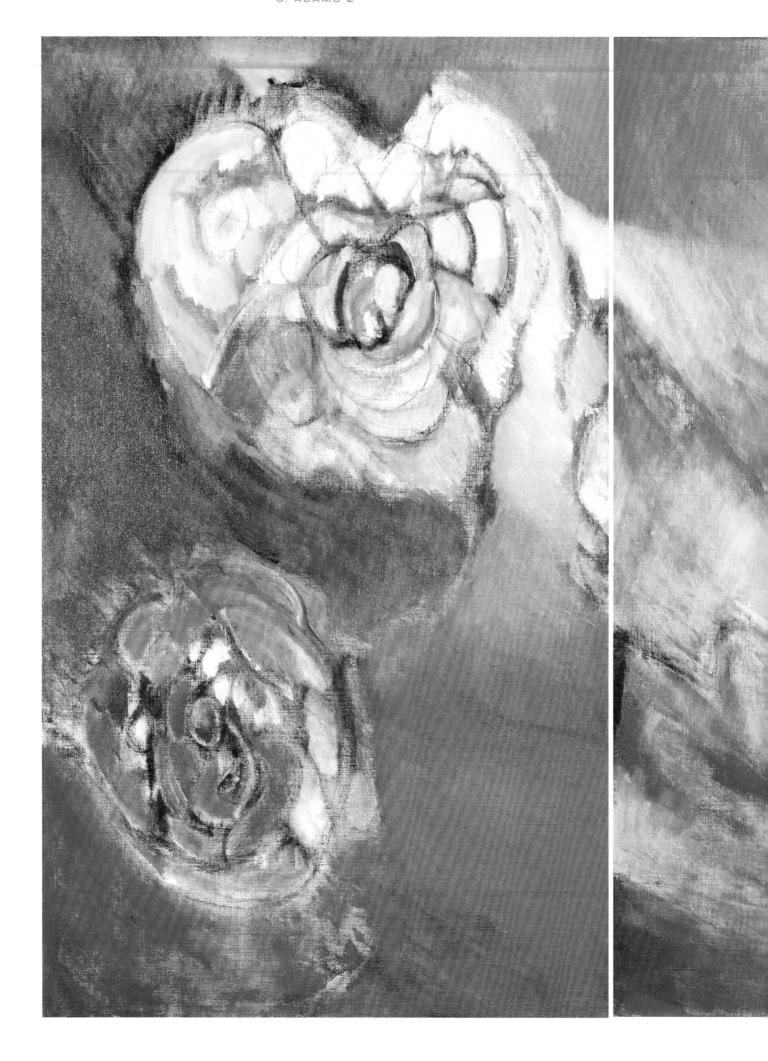

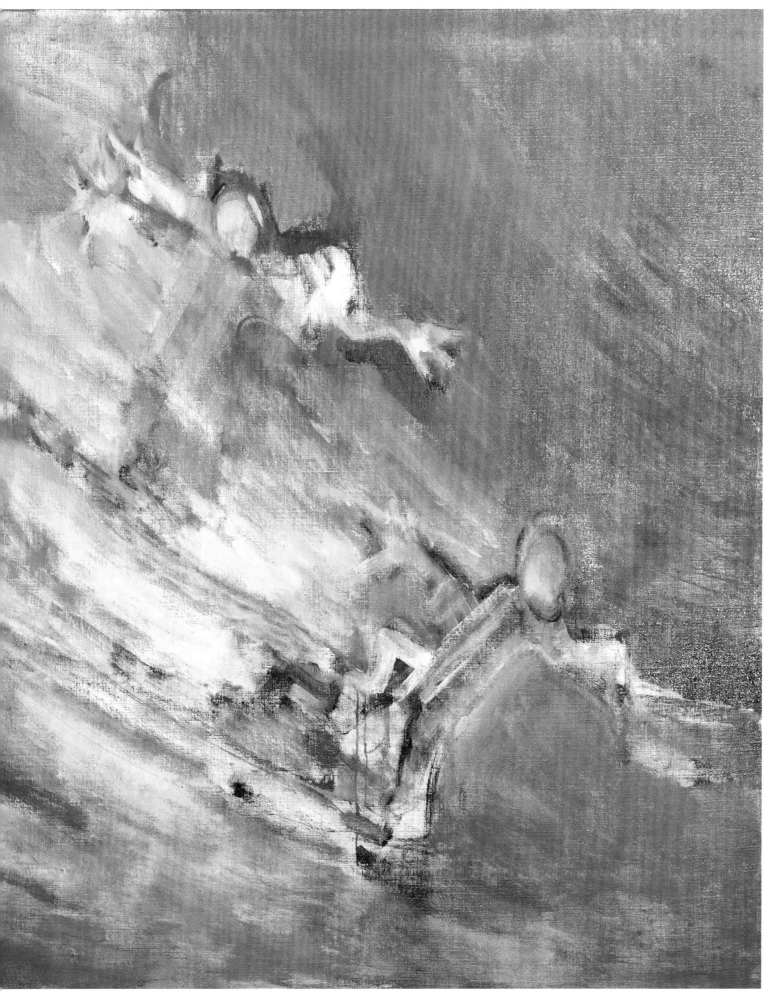

JOHN AND ABIGAIL ADAMS SHARING A COMMON PLACENTA, PANEL 1 AND 2, 2012, OIL ON LINEN - 50 X 80"

John's face also shares his inward thoughts and makes them unfortunately clear to the world. He is old before he is young and frets about his hair. I sense that many of the strands are just resting, soon to drop out, never to be replaced. Is he not like his father? Although he is still fetal, the whole of his frontal hairline starts to recede, ebbing farther and farther back.

We both think (we are talking simultaneously) that all humans (especially from Massachusetts) are born with an "innate moral sense" that must be coupled with a vigorous education. Mr. Locke believes newborns dwell as blank slates, good or evil to be elected by our own hungry souls and greedy fingers accordingly. Is it not the arbitrariness of human beings that makes the constraints of government necessary?

As John will tell you, our family has had its share of alcoholism, indebtedness, and unsteady marriages. They tried hectoring and then issuing commands, convinced that our souls are but guests in our thankless bodies. We will do the same with our own offspring.

In the beginning, we believed that the loud noises we heard in the upstairs of our womb are the mutterings of Mother's dysfunctional stomach. The gurgling and hissing is one thing, but irregular thumping sounds have of late convinced us otherwise. John, who is quick to assume the worst, is convinced that it is the dancing of ghosts— not just any ghosts but those of the Adams family. The patriarch, whose seed continued the long life of farmers, lived his whole life in Braintree. What public devotion they evidenced was focused exclusively on a fifteen-mile radius—four generations had been born and died in this same house. Being thrifty, they all occupied the same womb in turn. Better to use a womb that is commodious and well made, one that can be passed from father to son. Since life is not easy and should never be taken for granted, the Adams family has always been able to claim they were their own men and the equal of anyone. The women have been quieter and less remembered.

Truth be told, Abigail is my dearest friend—worthiest and dearest friend in the world. She is there for me. When I am low in spirits and under-appreciated in my public life, both she and our common womb sustain me. On its walls, inscribed by four generations of Adamses, are pithy admonitions that we have all taken to our hearts.

"Let frugality and industry be our virtues."
"Fire them with ambition to be useful."
"Great necessities call out great virtues."

Yes, John is the tenderest of husbands and when we kiss, it is not just once. He stops holding his breath and kisses again, exchanging his breath for mine. It is as if the North Star has invaded the family womb. John's tongue is given to more than the sounding of his words. Its insertion and quick probing beyond the outer surface of things enfolds my center, the home of who I am.

The banging upstairs has become unbearable. I sense true distress, and it is only right that I venture forth to relieve our ancestors' calling. Abigail looks at me in silence, which I know I can interpret as assent. I prepare myself to go upstairs. Not just a few feet up the stairs, but a journey to the heart of our ancestral being.

I help John put on his dead father's coat, which is still bulky despite its tatters. It will protect him from harm or, I should say, the unknown.

As I mount the steep stairs, I encounter strange objects that impede my progress. Here are the games and candy of youth,

the keepsakes and books of adolescence. Near the top of the stairs, before the turn left onto the second-story landing, I find all the future heartaches of misplaced vanity, the reproaches of my political enemies. They congregate in large shadows that appear poisonous to the touch, spreading a kind of darkness that can kill. Climbing the stairs, I can read my whole life as it opens itself like the pages of a book. Chapters and paragraphs, sentences and words march before my eyes as if living my life before I can live it myself.

Here is a world I can never imagine or perceive. The clarity of detail works its influence on every aspect of my identity. As I get closer to the second floor, turning to encounter the full landscape of this part of the womb, a huge outpouring of light overwhelms me, bathing my body, creeping deliberately into my intellect and powers of observation. There against the slanted walls of the second floor are four generations of Adamses. It is not necessary to name them; they seem in their basic decency and hard-working honesty to be leaves from the same tree. Their fears are registered in their faces.

Do we kill our fathers to reassert the primacy of our own feelings? Do we rewrite their lives so they can become examples for our own? (My father was also named John). On the left, nearest to the entrance to this floor, stands my father as I remember him, before the changes wrought by illness. Still vigorous, he reveals the look I have come in time to identify as American: that the earth as a place to be put right, where innocence is ultimately prized but then lost. His world and his father's before him become invented places: nature to be tamed, struggle as existence. Their modesty and hard work necessitate their being invisible.

I call out to my husband and he begins his descent to join me.

As I navigate back down the stairs, the journey seems less encumbered because what awaits me is a large parasol holding the sun at bay, suggesting the curving dome of the sky. I drag the parasol with me and deposit it into the outstretched hands of Abigail.

It unnerves me to receive the parasol because John has dragged it in a way that turned it inside out, releasing the cruel weather of hard life, ungovernable desire, and uncontrolled illnesses—warnings that this world will not be easy.

John is sleeping now. Since we share a common placenta, he is close to me, and I feel his troubled breathing. Has he seen too much, too soon? He will, he knows, become weary of the shadows of politics, yet clearly cannot live without the struggle. Never in his days will he be appreciated or have popular support. He will be perceived as a loser, his energetic focus as cruel ambition, his self-pity as pious vanity. ("When a man is hurt, he loves to talk of his wounds.") He resigns himself to a future in which rheumatic pains and unpredictable diarrhea will restrict his movements. Insomnia and bad dreams will overwhelm his sleep. His struggle will influence mine.

I often think of mounting those stairs and joining the fifteen-mile circumference of my father's dreams. But I know I do not really have a choice. Or do I?

Or do we?

1
WASHINGTON
Dreaming the afterlife

1789 – 1797

WHEN YOU SEEK ME, LOOK FOR ME IN HEAVEN. Stare up into the dome from the rotunda of the Capitol and contemplate my becoming a god. I have grown accustomed to Americans seeing me in such glory, and the honors they have bestowed on me have constituted a large part of my life's happiness. My portrait is continually refashioned with new clothes (or no clothes) as our republic evolves. I was classically proportioned at the beginning of the nineteenth century, only to be unbuttoned with beating heart fifty years later, and then turned on my head and suffocated by Victorian domesticity at the turn of the next one.

Overwhelmed by so many visions that reflect the aspirations of others, I dream the idea of the afterlife not as a place to be adored but a spot for discovering who George Washington actually is. Is this not a place to undo the confusion that others' views of me have foisted upon my likeness? It is not my purpose to bring back someone else (as when Hercules stole Cerberus and rescued Alcestis). I am going to Hades to bring back no one but myself.

Yet entry to the underworld is not easy, and I am forced to seek directions. I discover Hades lies "beneath the secret places of the earth." Here on the underside, at the limits of the known world, across the river Potomac (or Patawomeck, an Algonquin name meaning a trading center, and no doubt, therefore, a place where souls are traded), is a land blanketed in mist and cloud. This realm of darkness is defined by intersecting streams that flow from deep and murky gorges. The Anacostia River carries sewage so remarkable in size and shape that crossing is easy. Along with the Tiber Creek (sometimes called the flood of deadly hate) and the Wappatomica (sorrowful and black, fiery and deep), there runs the Chesapeake and Ohio Canal (occasionally referred to as the "Grand Old Ditch"), which cries out a lamentation to guarantee oblivion. These infernal rivers disgorge their venomous streams into the burning Chesapeake Bay. Once in Hades proper, I find myself in a barren patch of earth where the dead occupy themselves by recollecting the content of their lives. This discomfiting place near the intersection of Fourteenth and Constitution is unstable and especially stinky because the Tiber Creek, a tributary of the Potomac, flows underground but still contributes to the rank residue left by this year's flooding.

I feel cold upon arriving here, at this place not of punishment but sorrow, and pull my cloak over my head. Now appearing like the dead, I can move readily through their numbers while veiling my ears. Those who died at the battles of White Plains, Trenton, Saratoga, and

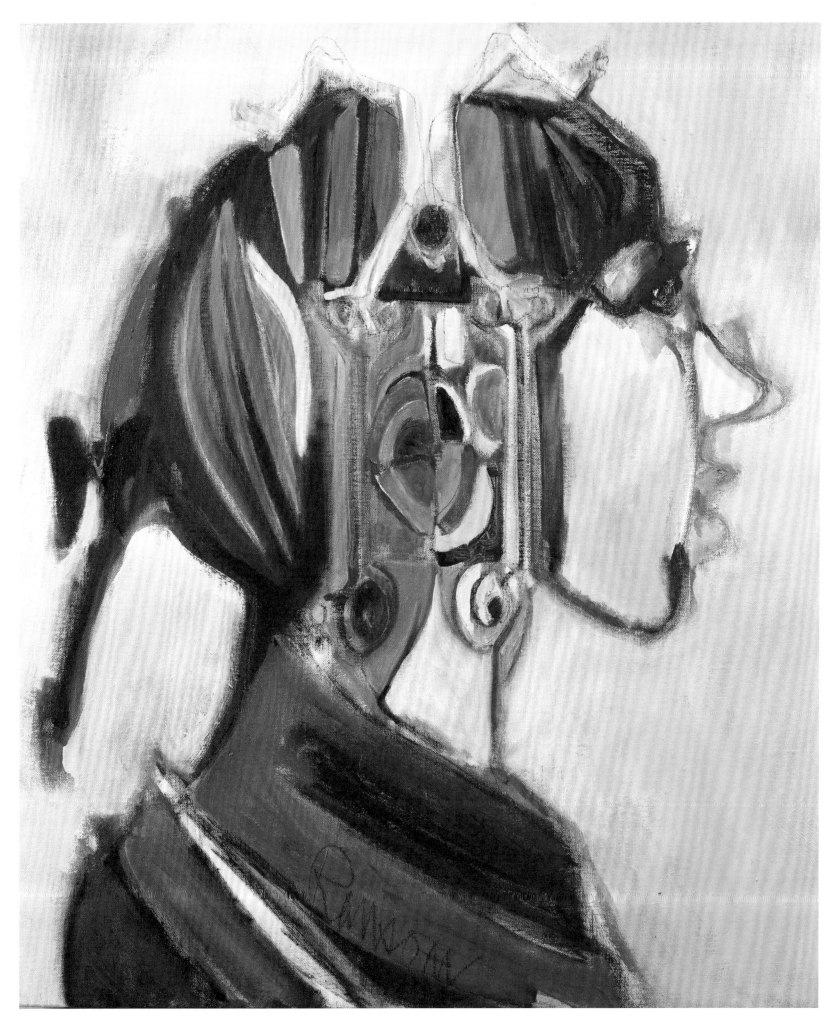

WASHINGTON I DREAM IN MY DREAM ALL THE DREAMS OF THE OTHER AMERICAN PRESIDENTS, 2011
OIL ON LINEN
42 X 40"

Yorktown open their mouths as I begin to encounter all the souls who have touched me in some way or another since the time of my birth.

I see my father, Augustine Washington, who died when I was eleven. I never really knew him. There is my half-brother Lawrence, who lent me the image of a father when I needed it most. I thought I might encounter Mary Washington, my mother, but she is nowhere to be seen. I fear this encounter because I know that I would find her but a vapor if I hugged her. Even in death, will I not find human love here? The steadfast love of Martha Washington or the fleeting love of Sally Fairfax?

I journey to the western limits of Hades, beyond Capitol Hill, leaving the Plain of Asphodel (Adams Morgan). I harken to Elysium, the wide-gated home of heroes and patriots who dwell in a meadow by the North Branch of the Potomac, where it streams from the junction of Grant, Tucker, and Preston countries in West Virginia. Amidst lost and forlorn bushes and capricious flowering weeds, the shades of fallen heroes wander.

I stumble on my way, soon turning north to the fields of Elysium, spaces others would later call Georgetown in my honor. There surges the Wancopin Creek, a tributary of the Potomac flowing eastward to Delaplane, where it levels out and turns in a northeasterly direction. It then passes under US Route 50 and enters a brackish pond where souls needing to return to earth in new bodies drink the salty oblivion of their former lives.

The roar of the highway soon fades as I walk in a determined fashion, noting the small number of primroses and violets. Smelling their surrendered sweetness, I feel the breath of Persephone making ready to practice the art of growth and cultivation before leaving for another realm. I can only guess the season. It seems to be early spring; the celandines are beginning their journey to yellow. I walk on, and these blooms' promise multiplies as their clusters thicken and grow increasingly bold. I smell Hyson tea, gooseberry jam on toast slightly burnt at the edges. I follow these odors knowing full well they will lead me to Sally Fairfax, who seems to have set up her household near a grassy meadow, open and fertile in the southern suburbs of Hades. The sky is a rich purple, and I watch a bank of puffy clouds tame the moon. Only Sally's dripping gutters break the silence of my visit.

I fail to find her and decide to await her return. I sit near the chimney, one garlanded with flowers and grasses. The hearth is black and thick with soot, suggesting continuous fire. Sally has thrown her last-worn clothes in calculated confusion on a bed still warm with sleep. Her outer dress of silk and ribbons suggests strong limbs, and her linen undergarments are arranged to expose their owner's hot flesh. Her large breasts have made permanent indentations in the fabric. Fingering them, I discover what I had only imagined.

The happiest moments of my life were in Sally Fairfax's company. Now, pressing her clothes to my body, I become her and feel her feelings about me and about all the thousand things we discussed over the years. And everything we could not discuss. When I touch the curves of my own body, I encounter hers.

We met years ago, but our union could never be consummated because she did not fit into the larger picture I had constructed for my future. I begin by pressing her underwear against my face and then take her linen sheath and draw her to me, holding my arms tightly around the garment. The fabric surrenders all resistance and transfers its sweet sweat to my own flesh. My blood surges with desire as I slip this generous shift with low neckline and elbow-length sleeves over my head to become the beloved object of my tender desire. In

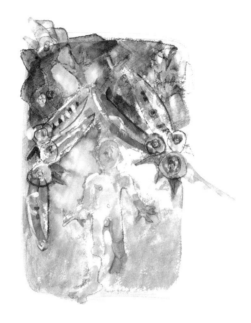

George Washington emerging

Ransom 11

sleeping

GEORGE WASHINGTON EMERGING, 2011
WATERCOLOR
30 X 22"

the architecture of my body, there has long dwelt a large amount of inflammable matter, however dormant. At this moment, the torch is put to the pyre, and I burst into a blaze that threatens my existence. I fear extinction.

I am a big man, muscular and forceful, but her clothes suit me. The feel of silk against my military skin leaves me quiet and pensive. The soft ribbons delight my eye and touch, and I savor the rapture of feeling what a woman feels. Everyone has his own fashion of loving. Mine does no harm to anyone, though I would not want to be known as the

Mother of his country. Having been born with my clothes on, I am perceived by my countrymen as puzzling and unemotional. I share this other side of my heart and head with no one.

The inexhaustible inventiveness of love colors my gait. The sun follows me, and flowers survive long past their time. I take no shortcuts but walk the full course, experiencing all those precious moments when stars actually multiply in the sky. I return to her bedroom, undress, and become me again. In our actual lives, her absence is all too real.

I leave from her backdoor and never look back, but I suspect I have left a large part of myself behind.

Looking forward and walking quickly, I encounter the smell of oranges when I again approach Route 50—farther to the southwest than where I left it. The aroma merges with that of a robust red wine and later, closer to my destination, the untamed rustic smell of a hearty fare of roasted pork with scallions fills the air.

The scent of the country permeates my own body and cohabits with my Martha's subtle odor of domesticity. She always lays her table promptly, and we dine facing one another. I take full bites, sometimes out of frustration and impatience with life. She encourages me to nap after eating, promising that it will aid my digestion. While I sleep, she brushes my uniform, mending whatever is askew. Sometimes she fastens sprays of fresh oak in my pockets and hides tufts of bluebells and woodruff in my boots.

She is as short as I am tall, round and plump with a double chin and high forehead. Many think her older than me. Time is not gentle, and her plainness has not improved with age. But her sweet kindness is shown in her dark brown eyes, which she wisely highlights by wearing pastel garments of cream and pale claret she has stitched mostly by herself. Ours is a relationship closer to companionship than romance. Amorous striving never haunts the compartment in my heart that is hers. Its own perfection is indentured to domestic compromise.

Our union never achieved conception, and perhaps my childless state encouraged the perception of me as the Father of his country. For me, at least, that is true. I have no child but America.

I have no desire to dress in Martha's clothes because I know her in other ways. Frequently I visit the small attic room on the third floor of our house where she spends pleasant afternoons sewing with two of her domestic slaves, Moll and Oney.

I finger closely the clothes I am now wearing. I must be a hard fit because of my wide hips. These uniforms, coats and breeches, came from London, which she then trimmed and fitted, scored and hemmed. And so I know my wife through my garments. I undress and spread out the breeches, coat, and shirt Martha tailored for me. How handsomely the different parts come together. Pleasure lies in their touch, pride in their junctures. My apparel provides a practical mirror to a relationship that occupies the top compartments of my heart and fits me with a secure and safe foundation for my own life and its public character. To know my clothes is to understand Martha and me.

I examine carefully the tiny overcast stitches she has made in my coat, veiling the raw edges of the fabric. Those at the shoulder tie together a variety of fabrics, freeing my limbs for vigorous action. This overcast stitch also protects the raw edges of my character, helps restrain my quick temper and exasperation, and dulls the sharper edges of my behavior. Understanding me, she uses blanket stitches to thwart my mind's unraveling and straight ones, so simple, to bring the different dimensions of my character together. Then I slip on my shirt; it veils my impatient heart with a reinforcing slipstitch when I do not want my feelings to appear visible.

Finally dressed, I look at myself as Martha would see me. My apparel, grand yet simple, integrates different dimensions of my life by stitching them together so that they might be seen as a whole. It is a two-dimensional projection on top of my body, correcting my many human foibles, masking my reluctance to trust and even acknowledge my passions. My meanness, obsession with self-control, and terror of failure are cleverly shrouded in the cut of the garment. Martha's deep and primal sewing of my too-human existence and my fear of disappearing within my own public reputation together celebrate the dialogue of my head with her heart.

Only those truly observant will notice the sutured wounds near my heart. Sewn with carefully composed overstitches, they seem an impenetrable support for healing. These lesions (and there are many) came mostly from deliberate blows by unlikely attackers. Instead of the up and down of the simple straight stitch, Martha brought the

she adapts her weave to those feelings she wants you to feel.

for Martha *Ransom 11* *I sleeping*

SHE ADAPTS HER WEAVE TO THOSE FEELINGS SHE WANTS YOU TO FEEL, 2011
WATERCOLOR
30 X 22"

hearts of my contemporaries

Ransom 11 *I sleeping*

HAMILTON JEFFERSON MADISON ADAMS HEARTS OF MY CONTEMPORARIES, 2011
WATERCOLOR
30 X 22"

needle around the edge of the laceration and pushed through from the bottom up.

These vicious wounds, mostly from presumed friends, left deep hurt. Voracious jaws and rounded teeth inflicted significant damage to the tissue under my skin, affected blood vessels, bone and muscle, tendon and nerve. My military retreats must not be perceived as defeats, certainly not as failures. Like Moses, I would prevail not by destroying my enemy but by maintaining a united cause grounded in a

belief in these United States. Martha and I stitched these dreams together. With her loops of thread removed, the scars, once raised and bloody, gradually flattened and lightened, yet remained a visible badge of our commitment.

I remain in her attic room, examining closely the handiwork of my wife's steady hand. Her stitches, like Penelope's weavings, are strong and solid. Predictable in their cohesive dedication, they have no need to unravel, and I wake up.

preventing

my unravelling

with a cross stitch

Ransom 11

sleeping

PREVENTING MY UNRAVELLING WITH A CROSS STITCH, 2011
WATERCOLOR
23 X 15"

to really know
my friend, I dressed
in her clothes

for Sally Fairfax RANSOM 11 sleeping

TO REALLY KNOW MY FRIEND, I DRESSED IN HER CLOTHES, 2011
WATERCOLOR
23 X 15″

AFTERWORD

Dreams that can only wait

I YAWN A LOT WHILE I WAIT. *It's hard waiting because it interferes with dreaming.* It is even harder to look like I am awake when I am. But I am patient. All vice-presidents must be because we can't be fired. Our bed (Karen's and mine) is like its occupants, mid-western nice with a dash of determined abstinence. Lights out at 10, no eating in bed, no visitors allowed. While waiting, I practice my devotional stare, which I modify per occasion. Moral disapproval takes many forms and I have a lot of time to wait.

Near us, down the hallway to the left, away from the façade of our large white house, is a small, crowded room that sits in half-light. There they linger, inhabitants like me who postpone dreams and wait instead for a death not necessarily our own. Hannibal Hamlin, Schuyler Colfax and Al Gore sleep the deepest. A little snoring, but mostly quiet. John Calhoun and Dan Quayle twitch and jerk not in their dreams, but because of what I understand are suppressed instincts. Henry Wallace and William Rufus King are nowhere to be found. I suspect they do not dream. Joe Biden and Nelson Rockefeller dwell in their own sleeping chambers and have left word they are not to be disturbed. Aaron Burr, Spiro Agnew and Dick Cheney can't seem to find a safe place to sleep because of their troubled lives. But these vice-presidents, all of us sleeping and daydreaming while waiting, will awaken instantly should we receive word that the president has died.

we fill our American hearts

Ransom 13

WE FILL OUR AMERICAN HEARTS, 2013
WATERCOLOR
30 X 22"

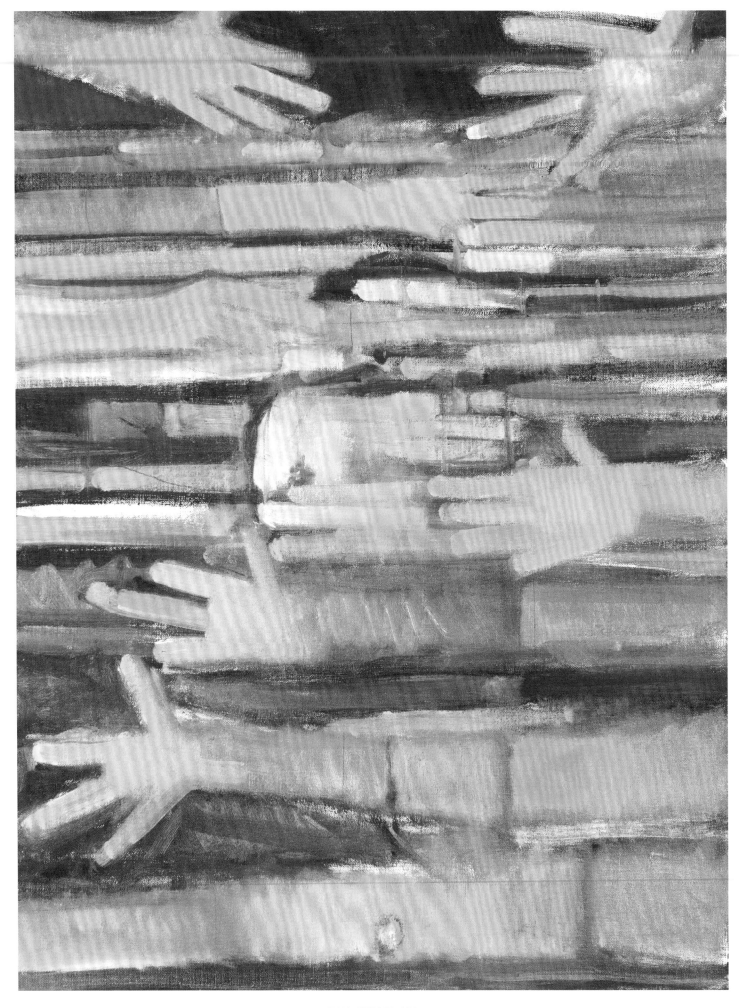

BARACK EMERGING, 2014
OIL ON LINEN
40 X 30"

ABOUT JOHN RANSOM PHILLIPS

WORKING ACROSS VARIOUS MEDIA—PAINTING, FILM, THEATER AND POETRY—JOHN RANSOM PHILLIPS LIVES AND WORKS IN NEW YORK, HAVING ALSO SPENT SIGNIFICANT PERIODS OF TIME IN EUROPE AND EGYPT. He completed his PhD at the University of Chicago on the destruction of art during the English Reformation while continuing his painting and creative writing. Throughout his career, Phillips has always engaged history. Photographer Mathew Brady, Renaissance painter Pintoricchio, and Mao Zedong's wife, Jiang Ching, have all come under his focus, as he explores their dreams, fantasies, secret wishes and desires. Other books include: *Bed as Autobiography,* 2004, *A Contemporary Book of the Dead*, 2009, and *Ransoming Mathew Brady,* 2009.

Phillips' paintings combine image and text, harnessing the legacy of symbolism, where states of mind and emotions are explored and given deeper meaning. His work demands the viewer to probe what is portrayed beyond everyday appearances, challenging perception—in all its forms. His oil paintings and works on paper have a dream-like quality where forms morph and melt into one another. In his *Sleeping Presidents* series, beds become wondrous landscapes where psychological narratives are revealed. Even presidents take to their beds to be born and to grow, to hide and to dream, to lie alone and cling together, to rest and to die.

INDEX

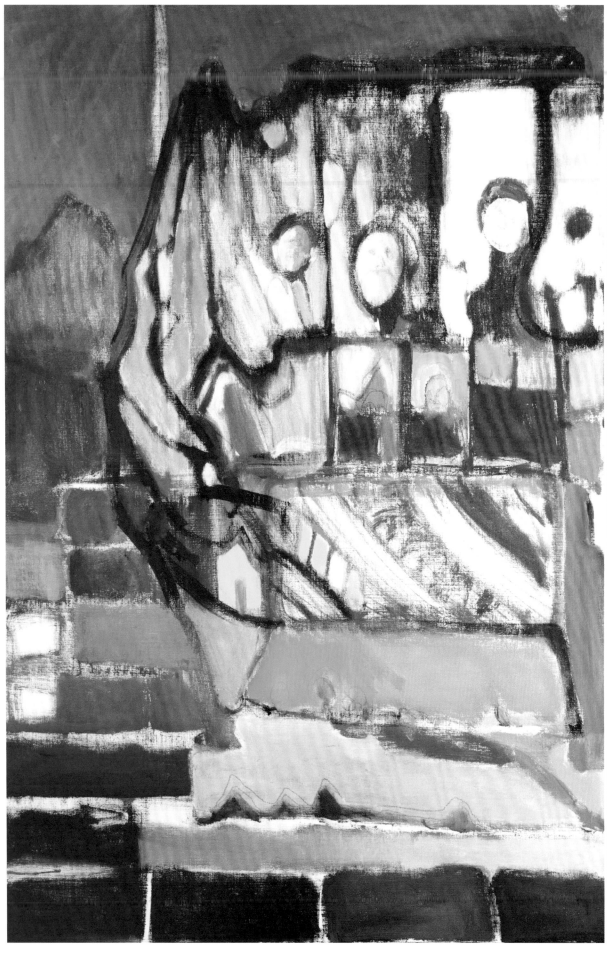

SLEEPING PRESIDENTS

SLEEPING PRESIDENTS CONSTRUCTING AMERICA, PANEL 1, 2 AND 3, 2012. OIL ON LINEN, 60 X 120"